Desert Bighorn Sheep

WILDERNESS ICON

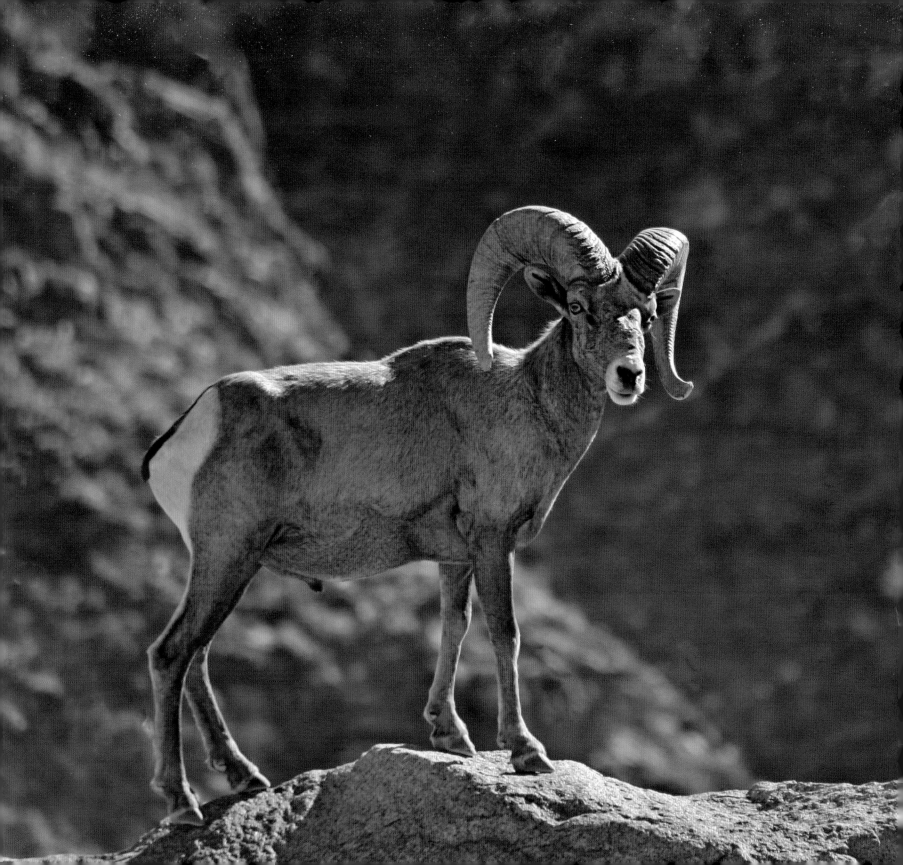

Desert Bighorn Sheep

WILDERNESS ICON

Mark C. Jorgensen

PHOTOGRAPHS BY
Jeff Young

SUNBELT PUBLICATIONS

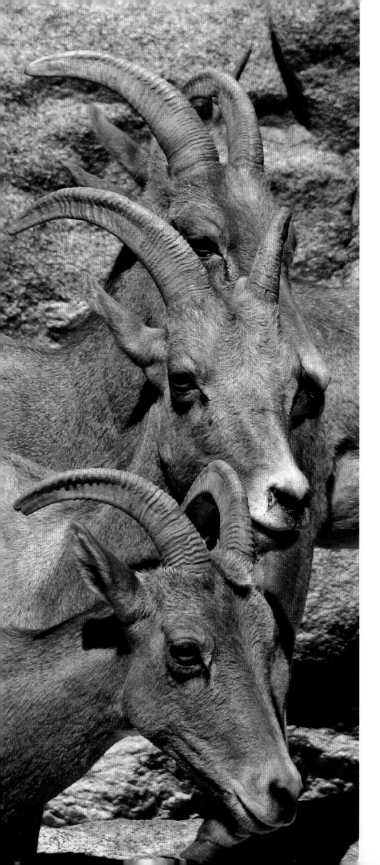

Desert Bighorn Sheep: Wilderness Icon

Sunbelt Publications, Inc.
Copyright © 2015 by Mark C. Jorgensen and Jeff Young
All rights reserved. First edition 2015

Edited by Anita Palmer
Cover and book design Kathleen Wise
Project management by Deborah Young
Printed in China

Sunbelt Publications, Inc.
P.O. Box 191126
San Diego, CA 92159-1126
(619) 258-4911, fax: (619) 258-4916
www.sunbeltbooks.com

19 18 17 16 15 5 4 3 2 1

All photographs are by Jeff Young unless noted or in public domain.

Library of Congress Cataloging-in-Publication Data

Jorgensen, Mark C., author.
 Desert bighorn sheep : wilderness icon / by Mark Jorgensen ; photography by Jeff Young. -- First edition.
 pages cm
 Includes bibliographical references and index.
 ISBN 978-1-941384-00-8 (pbk. : alk. paper) 1. Desert bighorn sheep--United States. 2. Desert bighorn sheep--Mexico. I. Young, Jeff, 1945- illustrator. II. Title.
 QL737.U53J69 2014
 599.649'7--dc23
 2014015199

Sponsors

Frank W. Colver

Ann Peckham Keenan

Ralph Singer and Louise Bahar

 California State Parks
Colorado Desert District
Anza-Borrego Desert State Park®

 Anza-Borrego Foundation

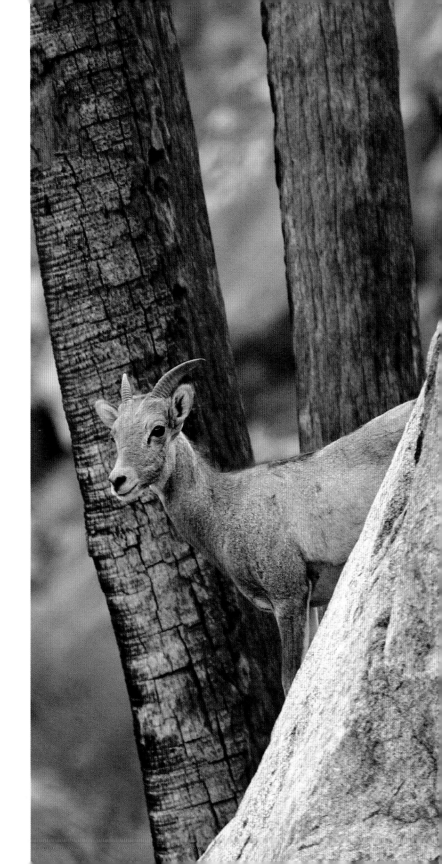

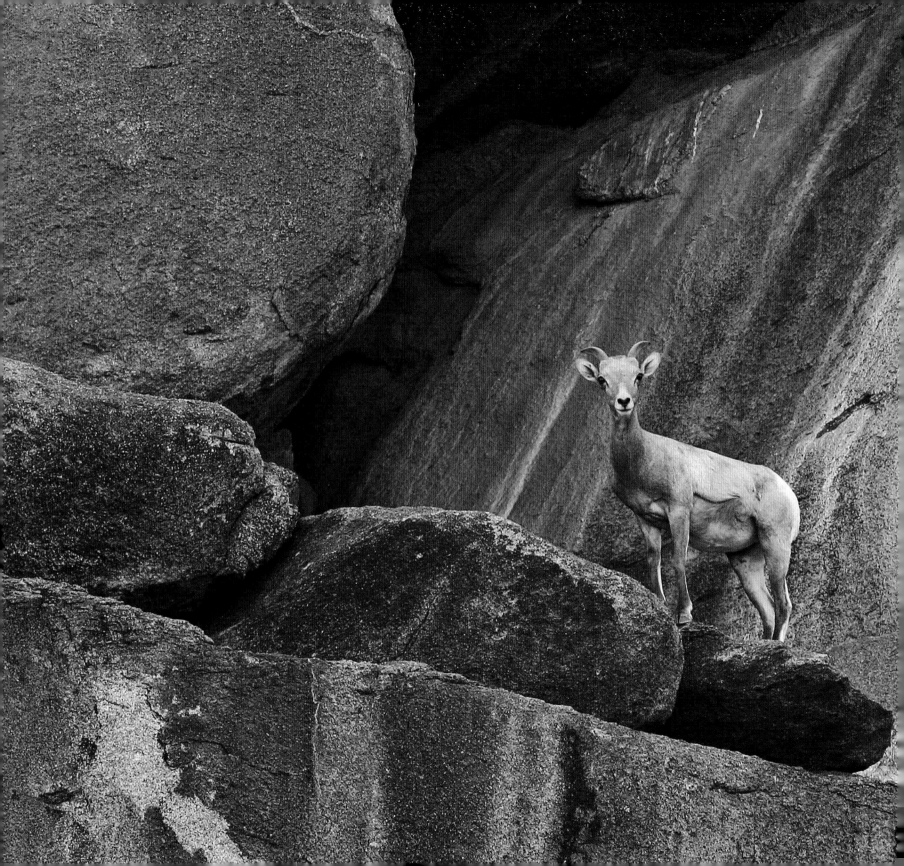

Table of Contents

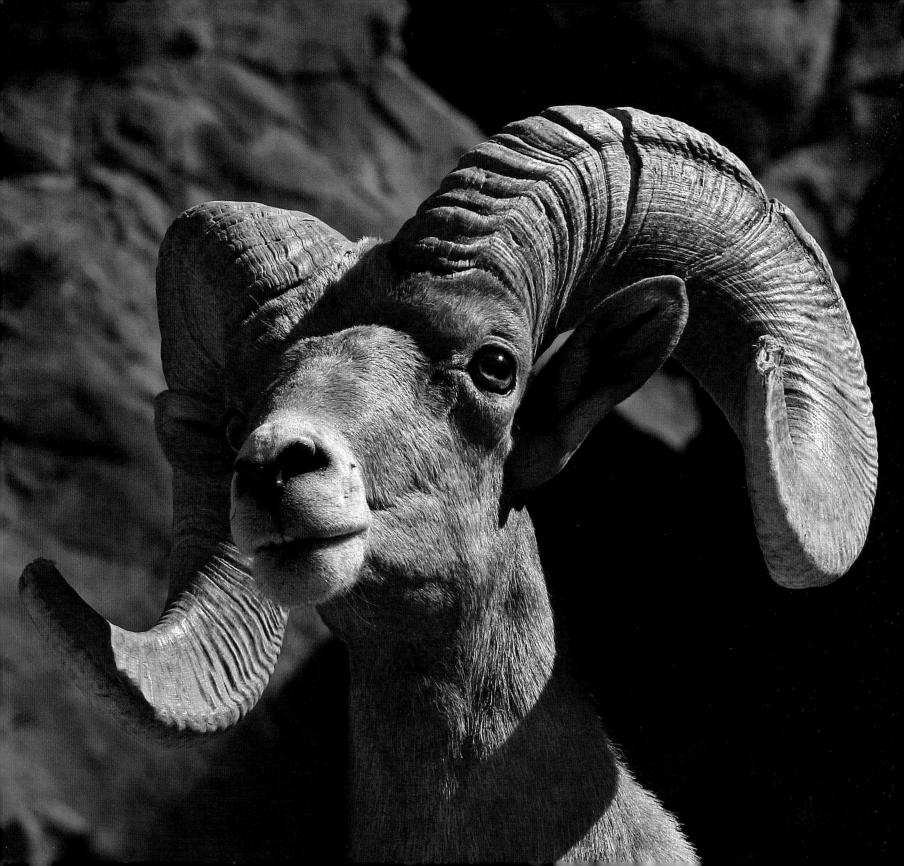

Foreword

This book offers a rare glimpse into the world of desert bighorn sheep, which few have been able to witness. True, there are numerous scientific reports that investigate various aspects of bighorn sheep ecology and conservation, several books on bighorn sheep management and harvest, and several beautiful photographic books featuring bighorn sheep. Yet, this book is special because it combines an intimate photographic visit into the lives of desert bighorn sheep through Jeff Young's captivating photos, with interpretation and a tour through bighorn sheep biology, behavior, and management by Mark Jorgensen.

Jeff's photos are unique because they go beyond portraying bighorn sheep in majestic poses on ridgelines, by including photos that capture behaviors and interactions not commonly witnessed. Mark's deep understanding of bighorn sheep, years of experience, and completely engaging style of communication build the informational context around these photos. Few people have had the opportunity to observe bighorn sheep in the wild and to

see their beauty in the harsh environment that they call home, or to spend patient hours and days witnessing their diverse behaviors and interactions. This book captures those special moments.

Although Jeff Young's primary career was in business, he pursued his passion for photography during his free time for many years, and then was able to focus on it more completely after retiring. His photographic adventures have taken him to the Amazon and on many trips to Yellowstone, the Tetons, Glacier National Park, and the California coast, with a focus on wildlife photography. After seeing desert bighorn sheep for the first time, the animals quickly became Jeff's new passion, and he has spent countless days observing bighorn sheep in Anza-Borrego Desert State Park in southern California's desert. Although his original intent was simply to photograph the bighorn sheep, he quickly became fascinated with their behavior.

I first bumped into Jeff in a desert canyon where we were both looking for bighorn sheep. His extensive time in

the field benefited those of us studying this population, as he frequently gave us updates on his observations. When he started showing up at Desert Bighorn Council meetings to listen to biologists speak about bighorn sheep management, conservation, and ecology, I knew he was hooked and had a deeper interest than just capturing photographs.

The following quote wraps up Jeff's passion and commitment to bighorn sheep: "To watch the sheep in silence and solitude is what it's all about. My only intention is simply to show people photos of these magnificent animals, and hope that they appreciate and do whatever they can to preserve them." His photos certainly do speak a thousand words.

Mark Jorgensen has spent decades observing bighorn sheep, and working to conserve them and their habitat. I first met Mark in the early 1990s when I volunteered to look for bighorn sheep signs in a remote part of Anza-Borrego Desert State Park. I knew little about bighorn sheep and little did I know that Mark and I would work together on bighorn sheep conservation for many years to come. All along, Mark has been a wealth of knowledge, and I've continued to learn from him.

Mark's love for the desert and its inhabitants started at an early age, when he was growing up in San Diego. His older brothers once told me how, as a teenager not yet old enough to drive, Mark would beg them to drive him to the desert and leave him there for days at a time to explore. And they did! His subsequent career revolved around conserving the desert, including bighorn sheep habitat, monitoring desert wildlife, and sharing his knowledge and passion about the desert with others.

Among many accomplishments, Mark helped California acquire hundreds of thousands of acres of bighorn sheep habitat, and developed an annual volunteer bighorn sheep count that is now in its 42nd year and has logged over 35,000 volunteer hours. He has also spent countless hours surveying bighorn sheep both from the ground and the air, and has helped facilitate, fund, and conduct field studies on bighorn sheep lamb mortality, habitat use, mountain lion predation, and population health. Mark has also served as an elected Technical Staff (Board) member of the Desert Bighorn Council for multiple years, served on the U.S. Fish and Wildlife Services' Recovery Team for bighorn sheep in Peninsular Ranges of southern California, and has authored and co-authored multiple publications about bighorn sheep. All along, he has captivated many audiences with his informative and entertaining talks and stories. We are fortunate that he has chosen to continue sharing his knowledge through this book.

Throughout their range, bighorn sheep face challenges such as loss, modification, and fragmentation of their habitat, introduction of domestic livestock that carry diseases deadly to bighorn sheep, predation, drought, and climate change. We certainly need to work together to protect this incredible species. The combination of Jeff's photographs and Mark's deep understanding of these animals has resulted in a unique visit into the lives of desert bighorn sheep and the complexities of their ecology, conservation, and management. I hope that you enjoy this book, and that it will instill in you a solid appreciation for this wonderful animal and the desert that it calls home.

Esther Rubin
Chief of Research Branch
Arizona Game and Fish Department
December 2013

Acknowledgments

The photographer and author would like to extend our gratitude to a number of people who have influenced us over the years and who have helped make this book a reality.

From Jeff Young: There are three friends that have been most responsible for the photos you see in this book. Janene Colby and Mark Jorgensen have taught me all that I have come to know about the desert bighorn sheep, and Paul Johnson has fine-tuned my ability to use cameras and lenses.

Paul Johnson, my photography mentor, has worked as a park naturalist in Anza-Borrego Desert State Park (ABDSP), a field researcher of rare plants and a freelance photographer; he is currently involved in photographic monitoring of vegetation recovery. Originally taking a class from Paul years ago, I continue to meet with him for helpful critiques and advice. I mentioned to him in one of my early sessions that all I really cared about was photographing the desert bighorn sheep. His advice was to do just that and specialize. Paul has helped me to get the best out of my equipment, and introduced me to editing. He's an incredible photographer, teacher, and desert guide.

You know Mark Jorgensen as the author of this book, and already understand his unique qualifications and expertise. He knows more about desert vegetation, mammals, birds, insects, and the history of the area than any one person I have ever met. Stumped as to what the sheep were doing in my early photos, I took a batch of them into the ABDSP headquarters hoping to get some explanations. That was the first time I met Mark, then park superintendent, and he was the first to teach me about desert bighorn behavior. Mark has always been generous with his time and in sharing his knowledge of the desert. In addition to sheep information, he continues to show me things that I didn't know existed, like hunting blinds, guzzlers, and more.

Janene Colby is a bighorn sheep biologist with the California Department of Fish and Wildlife. She does everything from population monitoring, research, lamb survival monitoring, radio collaring, and necropsies (autopsies) on sheep mortalities, to name a few responsibilities. She's incredibly dedicated and climbs mountains that I only see through binoculars. The first

time I ever ran into Janene on a canyon trail, she must have grudgingly "deemed me worthy" to pull herself away from her spotting scope to answer more sheep behavior questions. In subsequent hikes when we happened to be in the same area, she continued to be a fountain of desert bighorn information. Not only has she taught me what bighorn are going to do before they do it, importantly she has taught me how to behave in their presence. Rams and lambs are my favorite subjects, but she has given me an understanding of the importance of ewes—even the collared ones! Janene has also been a field biologist in the research of grizzly bears, river otters, Mexican spotted owls, amphibians, and more.

My thanks to the Anza-Borrego Foundation for their work in land acquisition, protecting and preserving the desert and its wildlife. I am especially grateful to two people who have shown me that my work is of value to others. Kelley Jorgensen, who at the time was interpretive sales manager, persuaded me to do a desert bighorn photo exhibit—and made it happen. Also, Education Manager Briana Puzzo has used my photos to educate and increase public awareness through *Desert Update* and other media. Thanks to Sonja Lane for editing many of the photos you see in the book.

While it may seem somewhat bizarre to include the sheep in the acknowledgments, their tolerance of the guy with the backpack and cameras, and their jaw-dropping "behavior shows" made all of this possible.

Finally, I thank my wife, Jean, who understands how important these frequent desert trips mean for my sanity, solitude, and passion for watching and photographing wildlife. For over 40 years she has supported my adventures to South America, the Sierras, and now the desert. And more remarkable, she is a great mom, nanna, and wife.

From Mark Jorgensen: I look back to an early influence more than 50 years ago to a California State Park Ranger, George Leetch, who introduced me to the desert bighorn sheep during an interpretive program in a remote campsite in Anza-Borrego Desert State Park. Don Sterner and Phil Benge joined me for many early hikes in bighorn habitat, and Sterner was with me when we both observed our first desert bighorn in the wild in 1967.

A few years later the manager of the park, Bud Getty, hired fellow college student Bob Turner, Jr., and me to study the desert bighorn for four summers and offer management strategies to the park. Getty found seasonal funding to keep the research going year after year and continued to support the bighorn program by attending more than 40 annual summer sheep counts, even long after retirement. Along the way many researchers, rangers, and park superintendents provided opportunities to study the bighorn and to learn more in the field, in conferences, and through professional associations. Annual conferences of the Desert Bighorn Council in several western states and Mexico further enlightened me on the natural history and management challenges facing desert bighorn.

I would like to express gratitude to many friends and colleagues who guided me through the years and made my life-long work possible. My wife, Kelley, supported my work, odd hours, and field trips out of state, and waited at least one long night for her husband to return home from a helicopter crash while surveying for bighorn. Brothers Paul and Steve Jorgensen provided rides to the desert to search for bighorn when I was too young to drive and throughout adulthood accompanied me on numerous hikes and habitat projects.

Park superintendents Jim Hendrix, Dave Van Cleve, Mat Fuzie, and Dr. Mike Wells provided time, training, and support for bighorn projects, meetings, and capture expenses. Helicopter pilots Don Landells, Steve DeJesus, Brian Novak, and Mel Cain provided more than a thousand hours of aerial research, captures of bighorn and wild cattle, and a lifetime of memories. Fellow researchers Bob Turner, Terry Russi, Jim DeForge, Dick Weaver, Dr. Esther Rubin, Dr. Walter Boyce, Randy Botta, Steve Torres, Dr. Ben Gonzales, Dr. Dave Jessup, Dr. Rick Clark, Dr. Vern Bleich, Dr. John Wehausen, Janene Colby, Paul Jorgensen, Jim Dice, Dr. Stacey Ostermann-Kelm, Aimee Byard, Chuck Hayes, Dr. Holly Ernest, Pete Sorensen, Dr. Guy Wagner, Mike Puzzo, Jim Bauer, Chasa Green O'Brien, Bambi Woodson, Jim Zuehl, Dr. Winston Vickers, and Dr. Mike McCoy accompanied the author on decades of captures and field trips and in meetings in California and Mexico.

A supreme debt of gratitude goes to one of the most dedicated bighorn volunteers and best friend Ray Mouton, who has trekked the desert ridges and canyons for over two decades with telemetry receiver in hand, following bands of bighorn and recording thousands of sightings.

Bighorn habitat projects have been greatly enhanced by the author's association with Chuck Bennett, Scot Martin, Frank Padilla, Jr., Bill Snider, Jim Snider, Herb Stone, Gil McKinnon, Heidi Person, and Ed Jewett. Borrego Springs Rotary Club, led by Bill Walker, adopted two guzzlers and have faithfully maintained them for more than 25 years. Chuck Bennett maintained five bighorn water developments twice a year for almost two decades and provided stable sources of precious water to a struggling subpopulation of bighorn. During this period, with water supplied to a mountain range where six natural sources had been usurped by human development,

Bennett witnessed the herd increase from a low of 25 animals to almost 150.

Over 40 years of desert bighorn waterhole counts have been supported and coordinated by many California State Park folks, such as Jeff Snider, Ray Patton, Dr. Mike Wells, Steve Bier, Kathy Dice, and P.J. Zeiss.

Membership and association with the Desert Bighorn Council, Inc. and the Bighorn Institute have made for life-long friendships with some of the most knowledgeable bighorn biologists in the world. I extend gratitude to Dick Weaver, Jim DeForge, Rick Brigham, Don Armentrout, Clay Brewer, Kevin Hurley, Pete Sanchez, Dr. Raul Valdez, Jim Blaisdell, and Warren Kelly for their wise counsel and inspiration to do what was right for bighorn, no matter the consequences of career upward mobility.

For their support of this project by providing key updates on the status of desert bighorn in the United States and Mexico the author sincerely appreciates Ray Lee of Wyoming, who provided extensive information on Mexico, Dr. Esther Rubin of Arizona, Clay Brewer of Texas, Dr. Eric Rominger of New Mexico, Steve Torres of California, and Patrick Cummings of Nevada.

Ray Lee and Dr. Esther Rubin spent tireless hours reading the entire manuscript for technical accuracy and provided excellent comments and advice to improve the text. Esther Rubin was kind enough to write the Foreword for the book. Any errors in the text or captions belong solely to the author.

Diana Lindsay of Sunbelt Publications conceived the idea for this book many years ago and worked to bring this volume to reality. Debi Young of Sunbelt carried the project to completion with her skills in project coordination. Our gratitude to Kathleen Wise for her superb artistic design work on the project. Our thanks to Anita Palmer for her editing skills and patience.

Introduction

Jeff Young and I struck out on a journey together to create a book that would be the best photographic display of the desert bighorn sheep in print. We hope we have produced such a piece.

I met Jeff in the headquarters of Anza-Borrego Desert State Park when he walked in with an album of bighorn photographs he had taken over a period of months among the palm groves of the 640,000-acre desert wilderness. As I gazed through his small collection of pictures, what was remarkable was how different they were from the many thousands of sheep photographs I'd seen in my five decades of studying this magnificent animal. Years and tens of thousands of photographs later, that impression has only strengthened.

One can smell the creosote and the dust as one marvels at Jeff's photos. He captures the essence of the desert bighorn sheep through his unique perspective, his use of lighting, and pure natural settings. He finds life among the red rock, the limestone, the varnished granite boulders, and within the deep gorges. He hikes among the slopes of cacti, agave, yuccas, saguaros, and Joshua trees, seeking out the realm of the wild sheep. He captures the art of nature within the eye, the curved horns showing years of growth and combat, the bond of ewe and lamb, and the ruggedness of their desert habitat. He takes action shots in series and in mid-air, and captures wildlife behaviors rarely seen.

The desert bighorn sheep stands as a symbol of what is wild, remote, and foreboding. The bighorn has adapted to a realm of the highest temperatures on Earth, in canyons on the scale of the Grand Canyon, in a land of little water, high winds, large stealthy predators, and the ever increasing pressure of humanity. With human foresight, wisdom, and compassion, the bighorn and other wildlife species can continue to roam and thrive in the western wilderness.

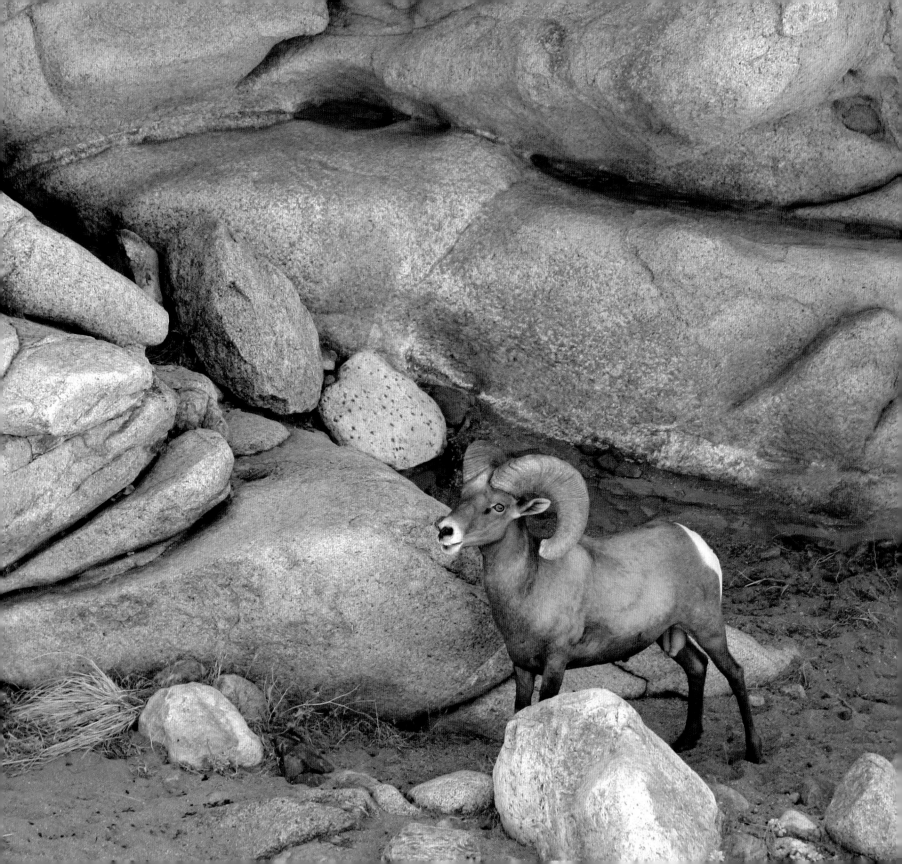

CHAPTER 1 | Origins and Distribution in the United States and Mexico

Old World Sheep

The predecessors of North America's bighorn sheep are found in a large arc of several thousand miles beginning near the shores of the Mediterranean. Over millennia wild sheep of various forms moved into Europe; others migrated through the Himalayas, to the Gobi Desert, and into Siberia. The sheep of the Old World tend to be tall, long-legged, open-country runners. They are well suited to the mountains, basins, and rolling valleys of Iran, Afghanistan, China, and Mongolia. In contrast, Ibex, members of the goat family, cohabit many ranges with Asiatic sheep, but tend to find their niche in the steeper cliffs and rocky ridge tops. Ibex are stockier, bearded, and their range is usually higher and overlooking the taller, more slender wild sheep.

Sheep evolved into races of argali (*Ovis ammon*) in the Altai and Gobi regions of Mongolia, and in Siberia, where they developed into a species known as Siberian snow sheep (*Ovis nivicola*). During one or several of the major interglacial periods between 75,000 years ago and possibly as early as a million years ago, *Ovis* wound their way over the ice and along shorelines from eastern Siberia, across what is now the Bering Sea, pioneering into the Western Hemisphere. A series of Ice Ages tied up polar ice thousands of feet thick, resulting in a decline of sea level of more than 150 feet. Paths into the Americas over the Land Bridge came across vast fields of ice and rock and along newly exposed shorelines. American wildlife natives made their way westward from Alaska into Siberia, becoming the cheetahs of India and Africa, the horses of Neanderthal cave paintings, the zebras of the African savannah, and the

Opposite: **A large ram halts in the shade of a granite cliff not too far from a small stream in the Sonoran Desert.**

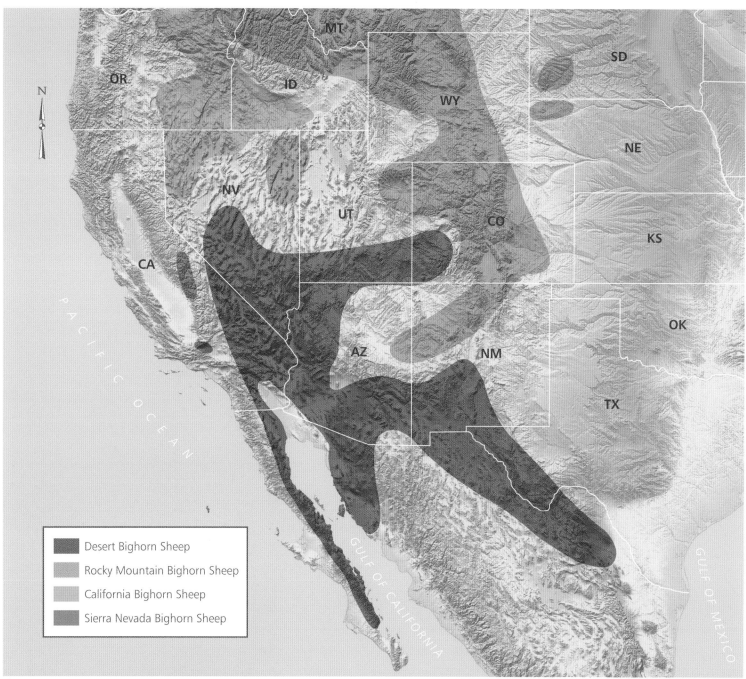

SHADED RELIEF BASE MAP COURTESY OF NASA

The range of the various subspecies of bighorn sheep in the U.S. and northern Mexico

camels of the Gobi. Asian natives such as huge bison and the genus *Ovis* followed the emerging mountain ranges and green slopes eastward into a New World.

Exactly when wild sheep first made their entry into North America is vaguely described as "during the Ice Age." There are fossils of ancient *Ovis* scattered throughout the West. Sites holding the secrets of *Ovis* include Natural Trap Cave, Wyoming; Porcupine Cave, Colorado; Gypsum Cave, Nevada; and the easternmost find on the Republican River, Nebraska. A recent discovery of fossilized *Ovis* vertebra in Anza-Borrego Desert State Park in California places *Ovis* to about 500,000 years in the New World.

As *Ovis* moved into the Western Hemisphere, it branched into two distinct species. One group of sheep, known as the "thin-horned" sheep (*Ovis dalli*), found the massive ranges of Alaska and western Canada suited

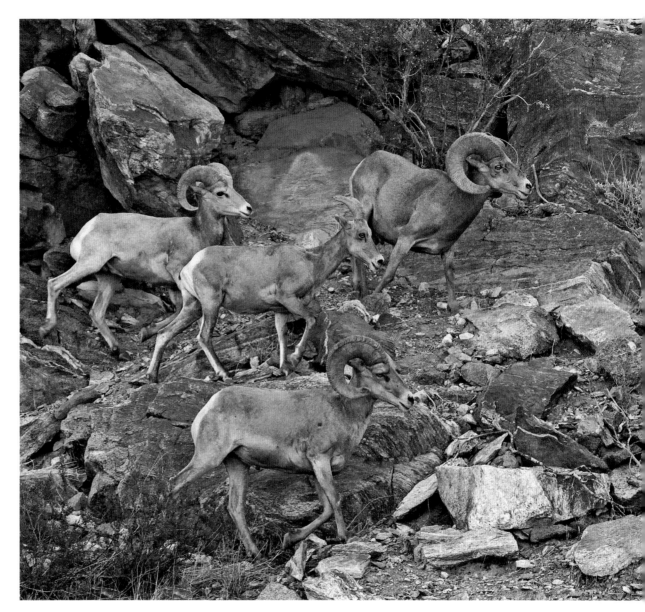

A ewe is surrounded by rams during the mating season.

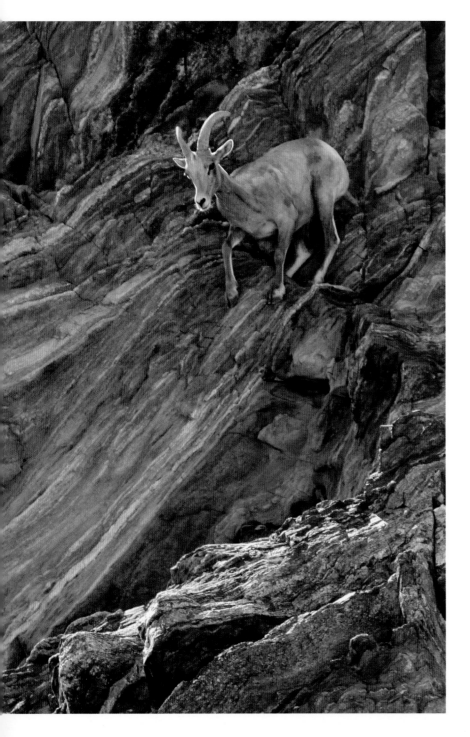

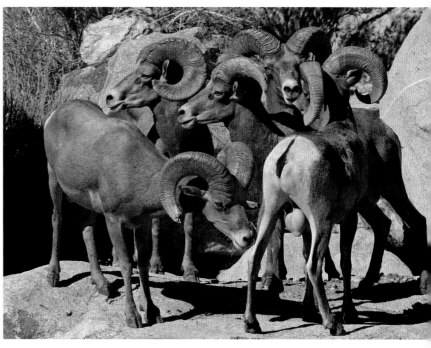

Left: **A mature ewe makes her way down a striated cliff toward water.**

Above: **Five mature rams cluster in early mating season. Head-to-head combat is soon to follow.**

them and they remained. They are the white Dall sheep of Alaska and western Canada and the darker Stone sheep of British Columbia.

Wanderlust for the New World drove the pioneering sheep which would evolve into two main branches of bighorn sheep (*Ovis canadensis*) further south. The Rocky Mountain bighorn (*Ovis canadensis canadensis*) migrated along the backbone of the Continental Divide from Alberta, Canada, to northern New Mexico; then branched into the California bighorn (*Ovis canadensis californiana*), and the Sierra Nevada bighorn (*O.c.sierrae*), migrating southward along the Cascades to the Sierra Nevada.

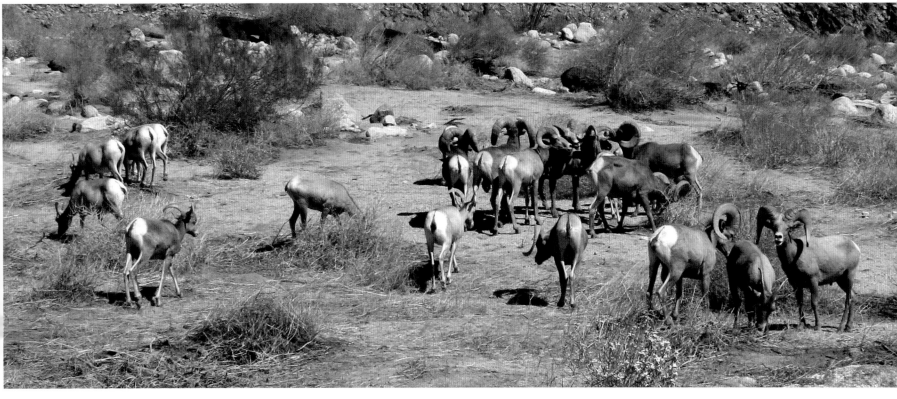

A large group of ewes and rams gather off the steep slopes to feed. "Escape" terrain is never far away.

Desert bighorn sheep took to their new home in the drier ranges of Nevada, Utah, Arizona, California, Colorado, New Mexico, Texas, Coahuila, Nuevo Leon, Chihuahua, Sonora, Baja California and Baja California Sur. These became the Nelson's desert bighorn (*O. c. nelsoni*) of southern Nevada and Utah, northern Arizona, and eastern and southern California; the Mexican desert bighorn (*O. c. mexicana*) of Arizona, New Mexico, Texas, and northern Mexico; Peninsular bighorn (*O. c. cremnobates*) of northern and central Baja California; and Weems bighorn (*O. c. weemsi*) of Baja California Sur. The Rocky Mountain cousin took on a robust, stocky form with a heavy, hollow-haired coat, and short ears suited for high elevation cold. Ranging into the lowlands, the desert subspecies appeared to have long slender necks, with shorter hair, and longer ears, and they became well adapted to the dry, hot climate which took over much of the Southwest.

Settling into the New World

Prehistoric distributions of bighorn sheep ranged from western Canada southward to northern Mexico, eastward to Nebraska, the Dakotas, and west Texas, and westward into Washington, Oregon, eastern California to the tip of

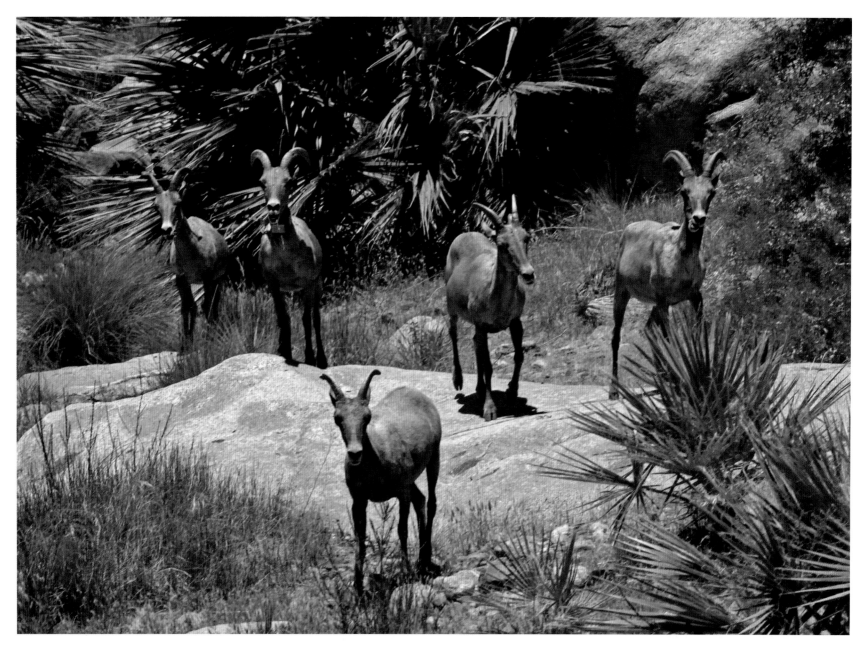

Five ewes depart from a palm grove after watering (note radio collar on second ewe from the left).

Baja California. Wildlife ecologists speculate the prehistoric populations of bighorn sheep were widespread, and possibly numbered more than one million. The wild sheep ranged freely among and between the basins and ranges of western North America from Alberta to the tip of Baja California, and from the Peninsular Ranges of southern California eastward to Nebraska and Coahuila, Mexico.

Subspecies of bighorn sheep developed in response to the environmental challenges of climate, with wide ranges of temperatures and precipitation regimes, from deep snows to scant rainfall, desert vegetation, geographic isolation, and latitude. One race, the Badlands bighorn (*Ovis canadensis auduboni*) became extinct in Wyoming, North Dakota, and South Dakota. Native populations of bighorn in Nebraska, Texas, Coahuila, and Chihuahua were driven to extinction by the introduction of livestock diseases, overgrazing by domestic livestock, overhunting for subsistence, and the loss of habitat to the rapidly expanding human populations.

Bighorn populations were greatly reduced by human activities and the spread of livestock throughout the West. Perhaps less than 5% of the prehistoric population remains today, due in large part to the introduction of livestock diseases. Habitat fragmentation, human encroachment on water sources and sheep habitat, and early day market hunting by miners, prospectors, and ranchers further reduced native populations of bighorn.

Many populations of desert bighorn and Rocky Mountain bighorn sheep have been successfully restored through the foresight and dedication of numerous conservation and hunting organizations, private landowners, as well as state and federal wildlife agencies in the United States and Mexico (see Chapter 6, "Hope for the Future").

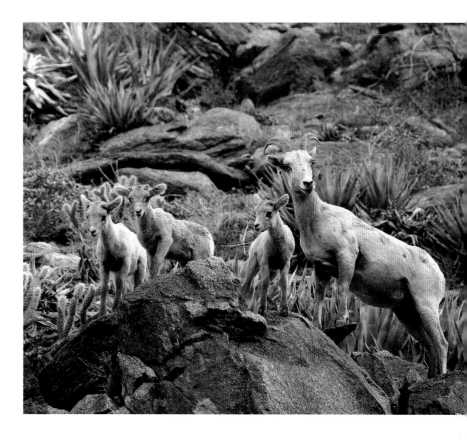

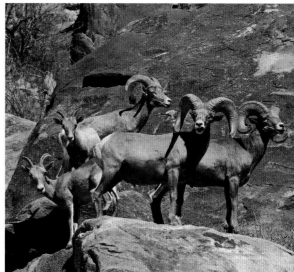

Above: A mature ewe babysits three lambs while other ewes feed and go to water.

Right: Three rams cluster around a ewe and her lamb.

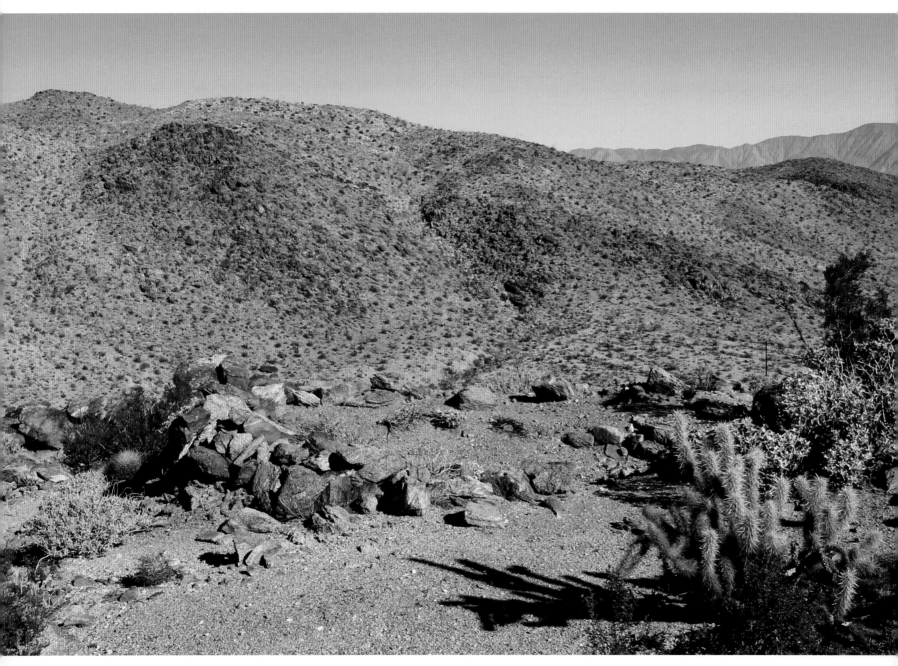

Pictured is a prehistoric bighorn sheep hunting blind in a complex of 16 stone blinds.

Native Peoples and Bighorn Hunting

Bighorn sheep hold special powers in the folklore and present-day beliefs of many Native American peoples, just as their predecessors did in the Old World. There are many rock art panels depicting stylistic sheep throughout the western states. Long strings of bighorn sheep, with horn size often embellished, line the canyon walls of ranges in the Coso Mountains of California, the Valley of Fire State Park of the Mojave Desert in Nevada, the canyons of Utah, and the Four Corners region of Arizona, New Mexico, Colorado, and Utah. Campbell Grant writes of a prehistoric bighorn hunting cult developed in the Coso Mountains of the Mojave Desert, where the abundance of desert bighorn led to the development of specialized hunting techniques that took advantage of the predictable behavior of the bighorn.

Many desert tribes of Native Americans were seasonal nomads, moving into the higher and cooler mountain ranges for summer and autumn and migrating into the lower deserts for the warmer winter and abundant spring. Desert bighorn were found in mountain saddles, moving along ridgelines and corridors between isolated ranges. Ewes would move into areas in winter and remain in traditional lambing grounds until the heat of summer prompted them to move them back into the deep canyons where permanent water could be found. Rams moved together in bachelor herds in the non-breeding seasons and could be found in groups of 15 or more.

Native hunters knew the seasonal movements of the wild sheep and staged near water sources and in saddles and ravines where they knew bighorn would be passing. In hot weather, bighorn would be forced to visit springs, seeps, and tinajas (rocky basins which hold water for weeks

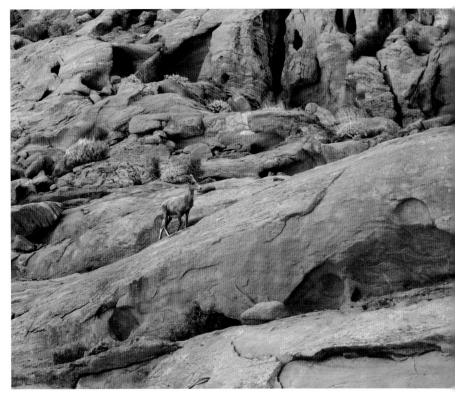

A mature ewe makes her way through the red sandstone of the Valley of Fire State Park, Nevada.

or months after rains). Hunting blinds made of crescent-shaped piles of stones a couple of feet tall made a perfect hiding place for the skilled hunter. Several hunting blind complexes have been documented, comprised of lines of multiple hunting blinds spanning the slopes overlooking springs or saddles.

One such complex in San Diego County, California, contains at least 16 rock blinds, spaced approximately 15 to 30 yards apart, overlooking a passage between two rocky ridgelines. The desert bighorn moved from one long ridge, across a sandy arroyo, and to the safety of the near ridge.

The line of blinds spread horizontally across the face of the mountain, overlooking the crossing. One can imagine several hunters afoot, walking along the canyon bottom, gently hazing the bighorn up the slope to the waiting hunters, crouched behind their stony blinds, armed with a bow and arrow, or an atlatl and spear. As the bighorn moved uphill between the concealed blinds, the hunters were poised for their shot, not more than 15 yards distant.

Similar hunting blind complexes have been described in the Warm Springs area of Saline Valley west of Death Valley, at Nevares Spring in Death Valley, and around remote tinajas in the Pinacate Mountains of northern Sonora, Mexico. Other hunting blind complexes have been described throughout the west, comprised of a central blind and expanded wings made of rock or piles of logs and branches. The bighorn would be slowly hazed into the winged traps, or would wander into the "squeeze" on their own, to be taken by the waiting hunters.

Native American Tools

In some parts of North America, the bows used to hunt bighorn were made of bighorn sheep horns. The Northern Shoshone, some of whom were known as the "Sheep Eaters," are documented to have made and used bighorn bows, referred to in old journals as the "most powerful bows, capable of killing even bison." The large horns of mature rams were softened in hot water, cut, and straightened into bows said to be stronger than any wooden bow. One such bow is depicted in the artwork of Swiss artist Karl Bodmer, whose numerous Native American paintings are represented in the Joslyn Museum in Omaha, Nebraska. Bodmer shows a Dog Dancer of the Hidatsa Tribe holding the highly prized bighorn bow during a ceremonial dance.

Bighorn sheep horns were fashioned into ladles, spoons, knives, awls, combs, seed-gathering paddles, jewelry, and fetishes. The hooves of bighorn were made into rattles used during ceremonial dances. Bighorn sheep hide was tanned and used for clothing, footwear, pouches, and quivers; and the sinew was used to make glue and as a strong backing for bows.

Rock Art

One of the most common rock art motifs in the American West is the bighorn sheep. Depicted in petroglyphs pecked into the ancient desert varnish of granite and sandstone, as well as painted onto rock faces in the form of pictographs, bighorn rock art is found in all the western states where bighorn are native. Some of the finest examples of desert bighorn rock art can be found in the Coso Mountains at China Lake and Death Valley, California; Valley of Fire, Nevada; in Utah at the confluence of the San Juan and Colorado rivers; in the canyons near Four Corners; along the Columbia River in northern Oregon, and in the Sierra de San Francisco in central Baja California.

Campbell Grant conducted extensive rock art surveys in 1966–67 in the Coso Mountains of the Mojave Desert and recorded more than 14,000 rock art figures, over half of which depicted desert bighorn sheep. Grant describes what he postulates was a bighorn hunting cult in which shamans would produce bighorn rock art in hunting areas to bring good bighorn spirits and abundant harvests of this important big game animal. Many of the rock art panels show lines of bighorn being watched over by an ornately decorated shaman.

Various weapons are also noted in the art panels by Grant. The most ancient rock art panels possess the atlatl-

spear or dart technology, which employed an extended throwing stick, known as the atlatl, to propel the spear. More recent panels reflect the advent of the superior bow and arrow. Grant surmises the introduction of the bow and arrow around 2,000 years ago may have led to overhunting of the highly sought-after bighorn in the Coso Range. This decline in one of the most important game animals may have led the Shoshone natives to move further east and north into the Great Basin region, taking with them their hunting techniques and their spirit-rich rock art.

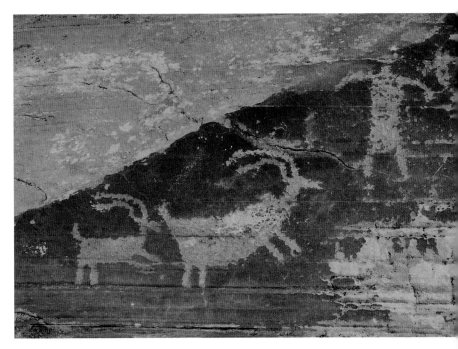

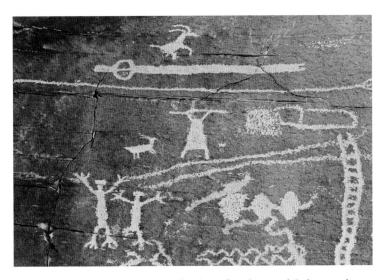

Above: Pictured are petroglyphs of a desert bighorn sheep hunter in Valley of Fire State Park, Nevada. The hunter holds a long dart over his head. Note the throwing stick, (just below the upper bighorn), known as an atlatl used to hurl the dart at high speed to its quarry.

Top Right: Archeologists describe a "bighorn hunting cult" which developed in the Mojave Desert. In some regions more than half of the rock art motifs depict bighorn sheep.

Right: Thousands of rock art motifs in the Southwest depict desert bighorn sheep. Many show large rams with spiraling horns, pregnant ewes, and hunters pursuing sheep with bow and arrow or atlatls and darts.

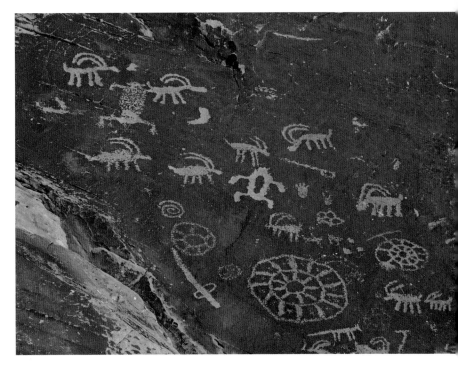

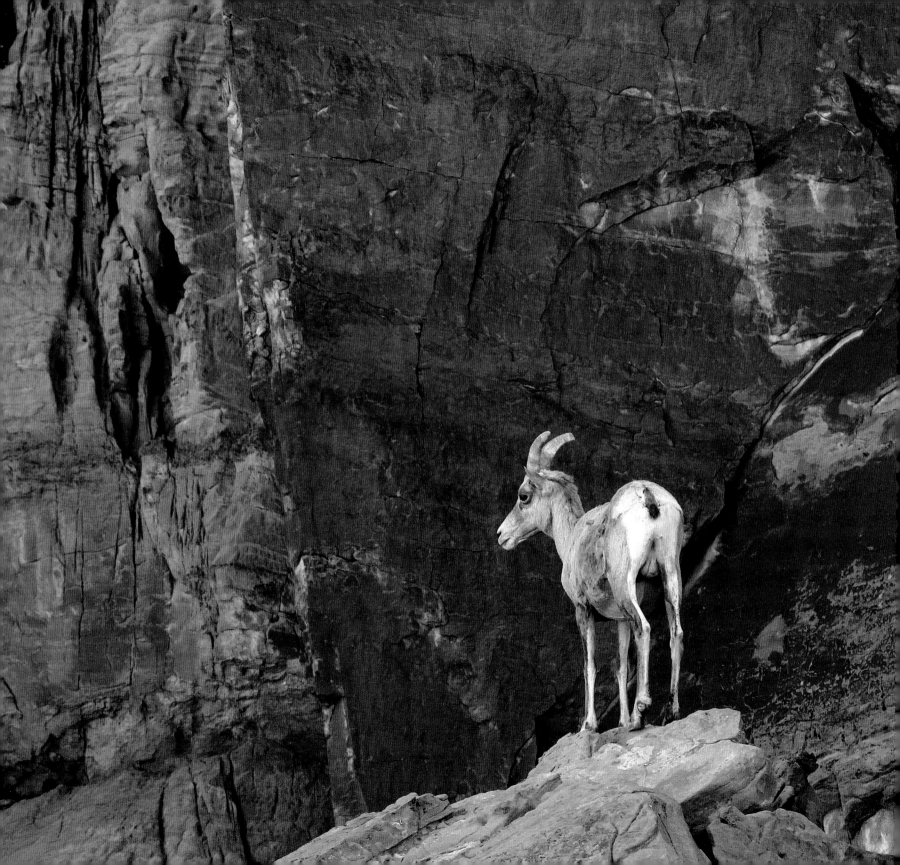

CHAPTER

2

Habitat— "Home" to Wild Sheep

The essentials of desert bighorn habitat include *steep terrain* with high visibility from which to observe the vast land below, suitable *diverse forage species*, and *access to water* in summer months. The home of the desert bighorn is steep, hot, sometimes cold and windy, sparse, and rocky; it receives slight rainfall and generally holds little water. Cacti, cliffs, alluvial fans, deep canyons, basins and ranges, thorny shrubs, tinajas, muddy seeps, and red rivers—these are the natural elements in the habitat of the desert bighorn sheep.

Steep Rocky Slopes—Escape Terrain

"Escape terrain" is what biologists call the steep slopes of classic desert bighorn habitat. The natural tendency for bighorn sheep is to run uphill when danger is detected.

They are usually not too far from slopes or cliffs, where, if spooked by predators, unfamiliar noises, human activity, or other sheep, they will flee rapidly to safety, spewing rocks and dust in their wake, until reaching a perceived safe perch. If danger persists, so does the flight uphill to higher ground, to big boulders, to the ridgetop or beyond. Once higher than the perceived danger, the sheep often stop, gaze, and assess the threat, standing and staring for as long as it takes to assure their safety.

Steep, rocky terrain is a key to giving the advantage over to the bighorn. If no danger materializes, a patient wait may ensue, sometimes for hours, until the sheep resume their activity, whether it be feeding, going to water, or lying in a smooth bed chewing their cud. Long mornings and afternoons are spent standing and watching over thousands of acres of desert landscape, on the lookout for the slightest

Opposite: **A ewe climbs to safe terrain in the red sandstone of Valley of Fire State Park, Nevada.**

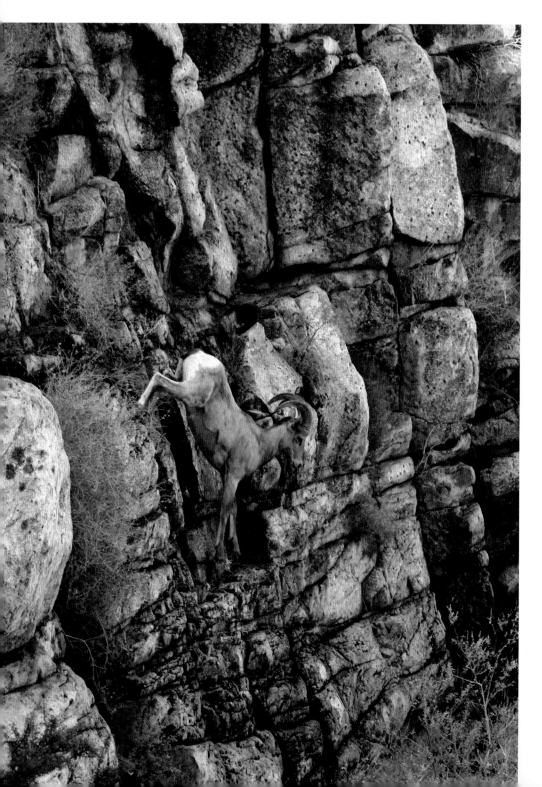

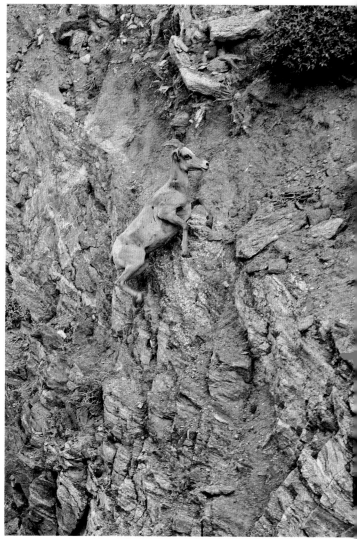

Left: A young ram seemingly dives headlong off a granite cliff. Early naturalist Ernest Thompson Seaton perpetuated the myth that rams jumped off cliffs head first, landing on their curved horns to break the fall.

Above: A bighorn ewe, showing agility and strength, scales a sheer cliff of broken rock. Few predators can keep up with their quarry in such situations.

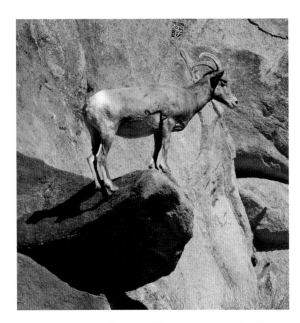

Above: **When descending to water, bighorn often find a prominent boulder to stand upon, vigilant for possible danger.**

Right: **This ram lamb has mastered the cliffs at an early age, pictured in midair, then landing on his front hooves to maneuver down slope.**

movement of a mountain lion, coyote, or the flight of a golden eagle. Ridgetop views provide the safety of distance and steepness, and often a slight breeze to bring some relief from the heat and insects.

Steep terrain is essential in the life history of the desert bighorn, but they by no means spend all of their time on the rocky slopes. Seasonally sheep may venture to the alluvial fans, valley floors, or canyon bottoms for choice food species, made green by channeled waters of winter rains, or a

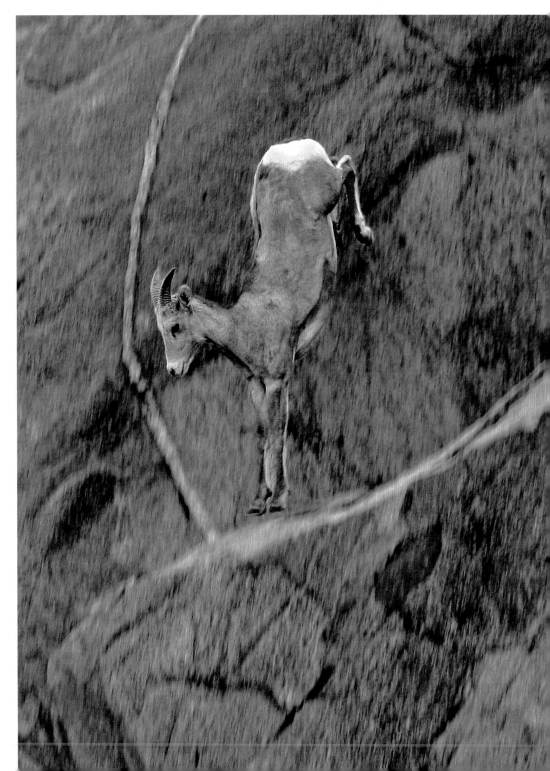

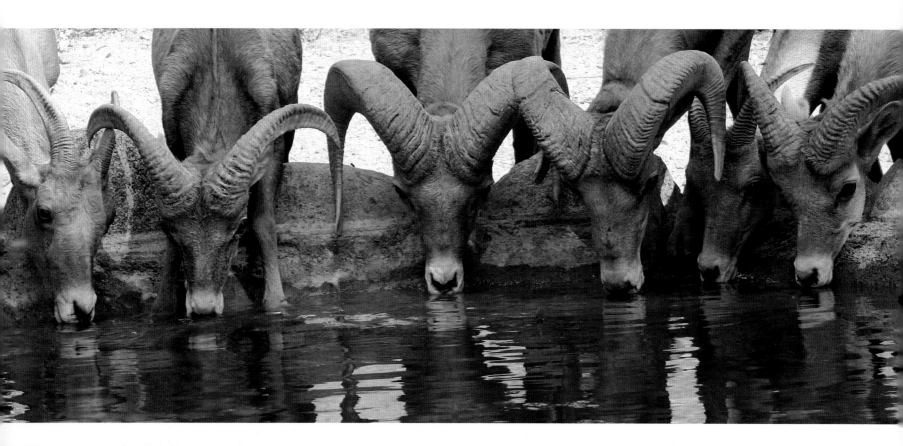

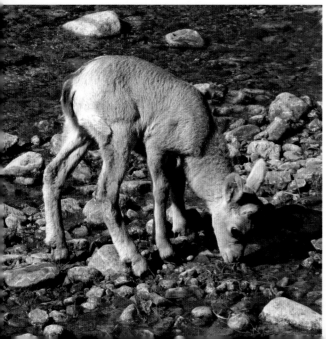

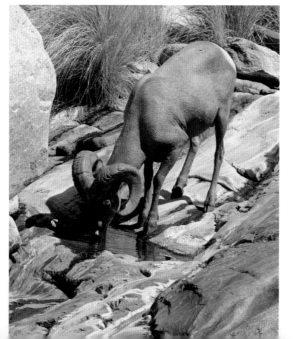

Above: Two mature rams are flanked by two yearling rams, a mature ewe and a young ewe at water. Often one or more bighorn watch for danger while the others put their heads down to drink.

Far Left: A young lamb makes one of its first visits to water, one of the most vulnerable activities for a bighorn.

Left: A large ram finds a shallow pool of water on bedrock from which to drink. This pool will be gone by the time summer arrives.

summer monsoonal flood. During droughts, the lower slopes, fans, and valley edges are vital to survival, as there are times when the upper slopes and escape terrain provide little nourishment, especially for the nutrient-starved ewes preparing for birth and then supporting a nursing lamb.

Bighorn are supremely adapted to life on the rugged slopes of the American West. Heavy, shock-absorbing hooves, keen eyesight and hearing, and the ability to flee long distances along mountain slopes give sheep the advantage over most predators and human hunters.

Living in a harsh land where predators may lurk in wait calls for vigilance, especially while feeding and going into canyon bottoms for water in summer. There's likely no higher danger in the daily life of a desert bighorn than venturing down the mountain slopes to a water source. Water may be in many forms: from a small stream such as in the Canyonlands of Utah, to a powerful and noisy river as in the

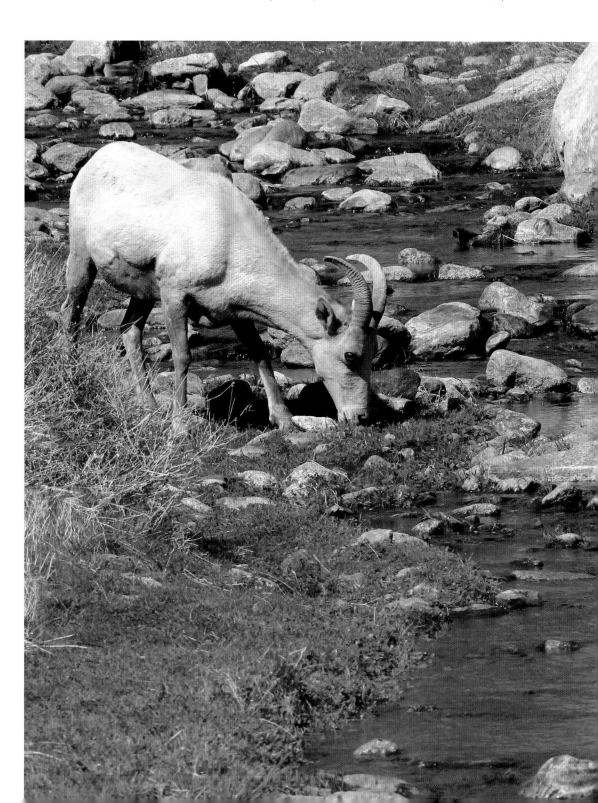

A pregnant ewe finds the nutritious forage she needs along a desert stream.

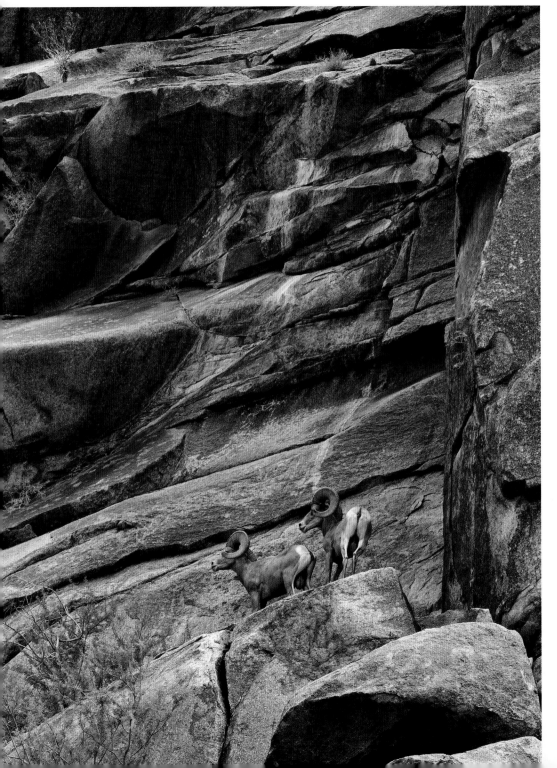

Grand Canyon of Arizona, a slow river along a noisy freeway such as in the Virgin River Gorge of Nevada, a deep tinaja in the Pinacates of Sonora, a dripping seep in a palm oasis in the Kofa Mountains of Arizona, or a wildlife drinker (guzzler) which captures rain water, in a remote range in the Mojave Desert of California.

Desert bighorn may stand and watch for three or four hours from a boulder perched high on a rocky slope above a water source, checking for pumas, coyotes, or human activity. When assured the path is safe they may venture further down slope, with a nervous, somewhat stiff-legged gait, holding themselves back, sometimes dislodging loose rocks below them, to the next stone perch. Stop, watch, gaze, move closer. Usually in a small group, led by an elder ewe, the sheep move to the water, ever watchful, ever wary. The slightest movement or sudden noise will send the group fleeing to higher ground. Stop, watch, move toward water. A mourning dove or Gambel's quail suddenly busting out of the brush can send the wary sheep scattering once again up the slope. Finally water is reached in safety and most of the group bend down to take up the life-giving liquid, as warm and mineralized as it may be.

Two large rams take refuge in high cliffs, sheer walls behind them, open view below.

Often, an adult ewe stands watch over the terrain while the group waters, and as others finish and stand watch the elder ewe takes her turn at the water. Escape terrain is never far away. The bighorn are ready to bolt for the safe slopes at the first alert. The desert air stands quiet and calm, the doves fly back, the quail walk single-file back to the waterhole, and the bighorn take the opportunity to feed on the greenery provided by the water source. The diversity of plants clustered near water provides nourishment not found on the slopes of escape terrain. The strategy of a ruminant is to eat rapidly while food is available, and wait until the safety of the steep slopes for chewing, digesting, and working the cud for the rest of the day.

Forage—Making a Living off a Desert Land

Desert bighorn sheep belong to the suborder Ruminantia. Ruminants are a group of large herbivores which have evolved with a key adaptation to forage in open country. Ruminants evolved a series of digestive chambers, including the *rumen*, the true stomach (*abomasum*), the *caecum*, and the small and large intestines. Bighorn sheep sometimes feed constantly and rapidly, consuming large amounts of dry and green forage. Feeding is a dangerous time for large prey animals

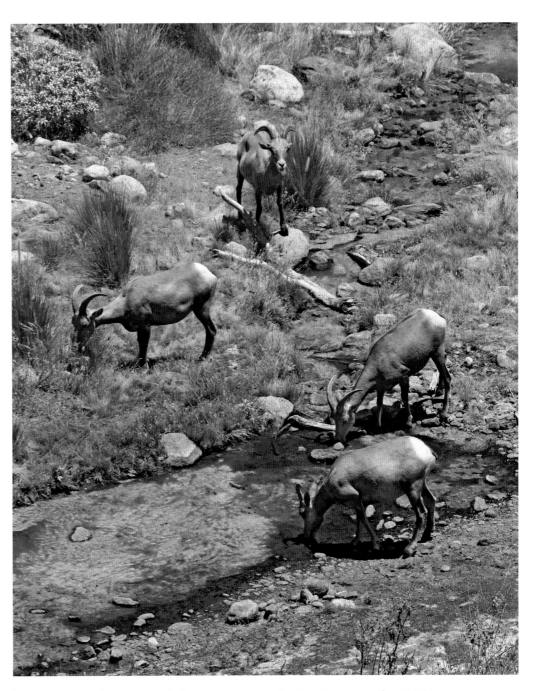

Four ewes, at least two of them pregnant, find a diversity of nutritious feed along a stream.

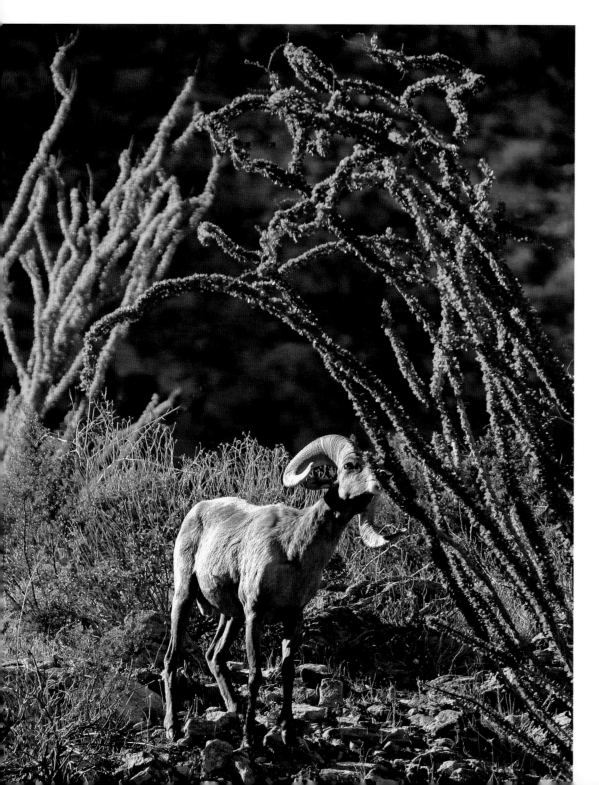

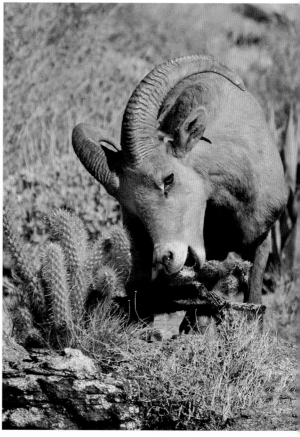

Left: **A ram takes advantage of a canopy of ocotillo in full leave.**

Above: **A yearling ram gingerly works over a cholla cactus to avoid the spines while getting into the fleshy pulp.**

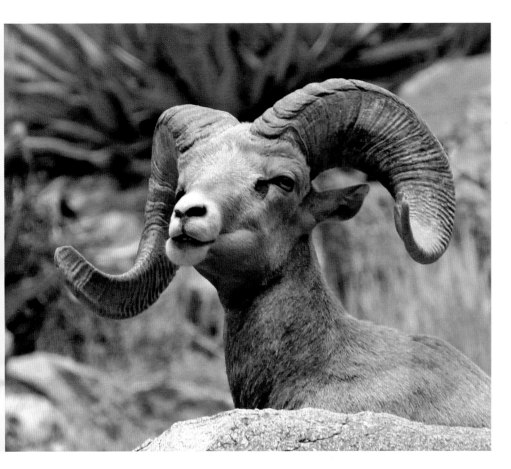

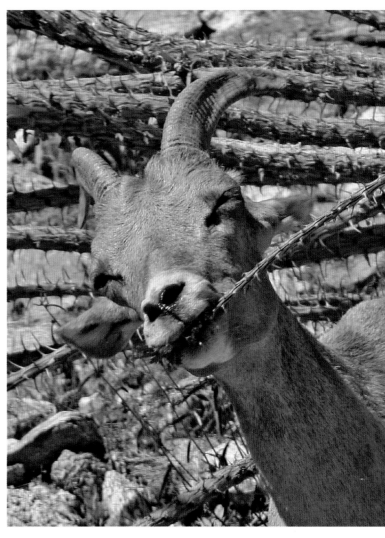

such as desert bighorn, so rumination allows the sheep to feed rapidly, then retire to an open slope to continue the digestive process of bringing the cud back up from the rumen, chewing its cud thoroughly, then swallowing the bolus once again for further digestion.

The rumen acts as a fermentation vat where bacteria and protozoa break down plant cellulose from the dry, rough forage found in their diet. The sheep can benefit only from the byproducts of fermentation after microorganisms break down the hard cell walls of their food. If the plant material is not refined by chewing, it retains its cell walls and floats in the rumen, available to be brought up again for more cud chewing. Thoroughly chewed and processed forage sinks in the rumen where it is mixed with saliva, water, and salts. Some plant proteins

Above Left: **Bighorn often feed rapidly, then retire to a safe perch to chew cud and process their mixed diet of shrubs, cactus, grasses, and annual forbes.**

Above: **A ewe consumes the last bite off an ocotillo branch.**

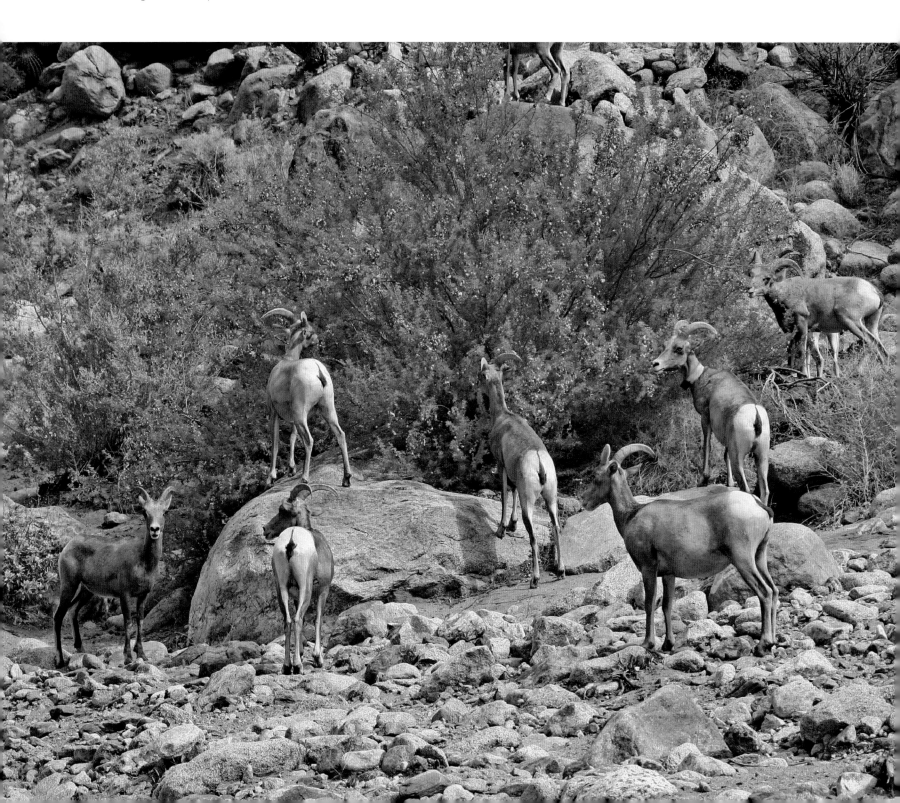

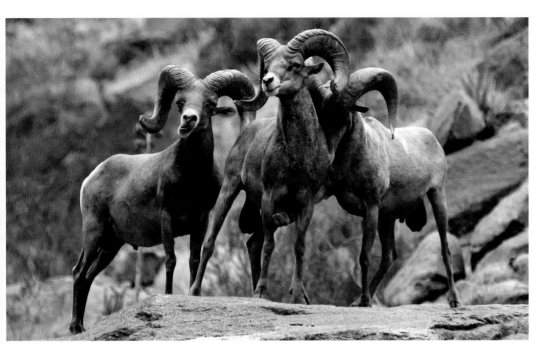

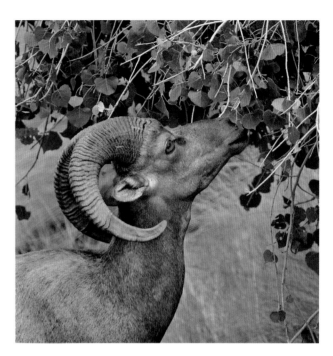

Opposite: **A group of ewes and a yearling ram (on right) feeds heavily on catclaw acacia. This plant holds ripe seeds and nutritious leaves into late spring and early summer, after most plants have diminished in nutrient quality.**

Above: **The ram on the left chews his cud while the ram on the right torments the ram in the center with a kick to the belly.**

Above Right: **A ram eats fresh cottonwood leaves in early spring.**

and fatty acids are absorbed by the walls of the rumen into the blood stream while the undigested plant materials and microorganisms travel to the next stage of digestion in the abomasum. In the true stomach, much of the food material can be digested by the bighorn's own enzymes and usable fats, proteins, and vitamins are extracted from the digesting mass. More absorption takes place in the small intestine before the remaining unprocessed forage passes into the caecum and is once again fermented by microorganisms for further breakdown into usable nutrients. The final stage of digestion and nutrient extraction occurs in the large intestine where the digested organic material is wrung out of almost all of its moisture and a nearly desiccated chain of pellets is passed out of the animal. An excellent account of the ruminant digestive process is offered in more detail in Valerius Geist's *Mountain Sheep*.

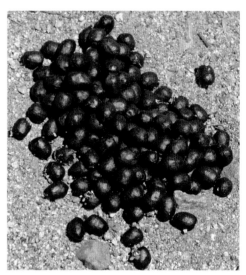

Pellets are the end of the ruminant digestive process. Nutrients and water have been absorbed, leaving a dry fecal pellet with little wasted moisture.

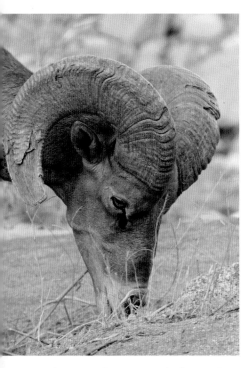

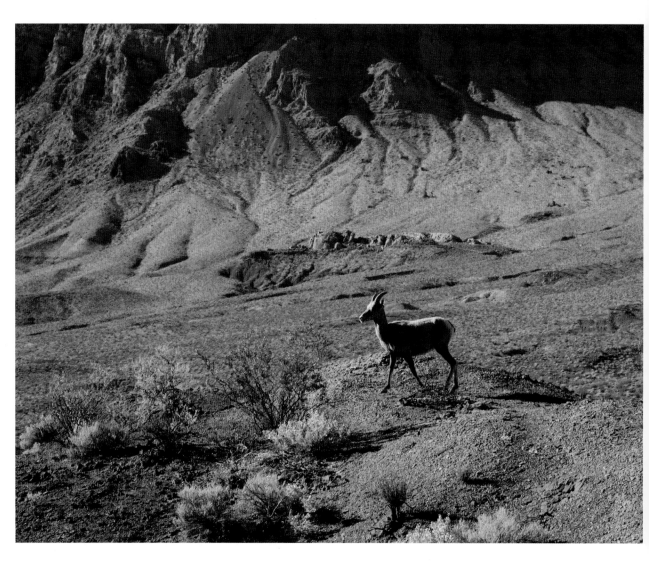

Above: **A large ram is browsing on dried annuals. Note "brooming" of his right horn.**

Right: **A ewe ambles high above a valley of volcanic flows and ancient sand dunes in the Mojave Desert.**

Lower incisors provide a perfect set of sharp blades to pluck grass, forbs, and browse. Sheep have no upper incisors, so the lower set of teeth rise to meet a hardened palette, pinching plant materials off near ground-level during foraging.

Feeding habits of desert bighorn are as diverse as the many desert habitats within their range in the American Southwest and northern Mexico. Bighorn, like the desert vegetation they depend upon, are opportunistic, subject to the vagaries of rainfall, drought, and competition. Desert bighorn range from below sea level in Death Valley to over 13,000 feet in the White

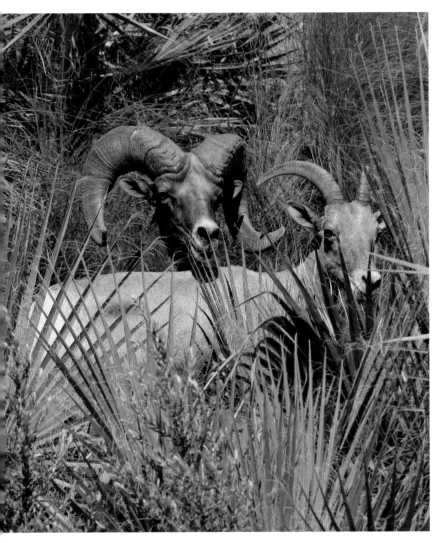

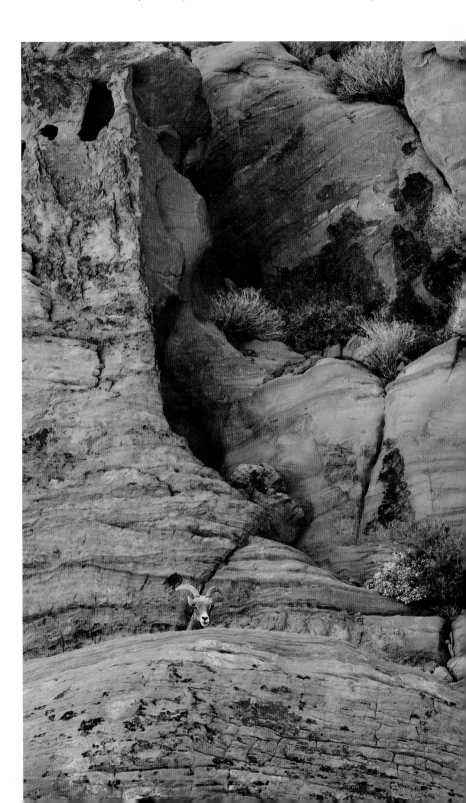

Above: A ram and ewe pair off in a native palm grove in the Colorado Desert of southern California.

Right: A ewe peers over a ridge from the safety of steep terrain in the Valley of Fire, Nevada.

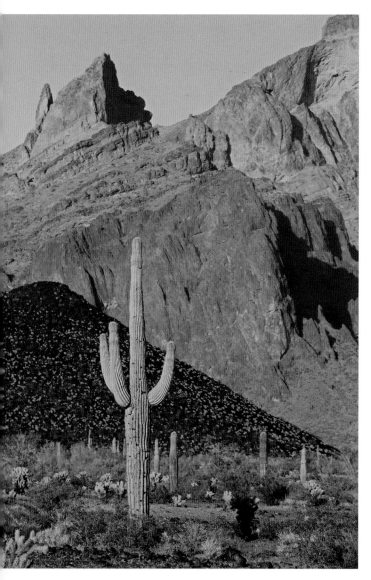

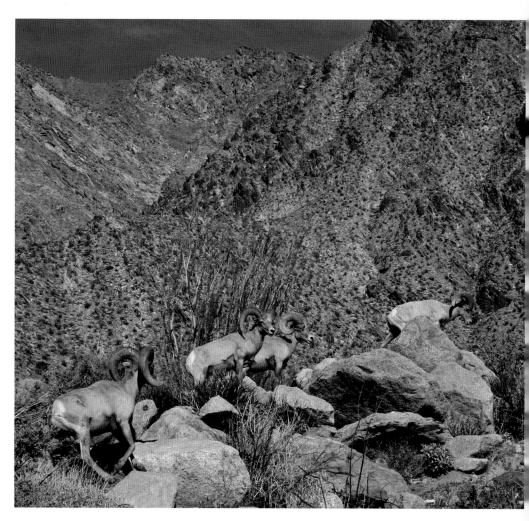

Above: **The saguaro and rimrock of Arizona's Sonoran Desert are one of the habitats that are home to over 5,000 desert bighorn in Arizona.**

Above Right: **Four rams heading upslope into escape terrain in the Sonoran Desert.**

Mountains of California. Wild sheep are found within the deep confines of Arizona's Grand Canyon as well as on the shoreline of the Gulf of California at the base of the Sierra de la Giganta in Baja California. The desert habitat provides diverse forage, from salt grass on saline playas to high peaks holding a host of forage species among the sparse forests of bristlecone pines, junipers, and ponderosas. Mojave slopes hold mountain mahogany, black brush, Joshua trees, catclaw acacia, as well as needlegrass and galleta grass. The Great Basin habitats provide sheep with

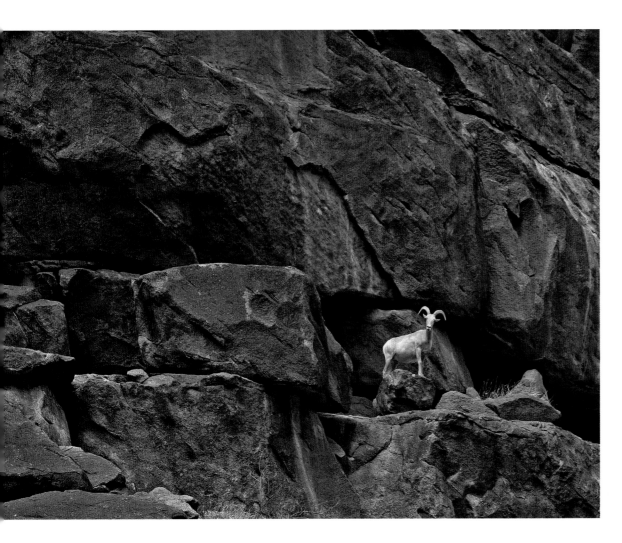

PHOTO BY MARK C. JORGENSEN

Above Left: **A ewe stands out against the desert varnished granite cliffs, protected from danger to the rear.**

Above Top Right: **Pictured is a Joshua tree of the Mojave Desert.**

Above: **A tall soaptree yucca (*Yucca elata*) rises above a prickly pear cactus in rimrock country of New Mexico. The soaptree yucca is symbolic of the Chihuahuan Desert and is found along with sotol, silktassel and grama grass from eastern Arizona to Big Bend, Texas, and into northern Mexico.**

the pinyon-juniper habitat with its plant communities of sage, Mormon tea, and winter fat, while the Sonoran Desert offers stony slopes of barrel cactus, fishhook cactus, alluvial fans of brittlebush, jojoba, saguaro cactus, and ocotillos, as well as fan palm oases. The Chihuahuan Desert holds a diverse assemblage for bighorn including grama grasses, sotol, silktassel, and mountain mahogany.

Studies of food habits show bighorn diet reflects the diversity of the habitats and seasonal availability of food species. An early green-up in late winter may send bighorn searching out the fresh shoots of grasses or other annuals on south-facing slopes and

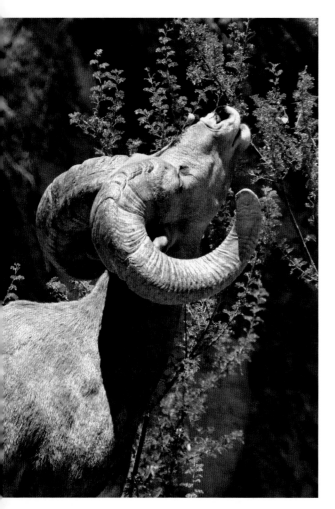

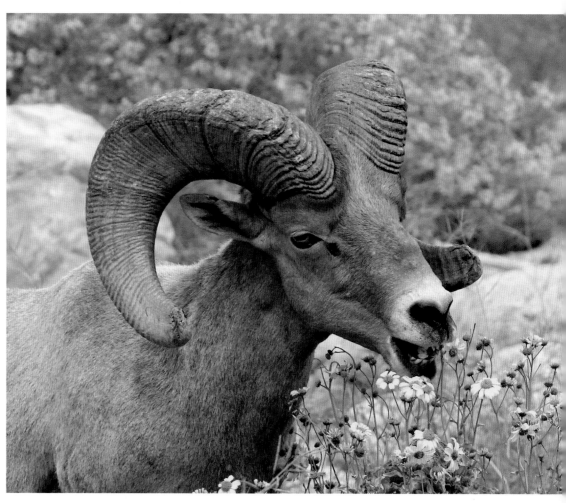

Above: **A ram stretches to reach catclaw in late spring.**

Above Right: **A ram browses on the fresh flowers of brittlebush. A member of the Sunflower family, brittlebush holds bundles of nutritious seeds in its flower heads.**

onto alluvial fans. Annual spring wildflowers in the dry deserts attract bighorn to the lower slopes and out onto the flatlands to take advantage of the nutrient-rich greenery, just prior to lambing season. Desert agave (*Agave deserti*) puts up a tall, once-in-a-lifetime nutritious fruit stalk, averaging 12 feet in height in late spring. Desert sheep often feed heavily on agave stalks, which considering they can grow more than one foot per day while emerging, must hold tremendous stores of energy and nutrients. Barrel cacti provide not only seed-rich fruits in spring, but are also a source of minerals and moisture when their tops are bashed off by the butting of rams in search of food. Late blooming plants such as catclaw

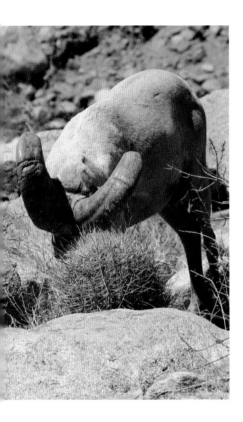
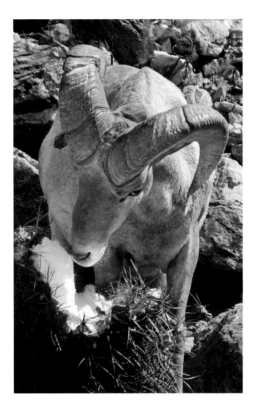
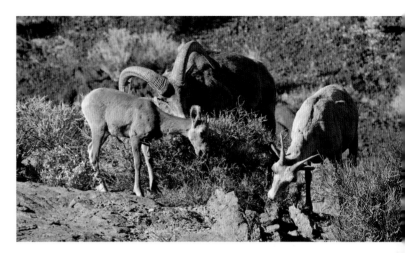
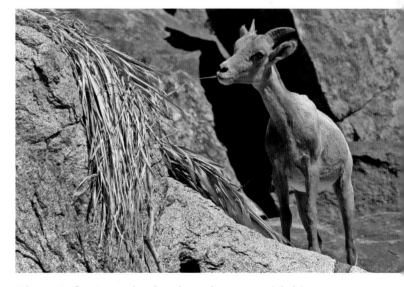

(*Acacia greggii*) in the Sonoran and Mojave deserts provide lush green foliage and nitrogen- and protein-rich seed pods after much of the spring green-up has faded, often providing an abundant part of the desert bighorn's diet into June and July.

The bighorn diet is varied as far as broad food types are concerned. Many studies show as much as 50% of bighorn diets in some desert ranges consist of grasses, and often note 30–50% of diets consist of browse species such as cacti, shrubs, and trees. Making up a portion of bighorn food selection are what researchers term "forbs"—annual herbaceous plants—often low profile ground cover species, available after abundant winter and spring rains. Bighorn are known to be attracted to the fresh leaves and seed pods of members of the pea family such as palo verde (*Cercidium* sp. and *Parkinsonia* sp.), mesquite (*Prosopis* sp.), catclaw, and ironwood (*Olneya tesota*).

Above Left: A ram bashes barrel cactus with his horns to gain access to the inner pulp.

Above Center: Once into the lush pulp of a thorny barrel cactus, a ram feeds heavily on the inner flesh for the moisture and minerals it contains.

Above Right: Young ram, a ewe and her lamb browsing on diverse forage in the Mojave Desert.

Above: A lamb experiments with new food items by eating a dead palm frond.

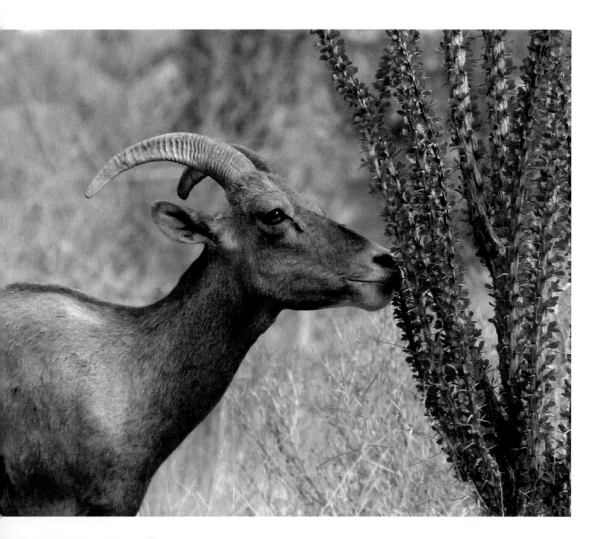

Some populations of bighorn in California's Colorado Desert, a sub-unit of the Sonoran Desert have been documented selecting for fishhook cactus (*Mammalaria dioica*) and in early spring they often nibble through long spines for the fresh green leaves of the ocotillo (*Fouquieria slendens*).

Water—Tinajas, Seeps, Springs, and Guzzlers

Water is an essential element of desert bighorn sheep habitat. They have to have it in one form or another to survive. Water is found occurring in desert sheep ranges in the form of desert rivers, such as the Colorado, Green, Dolores, Virgin, and Rio Grande. Springs throughout the desert carry names such as Diablo, Four Frogs, Rattlesnake, Sheep, Palm, Salt. The deep stone tanks known as tinajas have been given names such as Pinacate Tank, Tule Tank, Trap Tank, Sheep Tank, Tinajas Altas, and Stone Wash Tinaja.

In many areas of their range, desert bighorn live without open drinking water for about seven months of the year—the cooler months of fall through spring. Moisture is derived from native vegetation, and fresh growth seems an attraction to sheep

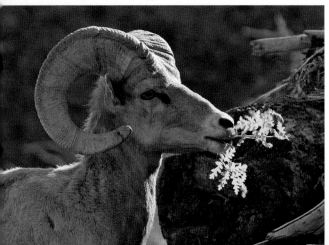

Above: A ewe picking out green leaves from between the sharp spines of an ocotillo. Scattered rains may give rise to a green-up of ocotillos within just a few days.

Left: A ram eats lush growth from the shade of a boulder.

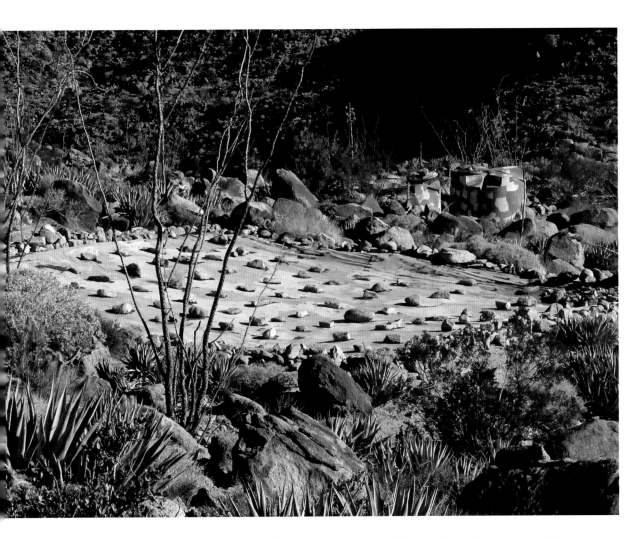

In areas where natural water sources have been usurped by human activity, rain collection devices known as guzzlers are constructed. The guzzler's plastic apron collects rain water and diverts it to camouflaged storage tanks, where it is then made available to wildlife in a drinker box. A float provides water on demand as animals drink.

when they're spending time away from water sources. A sporadic rainstorm may leave a green swath of growth in its wake, which readily becomes a magnet for foraging bighorn. When the temperatures begin to rise toward 100°F the need for free water becomes a priority, and most sheep move back to reliable sources.

In areas of the Colorado Desert of southern California several subpopulations of ewes are well documented leaving permanent water during the fall to head to lambing grounds seven to ten miles from known sources of water. One theory is the pregnant ewes move far out onto isolated high peaks where the density of predators may be lower, though radio telemetry tracking has shown some mountain lions do find the lambing grounds, at times

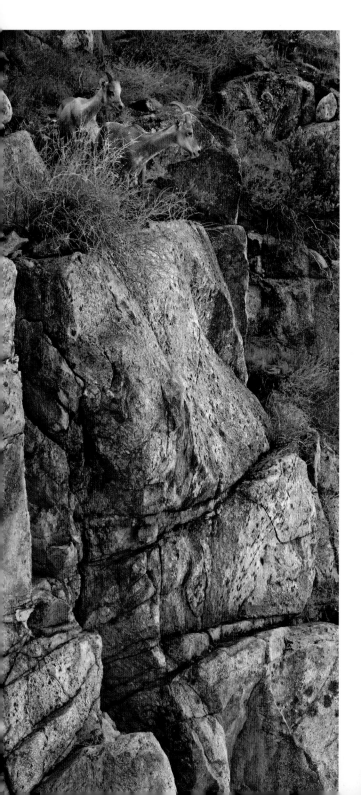

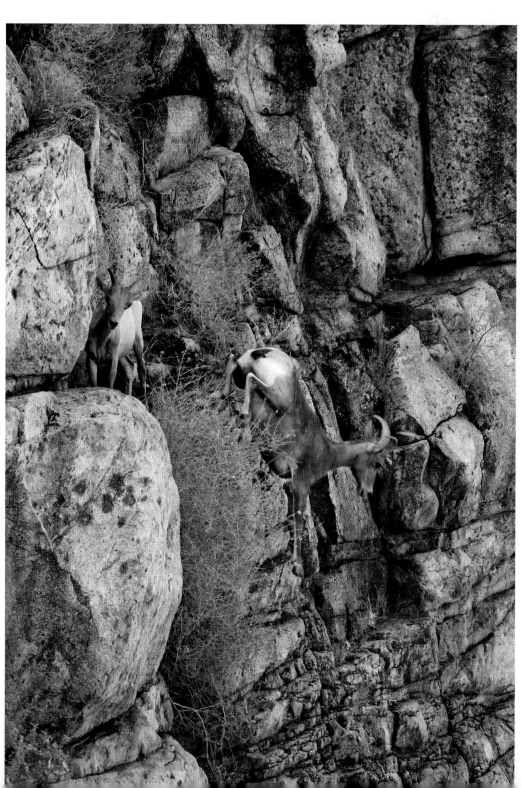

killing a pregnant ewe, or even the ewe and her newborn lamb. Ewes give birth in these "nursery areas" and rear their lambs until the heat of summer dominates the desert land. As summer takes over, the band of ewes, lambs, and yearlings make the move back to springs, guzzlers, and streams in the well-watered canyons.

Desert bighorn use several strategies to conserve water and energy in dry country. They have been observed in remote ranges with little to no known water spending a greater part of hot days beneath boulder overhangs or inside caves. More feeding and activity may also occur after sunset to avoid exposure to the heat of the day. Heavier feeding on plants containing high levels of moisture can also provide water to the sheep, at least in early summer. Plants such as barrel cactus, saguaro, pitaya, yucca flowers, buds of Joshua tree, and the flowering stalks of agave are all known to be used by desert sheep.

Opposite: A ewe and her lamb look for a way down the cliff. They reach the mid-point and the ewe takes the plunge, leading her lamb to water.

Right: A ram balances all four feet on a single pointed rock, showing the dexterity developed for life in the desert mountains.

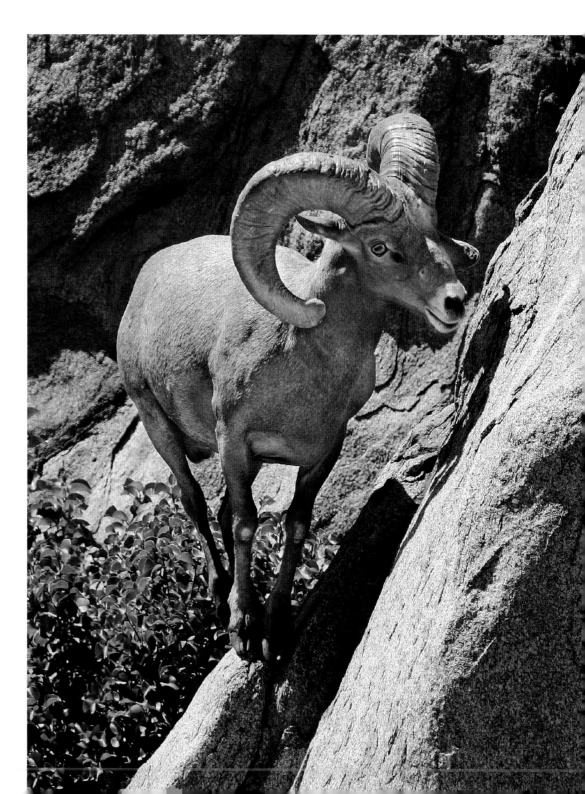

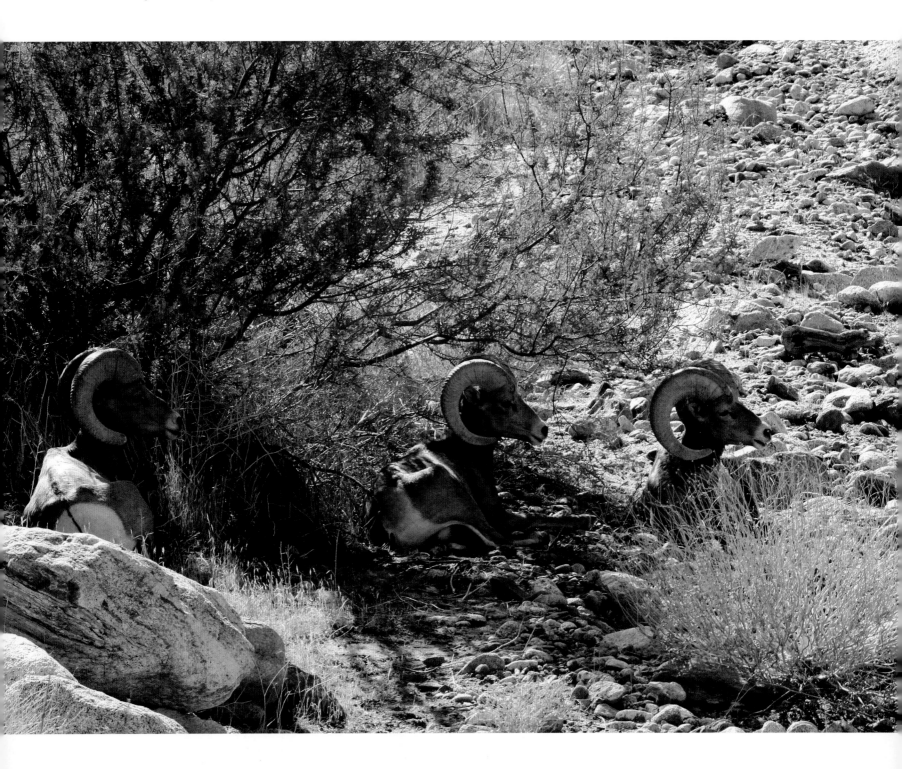

Desert bighorn have the ability to exhibit few if any negative effects with elevated body temperature, which often rises to levels of 104°–108°F during hot days. Humans do not have the ability to function well with elevated body temperatures, so in hot weather, humans use copious amounts of water to keep the body core below 100°F. If the ambient temperature is above body temperature, heat will be absorbed into the body, causing the body to react by sweating to cool the skin and keep the body core at near normal temperature. Desert bighorn have the ability to function quite well at temperatures over 100°F. On a hot day, standing in the shade, they will be giving off heat to the environment, rather than absorbing it. This provides a level of heat and water balance to the bighorn in moderately hot weather.

Lactating ewes with lambs will go to water sources if readily available and may visit as often as once a day during the lambs' first summer. Rams seem to visit water sources less frequently and may go three or four days in summer seemingly unaffected by dehydration. It has been noted that rams not going frequently to water will spend more time in the shade of boulders, beneath junipers, or in caves during the heat of the day. As the mating season begins and the rams enter the rut, water sources are the place to be to encounter ewes. Rams may concentrate their effort around the water source, spending much of the day within sight of the spring or creek. As ewe bands approach, the rams rise out of the shadows to make their presence known and to search for receptive ewes. Water may be a focal point for watering, feeding, mating, behavioral interactions, and the head to head battles for dominance between rams.

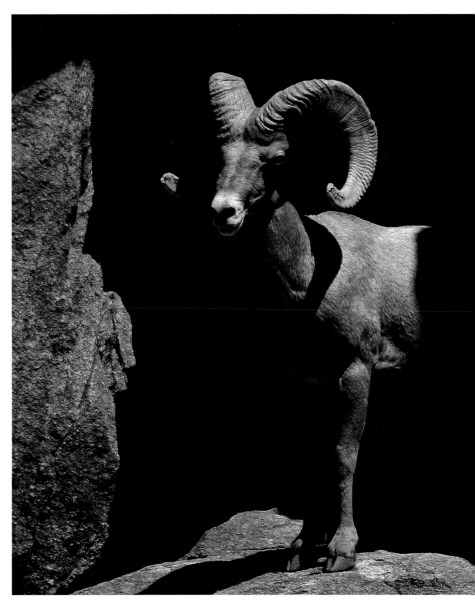

Opposite: **Three rams take advantage of shade on a hot sunny day. Temperature regulation is a key element to survival.**

Above: **A large ram emerges from a shadowy cave. During summer, in areas of scant water supplies, bighorn will spend more time in shady cliffs and caves to conserve moisture and regulate their body temperature.**

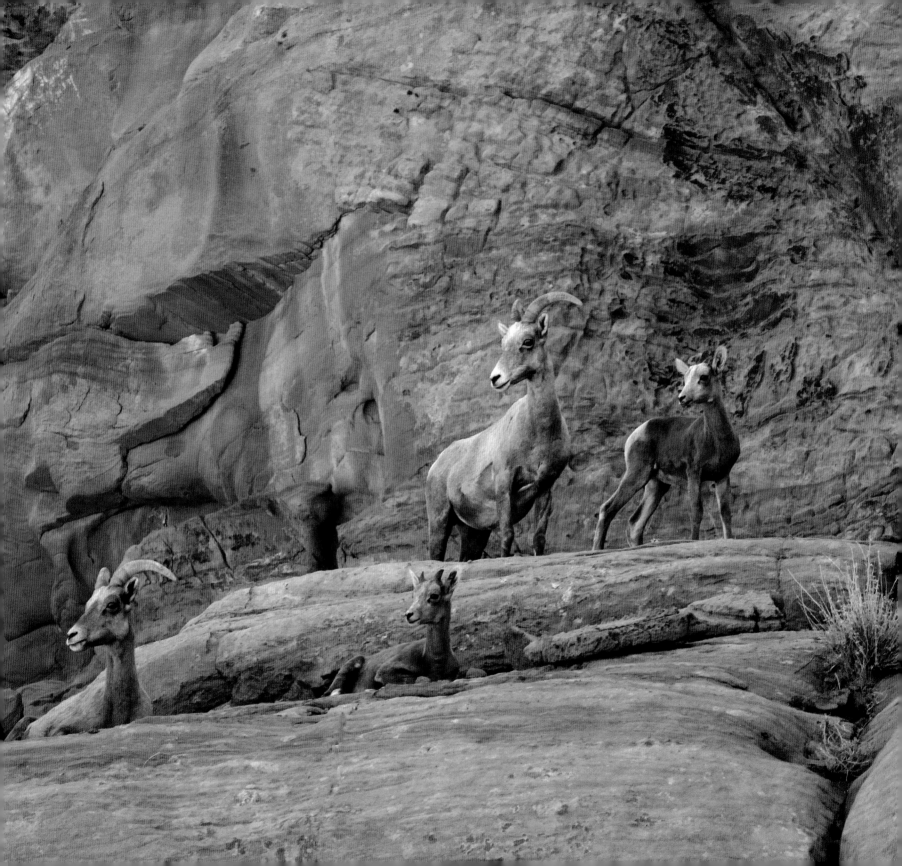

CHAPTER 3

Adaptations to a Desert Environment

Surviving Severe Water Stress

Water is the single most limiting factor within desert bighorn range. The availability of reliable water in hot summer months is paramount to bighorn survival. Moisture to sustain life can be found from three sources by desert bighorn sheep: permanent surface water, such as rivers, lakes, streams, springs, man-made water catchments, and seeps; seasonal water sources, such as water-pockets or pools after rainfall, large natural rock basins known as tinajas; and preformed water found within desert vegetation. The deserts of North America experience long hot summers with temperatures over 100°F beginning in May and often lasting into October. Summer rains vary with geography and monsoonal influence. Some deserts, such as Death Valley in the Mojave Desert, experience almost zero summer precipitation, while areas of the Sonoran Desert may receive up to half their annual total between July and September. Extended months without precipitation call for extreme survival strategies for large desert mammals.

Some researchers have postulated that desert sheep populations maintain their numbers without the existence of available surface water in their range. Other researchers have their doubts. Indeed, bighorn are found in isolated mountain ranges with no known water sources. Sheep may use these isolated ranges seasonally when their demand for free water abates during cool months; they may find small pockets of water after sporadic rain events; and they may alter their behavior to minimize water loss and heat gain. It is a wonder that desert bighorn can be found in some of these seemingly waterless ranges near Death Valley, the Pinacates of northern Sonora, and the dry ranges of southeastern California.

Opposite: **Two mature ewes with their lambs find safety in high sandstone cliffs.**

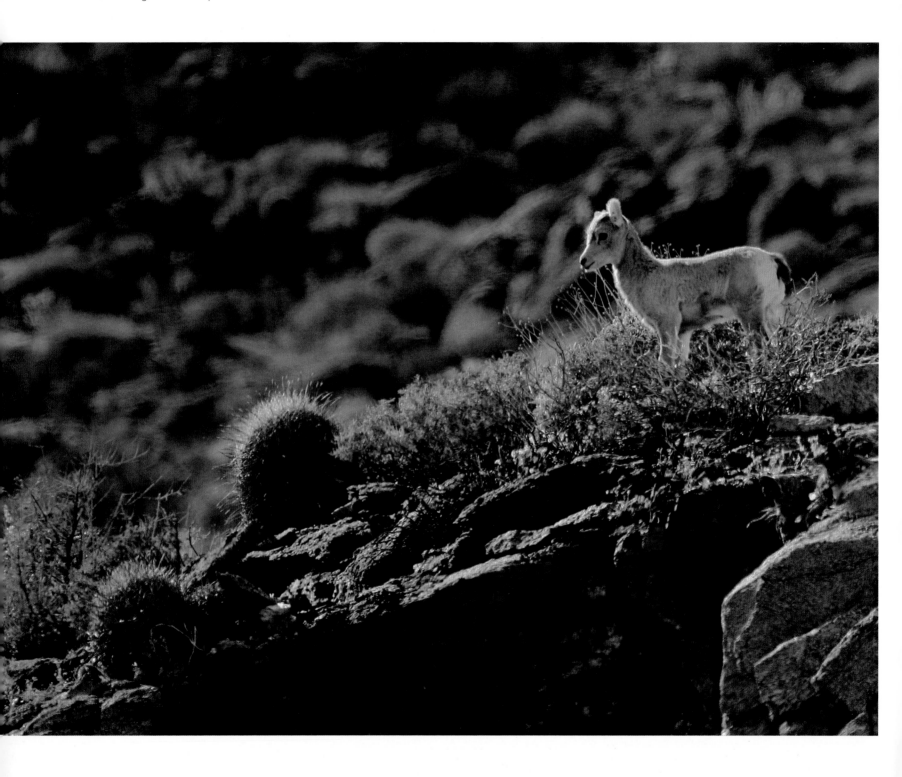

It is well documented in several subpopulations of desert bighorn in the Peninsular Ranges of southern California that bighorn inhabit dry mountain ranges for up to seven months, up to 10 miles from known sources of permanent water. Most of these bighorn are tied to springs and streams for the five months of summer heat, but as summer begins to let up in early October and the nights cool to 60°F, some bands of ewes leave their summer watering areas. They venture along ridgelines far out onto island-like mountain peaks where they will spend winter and give birth to lambs from January to April. Here they live on the preformed water available in native vegetation, and take advantage of puddles and water-pockets from unreliable winter rains. Temperatures will not reach 90°F again until March or April and the delicate balance of water intake and moisture loss in the bighorn is maintained, as it has for countless winters. The first few days over 100°F call for the long march back to permanent water, this time with lambs in tow, the elder ewes knowing the way, having followed their mothers on the same path.

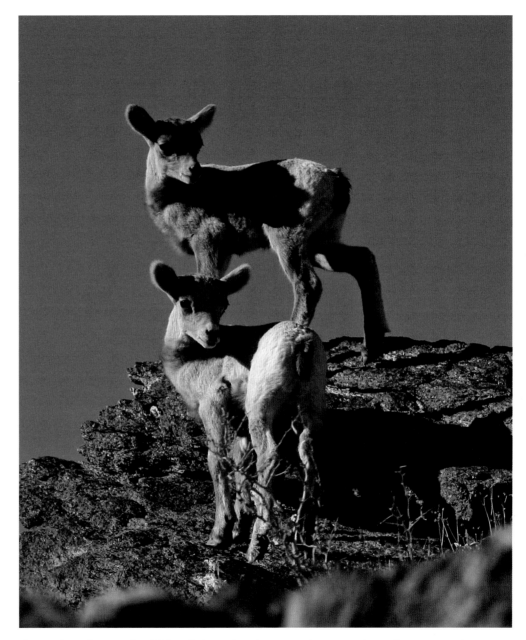

Opposite: **A month-old lamb learning her new home: what plants to eat, the danger of cacti and cliffs, and how to be vigilant for predators.**

Above: **A pair of lambs pal around together high on the boulder-strewn slopes of their home range.**

Below: A large ram watches over a steep canyon from his lofty perch.

Right: Mature ewes often find a prominent perched boulder or cliff from which to view the canyons below. Once confident the way to water or forage is clear, the ewe begins her descent.

Opposite: After waiting atop a vertical cliff face, the mature ewe has determined the way to water is clear of danger. She makes her head-long plunge down the ravine.

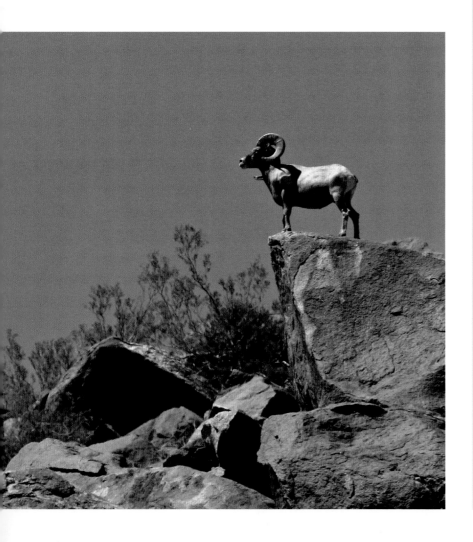

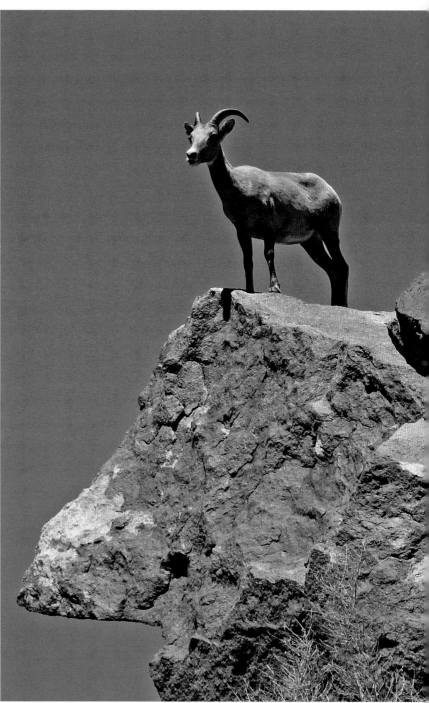

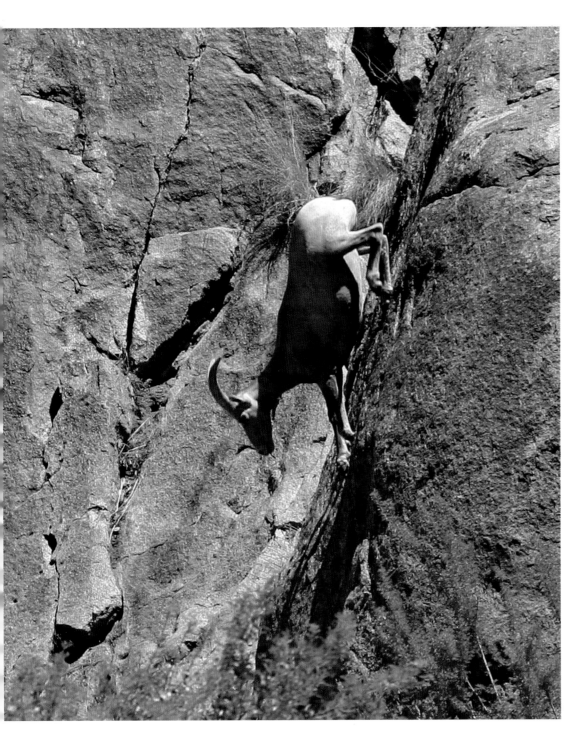

For most desert bighorn, the seasonal movement between summer and winter ranges happens without the knowledge of humans, save for researchers equipped with radio telemetry and GPS receivers monitoring the bighorn.

Desert bighorn sheep are well adapted for extreme temperatures, low rainfall, scant water sources, and seemingly dry forage. Studies have revealed that rams and ewes can withstand dehydration rates of over 20% of their body weight, coupled with the ability to take on large quantities of water rather rapidly upon finding water. One ram was documented taking on more than 4.7 gallons of water at the end of his bout with water deprivation—that's 40 pounds of water at one session! By comparison a human has difficulty consuming three or four quarts of water during rehydration and will usually lose consciousness at a water loss of 5–7% of body weight.

Desert bighorn have the ability to function quite well with fluctuations in body temperature. This helps sheep maintain daily activities during high ambient temperatures and in many cases give off body heat rather than gain heat from their environment.

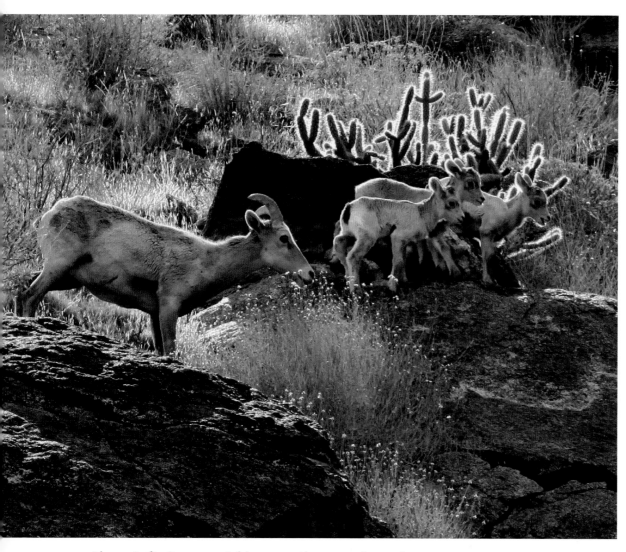
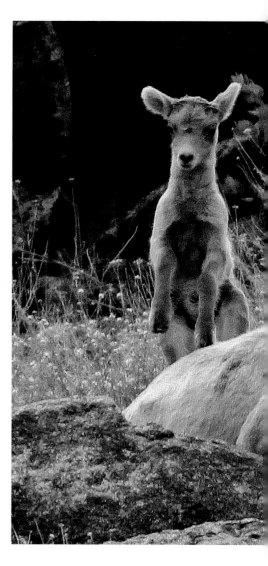

Above Left: A ewe watching over three newborns in a nursery area.

Above Center and Right: A young lamb exercises around and on its patient mother.

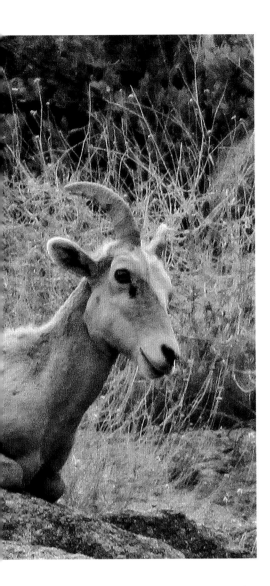

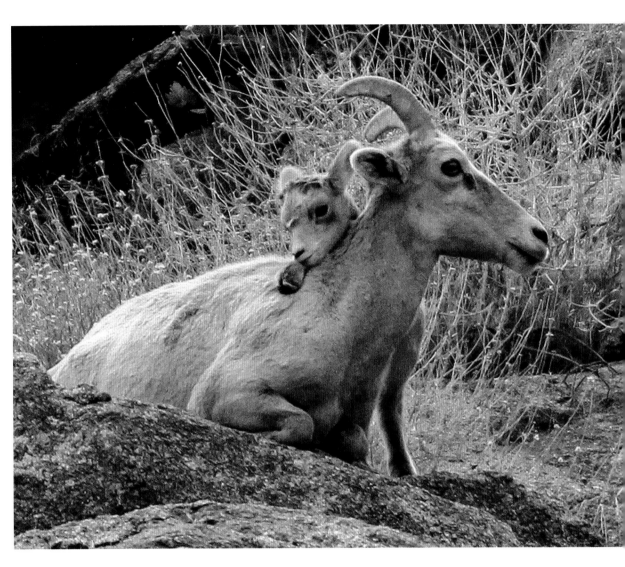

If the air temperature on a summer day were 103°F and the bighorn temperature were 105°F, body heat would be released from the sheep into the air, rather than being absorbed from the air as it would be in a human. Keeping cool through sweating creates a loss of water and energy. Bighorn can avoid high ambient temperatures by resting in the shade of boulders or shrubs and may become more active in the morning and evening hours, thereby reducing the urgent need for the dangerous journey down to the water hole. In dry ranges, many sheep may go long days or weeks without a trip to water, but in the long run, reliable surface water is needed to maintain a healthy population of desert bighorn in a mountain range.

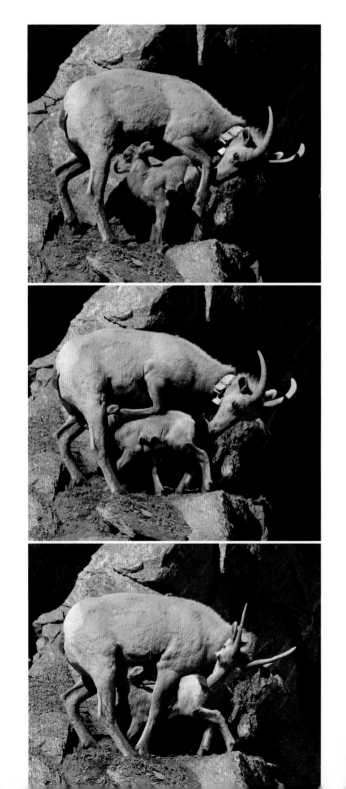

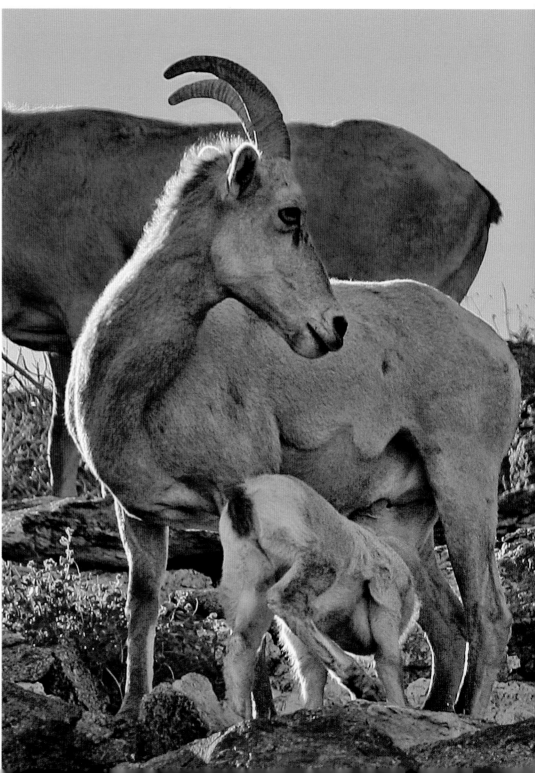

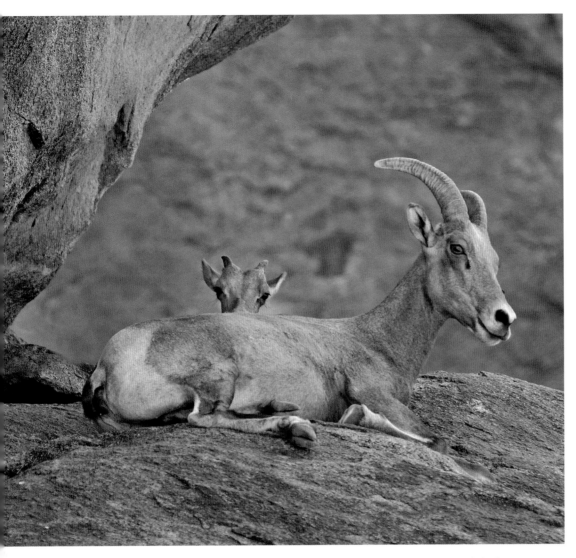

Body Shape, Hooves, Hair, Horns, Keen Eyesight and Rumination

Bighorn sheep are stoutly built mountain dwelling creatures well adapted to the steep terrain they know as home. Born on a remote rocky canyon wall or amidst a pile of broken boulders, the newborn bighorn begins its perilous journey in life overlooking spectacular vistas and deep canyons, and must quickly learn to maneuver along towering cliffs, escarpments of broken stone, and pillars of rock. The pregnant ewe isolates from her band to give birth alone and will return to the group a few days after parturition. The six to eight pound lamb will stand, wobbling a bit, and attempt to suckle. Within a day or two the little bighorn will be learning the slopes, following the ewe from its birthplace high on a desert mountain to meet other ewes with lambs.

Tiny, still-soft but hardening hooves will serve the lamb well all its life, whether it be a few days or a full life of eight to twelve years. The hooves of bighorn have a hardened outer wall with a softer pad for gaining traction on the near vertical

Opposite, Far Left: A newborn lamb searches for nourishment while its mother coaxes it to nurse.

Opposite, Left: A fuzzy lamb, only a few days old, takes its mother's milk while the ewe gazes the surroundings for danger.

Above: A two-month-old lamb gazing over its mother's back, rests in the shade of a granite boulder.

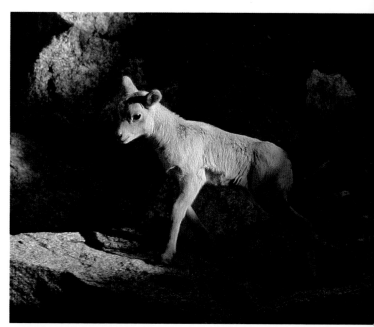

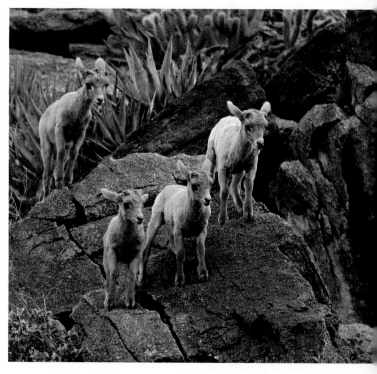

Above: A two- to three-month-old ewe lamb scales a red sandstone cliff to safety after feeding on the low country of an alluvial fan.

Above Right: Just weeks old, there's a lot to learn for this bighorn lamb if it is to survive.

Right: Of these four young lambs, it is likely only one or two will survive their first summer. Intense heat, poor forage, disease, and predators cause high mortality among young desert bighorn sheep.

Opposite: The front hooves of the ram are much larger than the rear hooves, adapted for supporting a head and horns that may weigh more than 30 pounds. Soft pads allow for maximum traction on rocks.

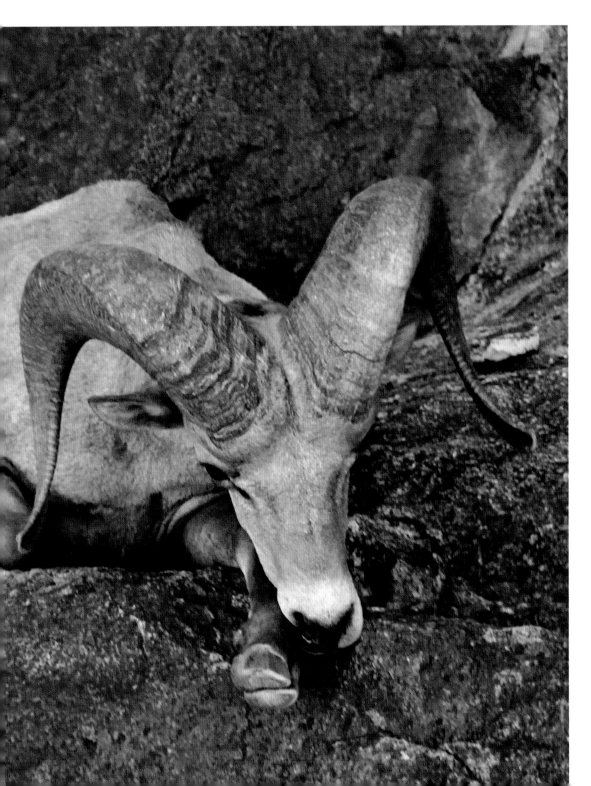

rock faces and slick rock. The hoof pad is similar to a toughened human heel that has faced a barefoot life outdoors—it's tough but supple enough to give a grip. The hardened outer wall of the hoof gives the animal the ability to dig in to the gravel slopes of its homeland, while at the same time equipping it for the mud or icy ridges of winter. The hooves of bighorn sheep are larger on the front feet than the rear, and in the case of the hefty rams, offer support to carry massive horns and the thick skull that may weigh up to 30 pounds. Ram hooves may measure four inches in length on the front and three on the rear, while ewe hooves may range from two to three inches in length.

Foot injuries are uncommon, but can result in a deformed hoof or ankle, putting the bighorn at a severe disadvantage in predator avoidance. Some desert bighorn, with leg or foot fractures due to falls or vehicle collisions, have been known to recover over a period of months. They have been observed in subsequent months and years surviving to give birth, having somehow avoided predation during the healing process.

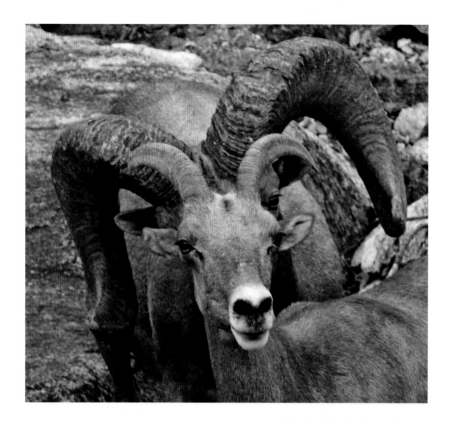

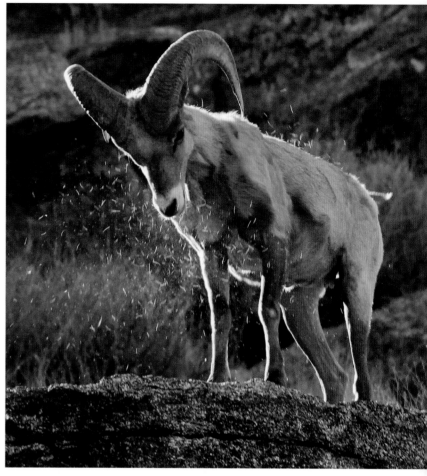

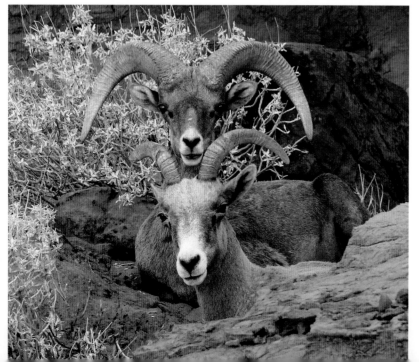

Above Left: Ewes and rams both carry curved horns which they retain throughout their lives. Ewes use their horns for protection against coyotes and bobcats, while ram's horns are well equipped for dominance battles with other males.

Above: In northern ranges the desert bighorn may shed its winter coat in large patches to give way to the new spring season. In warmer climes the hollow winter hair is shaken or rubbed off as this young ram exhibits.

Left: A yearling ram is pictured above a mature ewe. Both have divergent horns but note the larger girth on the young ram's horn bases.

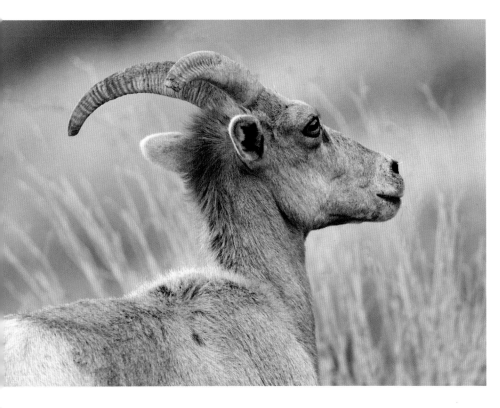

The hair of desert bighorn sheep is short, hollow, and scruffy during the hot months and longer, darker, and thicker during the cold season. A short mane forms from behind the ears down the spine to the curve of the neck. Hair on the lower legs is but a quarter inch in length and cactus spines are often found amidst the short hair, impaled into the hide. White belly hair is tufted on the lower torso, shortening to almost bare skin in the pits of the front and rear legs.

Color ranges from light tan in late summer, when the coat has been bleached out by five months of summer, to a chocolate brown winter coat. The summer coat offers a measure of reflectivity of the sun while the darker winter coat may allow for heat absorption. Bighorn in the southern latitudes do not experience a visible "shedding" of the coats as more northerly desert, Rocky Mountain, and California bighorn often do during the change of seasons. The sometimes thin, scraggly summer coat of the desert bighorn serves to protect the skin surface from the direct rays of the sun. This summer hair provides insulation needed to minimize heat absorption from direct sun, while being thin enough to allow body heat to be dispersed. Winter cold brings on the darker, thicker coat by November or December which serves the desert bighorn well through cold rains, driving winds, and the occasional flurry of snow. The distinctive white rump and white margins on the back of the legs are all that may be seen by the observer who happens to startle a bighorn in sheep habitat.

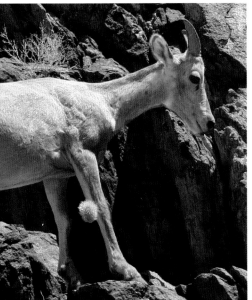

Above: During winter when bighorn carry their dense palage, a mane is prominent from the back of the horns to the lower neck.

Left: Cactus is one of the many hazards in the daily life of the desert bighorn. The loose stems of jumping cholla detach at the slightest touch, being carried for up to several days. Once rubbed off, the cactus may take root in its new location. Most desert bighorn in cactus country carry many broken spines in their lower legs.

Right: **A mature ram exhibits characteristic wide-eyes, giving him a wide field of vision. Note the row of lower incisor teeth and the hardened upper palate with no incisors, an adaptation ideal for nipping grasses close to the ground and picking leaves from spiny shrubs.**

Below: **Vision is one of the most important defenses against danger. Note the splintered horn tips on this ram, the result of "brooming."**

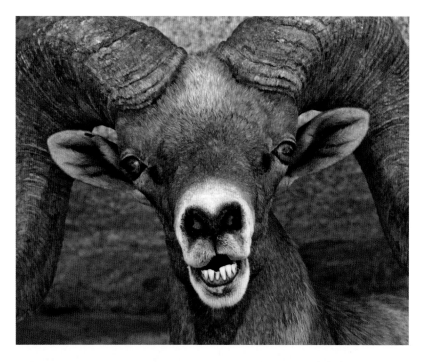

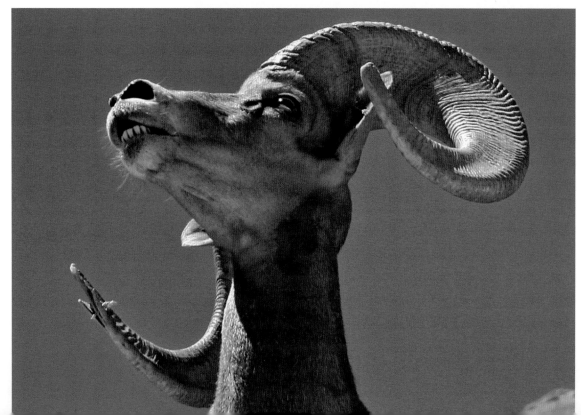

Vision is likely the most important sense used by bighorn to remain out of harm's way. No one knows the power of bighorn eyesight compared with human, but it is legendary. In fact, there are countless anecdotes from park visitors, hikers, and hunters who have spotted bighorn half a mile away, only to discover through their binoculars or scope that the sheep was staring right back at them. Thus the common belief the desert bighorn sheep have eyesight as acute as a set of powerful binoculars.

The eyes of a desert bighorn are rather large and appear to bulge somewhat, giving the sheep a wide-eyed appearance. The location gives the animal a wide peripheral view of their domain. The dark brown eyes of young bighorn turn to an amber gleam in adulthood. The horizontal pupil is wide and almost black.

The sense of sight in bighorn seems especially acute to detect movement in their environment, even amongst a mixed background of broken

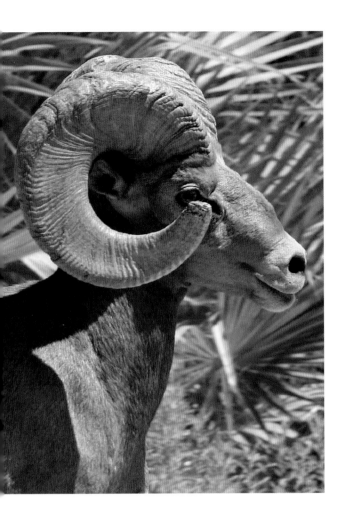

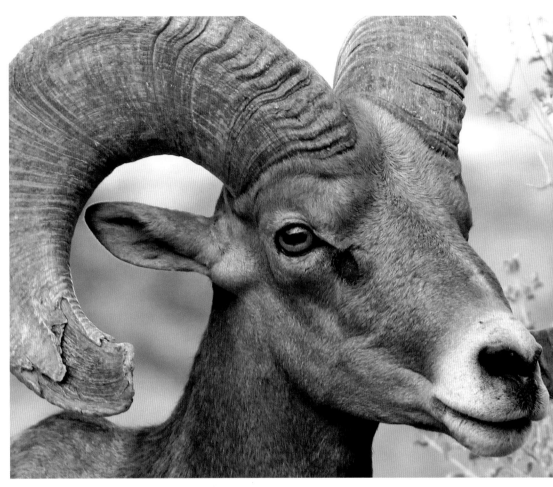

Horns grow throughout the bighorn's life. Rams have the tendency to "broom" off the tips by butting rocks and trees, one result being improved field of vision as shown above

rock and shrubbery. Desert bighorn are often observed standing, almost motionless, high on a lofty boulder or cliff, watching below for movement or any sign of a lurking predator.

When a mature ram's horns grow past a three-quarter curl the tips begin to obscure the animal's vision. This coincides with the ram's more frequent battles with other large rams. The tips of the curved horns begin to splinter and chip, resulting in broken ends, known as "brooming." The constant butting of other rams, boulders, barrel cactus, and tree trunks takes its toll on the six- or eight-year-old horns, but the broomed ends, no longer protruding above the line of the eyes, now allow for a full view once again.

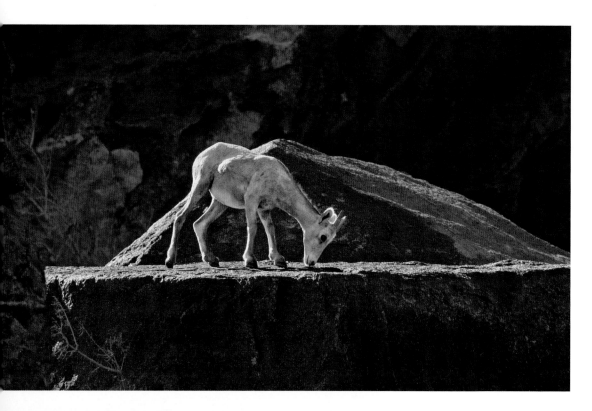

The senses of hearing and smell have been studied little in wild sheep. They no doubt play important roles in the survival of the desert bighorn, maybe not paralleling that of eyesight, but still important in certain situations. The desert can be one of the quietest places on Earth, so a keen sense of hearing could prove lifesaving in some situations when vision is obscured by boulders, shrubs, or cliffs. Hearing may help bighorn detect the approach of humans, a mountain lion, or hungry coyote.

The sense of smell plays an important role in the social interactions of bighorn sheep. Ewes identify their lambs by smell, and males use their sense of smell to detect receptive ewes. Rams identify other rams by the scent left on rocks and branches when rams rub their preorbital glands on objects. These glands create the large dark patches of folded skin in front of the ram's eyes. Field researchers have noted that bighorn detected something was amiss at up to 350 to 400 yards when the wind was moving to the bighorn from the human. In some instances early detection on the wind, whether it be smell or sound, may mean the difference between life and death for the bighorn.

Above: **A four- to five-month-old female lamb sniffs the scent of other sheep left on a flat boulder.**

Left: **Ram-ewe interactions involve scent communication, especially during the mating season.**

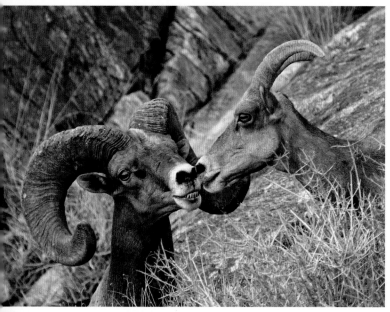

The desert bighorn sheep's agility and swiftness in foreboding terrain have been documented by naturalists, hunters, artists, and photographers for centuries. The stout build and strong musculature of the desert bighorn is well suited for the harsh country they make their home. Heavy-boned, taunt muscles, heavy hooves, and a lifetime of living on the vertical give the bighorn a distinct advantage over most predators. Coyotes seem to prefer surprise at the waterhole when hunting the bighorn—most sheep get away, but occasionally a coughing lamb or limping ewe will linger and fall easy prey to a team of coyotes. The mountain lions' advantage in hunting sheep is their stalk and ambush strategy, freezing when the bighorn raises its head from feeding, or from water, and then making a closer approach once the sheep puts its head down again.

Bighorn are at their best in evading danger on the steep slopes of their habitat. On flat or rolling ground they can reach modest speed, but they appear to lumber along, sometimes seeming to run in a rocking motion, moving along with powerful strides of their hindquarters.

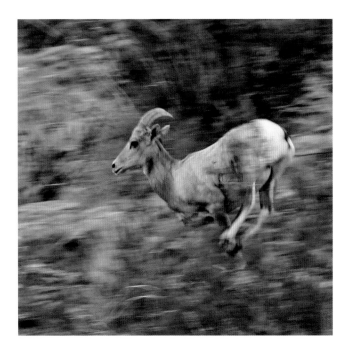

Desert bighorn are adept at running in rough country. At the first hint of danger the bighorn usually run uphill to avoid predators. Soft hoof pads with hard hoof walls provide superior grip between the sheep and its rocky habitat.

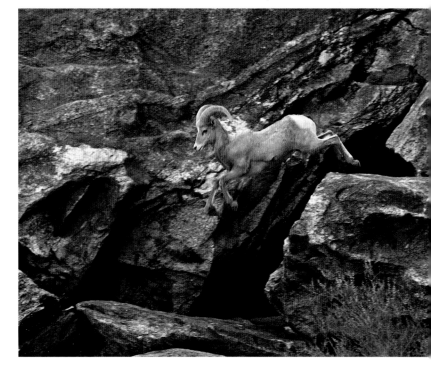

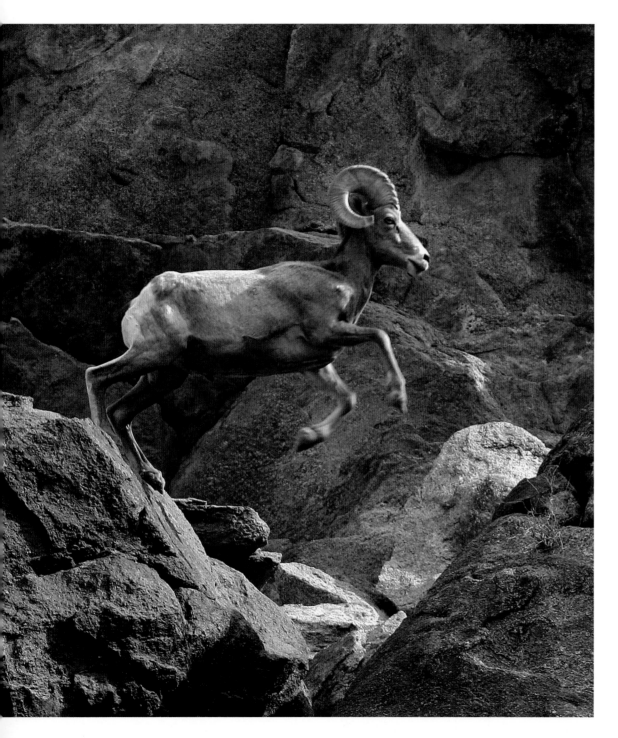

On the slopes, though, the bighorn outdistance most other animals in their habitat. They move with precision, hooves placed from one crevice to the next ledge, finding clear paths around bushes and rocks, avoiding cacti and ocotillos, then bounding through the air from one large rock to the next. Most pursuers give up when they see the distance growing between predator and prey—they head back into the dense riparian thicket to try again another day.

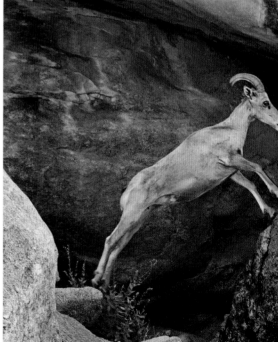

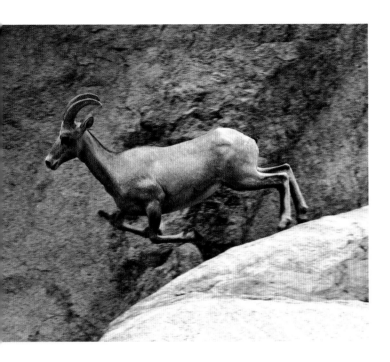

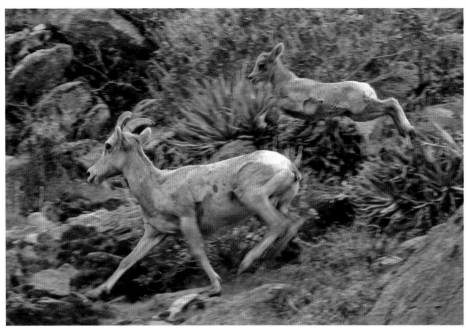

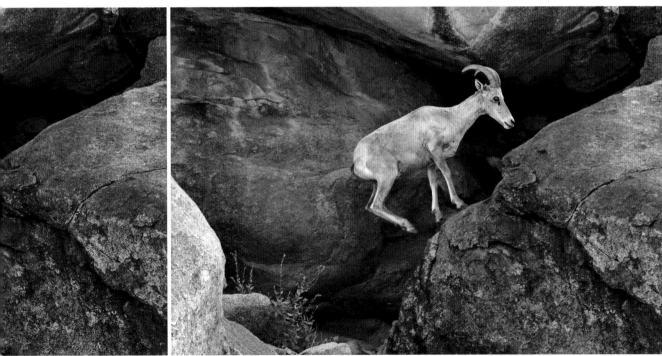

Adaptations of endurance, keen eyesight, and the ability to run and leap from boulder to cliff face give bighorn an advantage from many predator threats.

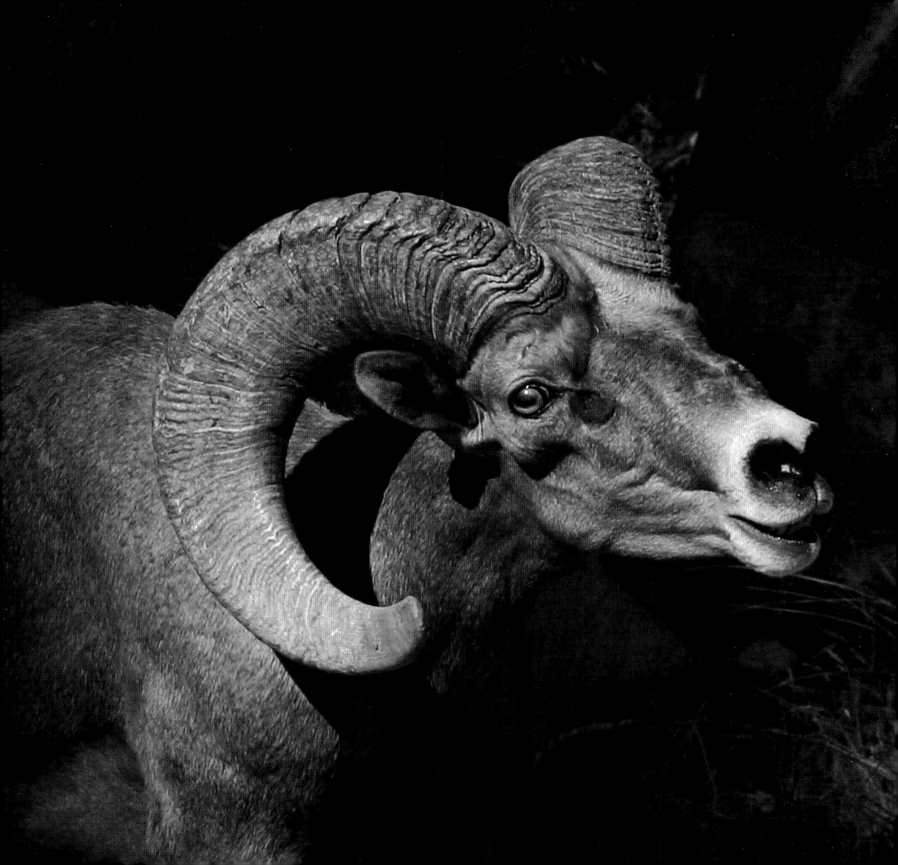

Life History and Behavior— A Year in the Life of a Desert Bighorn

CHAPTER 4

Horns and Ritualized Dominance Battles

Summer for most desert bighorn sheep means moving back to within a mile or so of a reliable source of water, be it a river, spring, wildlife guzzler, or tinaja. Forage quality gets poorer by the day as the intense sun dries the grasses, shrubs, and stubby trees on the dry slopes. Lambs, if still alive, are weaned, as it becomes more difficult for the ewes to produce milk. Rams move back toward water holes to begin the rituals of sparring with other rams, as their hormones stir them to pursue ewes for mating. Mixed groups of ewes, lambs, yearlings, and rams feed together during this season, trekking down to water—ever watchful. The breeding season, or *rut*, comes upon the desert bighorn.

"Rambunctious" is an apt word to describe the behavior of bighorn males in summer, as they move long distances in pursuit of ewes. They butt rocks, shrubs, cactus, and tree trunks. Several radio-collared bighorn rams have been tracked during the rut, moving from range to range, across valleys and roadways, as far as 75 miles. On occasion researchers have investigated sliding glass doors that had reflective coatings into which a large ram gazed, and apparently had impressed himself. Seeing the "other" big male in the mirrored window, the ram engaged the brute in head to head combat, only to end up inside of the home, bleeding in the midst of the broken glass, then gathering itself up and trotting back up the mountain, wondering what happened.

Opposite: **A fine mature ram displays his large set of horns and flairs his nostrils while posing in this stretch position. Note the large dark patch in front of the eye, known as the preorbital gland. This gland, found in sheep but not goats, produces a waxy substance which provides scent that is rubbed on other bighorn, and is left as a marker on trees and rocks, noting the ram's presence. Rams may display their horns to other rams in dominance or to ewes during courtship.**

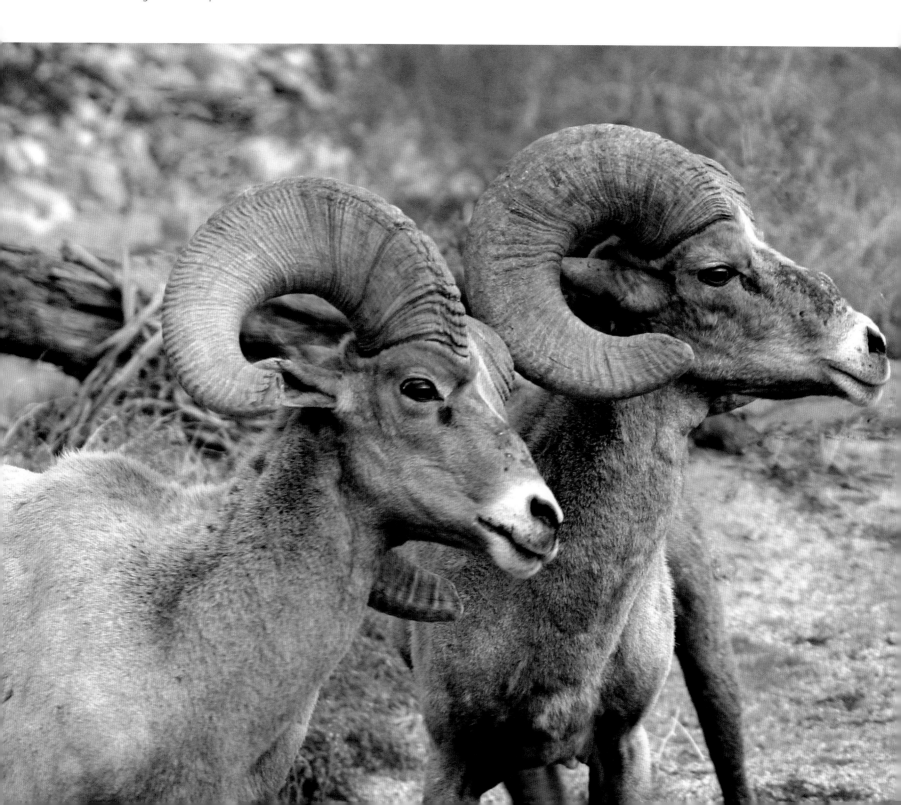

The sex drive of rams takes over much of their behavior by late summer, sometimes meaning they forsake feeding and trips to water in their endless pursuits. In one such incident, a ram had been struck on a paved highway by a pickup truck, and was knocked unconscious. After a few moments, the animal got up, shook itself, and walked slowly off the road. A biologist arrived within 30 minutes to track the bighorn. When found, the ram was sniffing a ewe. Despite a scraped and bleeding shoulder, he mounted the ewe and stood proudly overlooking the band of sheep.

Big *horn* is the namesake of this desert sheep, and both sexes grow them. The ewe carries shorter, pointed horns, and the ram sports large, curving horns to more than 40 inches in length. The massive rack, grown throughout the life of the ram, comes to the pinnacle of usefulness during the mating season. Dominance rituals are played out among rams in a population, and the tools of the ritual are the horns. A ram of eight to 12 years will usually sport a set of horns which have grown into three-quarters of a curl, sometimes growing to a full curl. The horns and skull of a mature ram will weigh up to 30 pounds, not counting the muscle and hide. The skull has evolved to be a massive network of reinforced bony struts and large sinuses, well equipped to absorb the tremendous collisions of head to head combat. The spine has evolved to carry this massive head, and absorb tremendous impacts, with the uppermost vertebra, known as the Atlas, being a full four inches in breadth. Heavy musculature and connective tissue support the weight and impact of head to head combat.

Opposite: The older ram on the right has endured many battles in his 10+ years. His muzzle shows the scarring of numerous blows and miscalculations during head to head combat with other rams. His younger counterpart shows horn brooming and some facial scars, but nothing to match his elder.

Right: The bighorn's skull has evolved with a network of reinforced bone and extensive sinuses, adapted to absorbing massive amounts of force in head-to-head combat.

Below: Older rams often show the scars of many dominance battles. Note the chipped horns of the ram on the left while the younger ram on the right still appears unscathed.

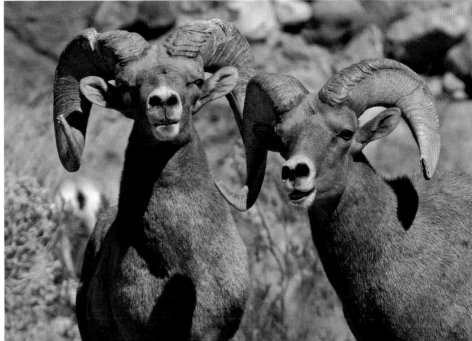

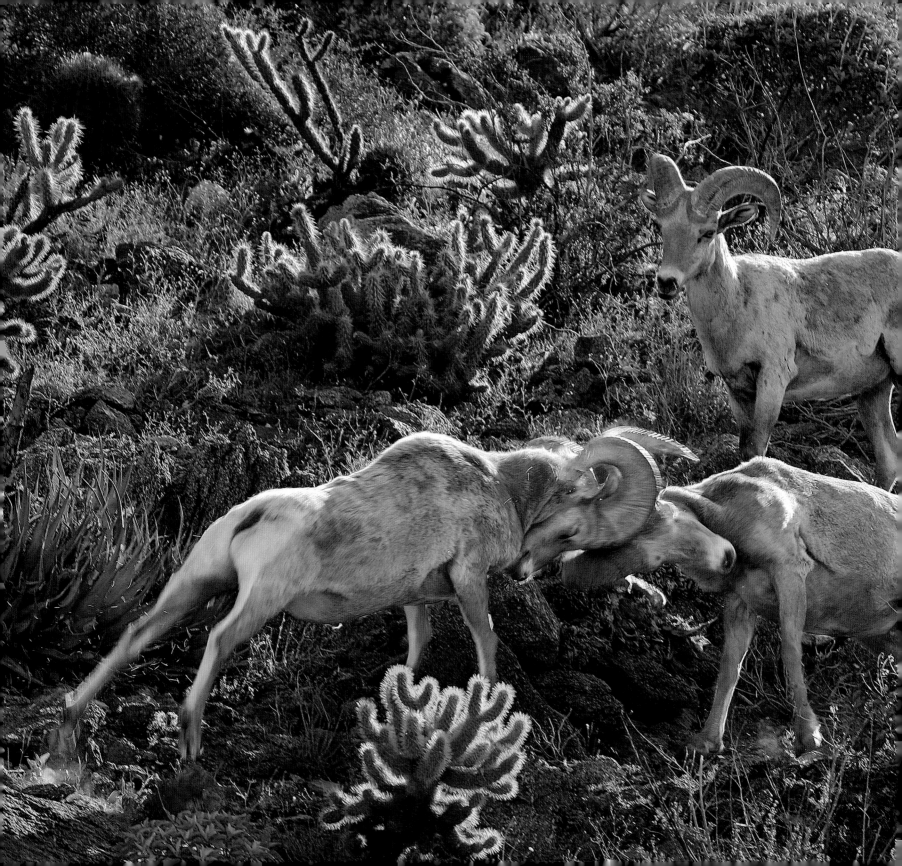

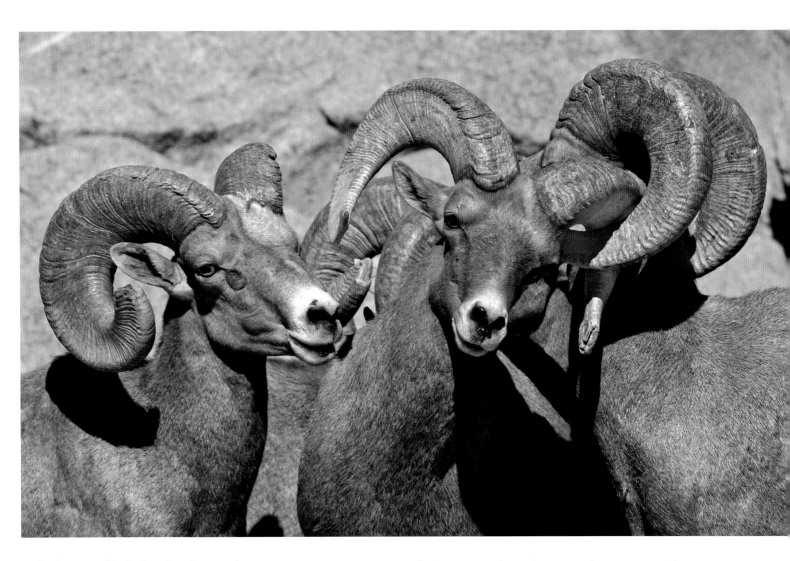

Left: Rams will vie for dominance in ritualized combat, striking head to head, sometimes for hours. Battle is usually done with a similar-sized ram while younger animals may stand by to observe and learn.

Above: There is constant challenging, horning, kicking, and jousting among rams, especially during the rut, or mating season. Note the two rams which have temporarily locked horns during their interaction.

The horns of a large ram show deep annular rings, much as the growth rings on a tree, growth during the bounty of spring, and a deep ring marking the halt of growth, coinciding with the rut and tribulations of summer.

The largest, most aggressive and powerful ram is often thought to do more than his share of the breeding with receptive ewes, theoretically passing on the most dominant genetic line to the next generation.

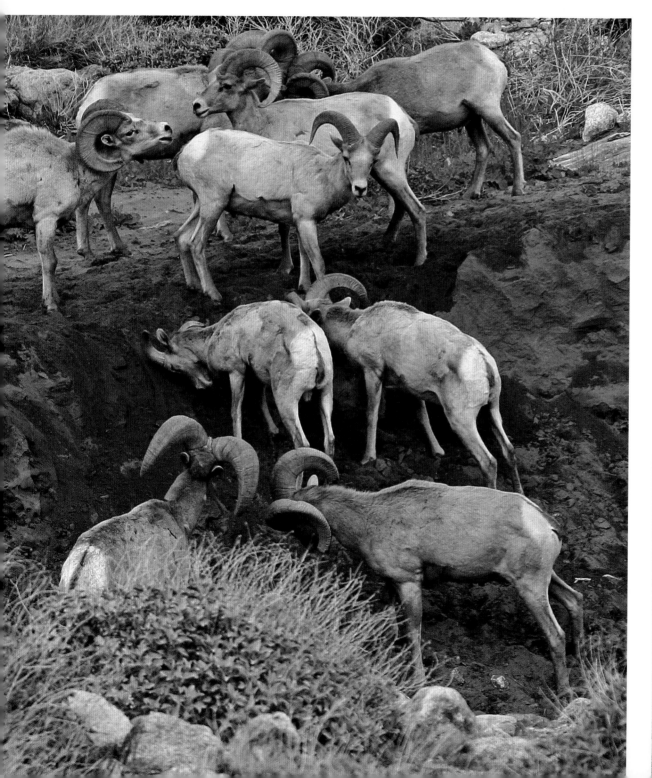

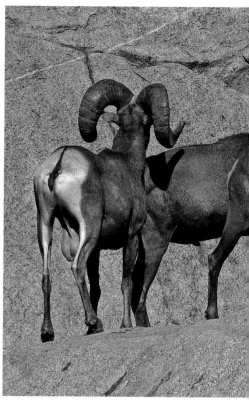

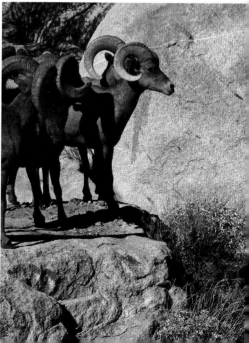

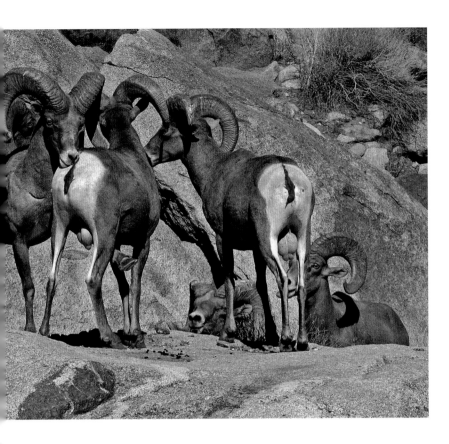

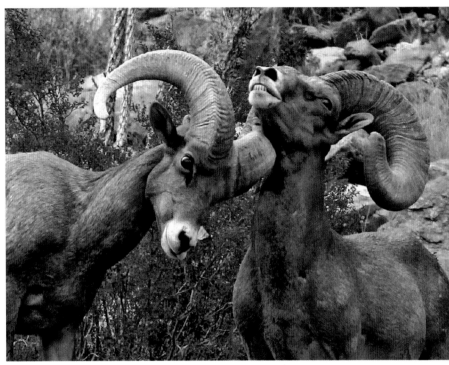

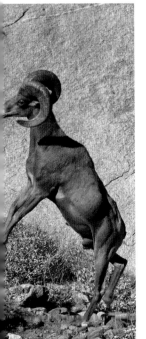

Opposite: **Nine rams from yearling to mature, acting out on a dirt bank and on each other as the male hormones are stirring.**

Above: **Seven mature rams gather in a major display of horns and dominance behavior. Note the ram in the center kicking his adversary in the belly with his left front hoof, taunting him to do battle.**

Left: **A seven- or eight-year-old ram stands on his hind legs in a challenge to a band of rams, with apparently none willing to engage in ritualized combat.**

Above Right: **Taunting by a young ram horning an old dominant ram is not likely to result in a serious battle.**

Dominance is determined among the rams much like boys in middle school—the toughest, most aggressive, often does as he pleases within the social structure of the group. Rams of similar size and horn growth will be the competitors for dominance. Ritualized combat appears to be conducted by a set of unwritten rules. Injury or death is not the intention of combat episodes, only to establish between the combatants which of them is the toughest, most durable, most *macho* (Spanish for ram). Often one ram seems to offer a challenge to the other, displaying his own set of horns with a side to side tilt of the head, sometimes butting the torso of his opponent. If the stage is not yet set for battle, the challenger may use his front hooves to kick the opponent in the belly or scrotum. This often rings the bell for round one of the match-up.

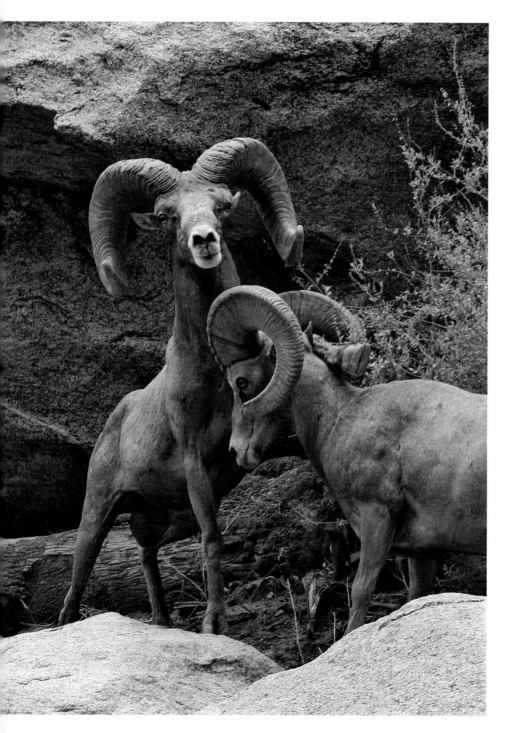

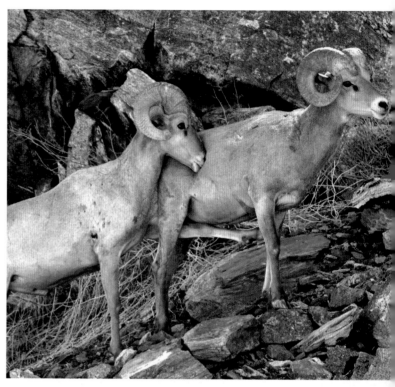

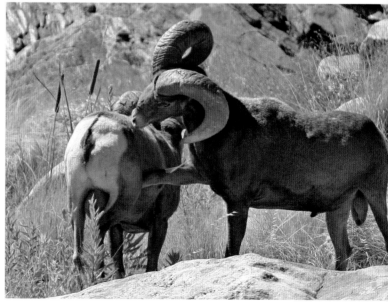

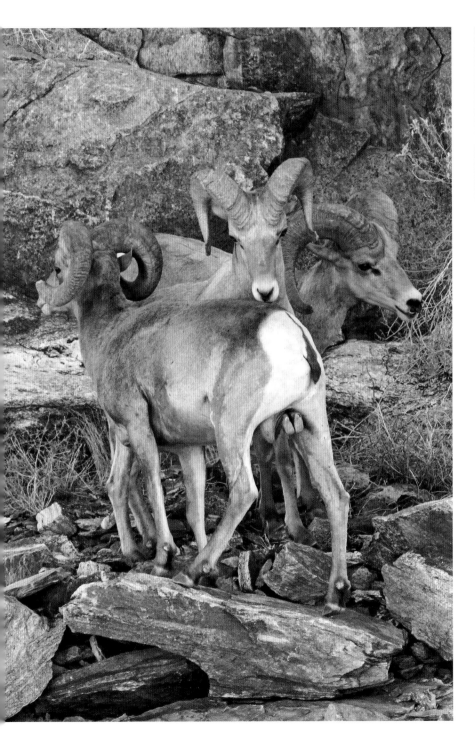

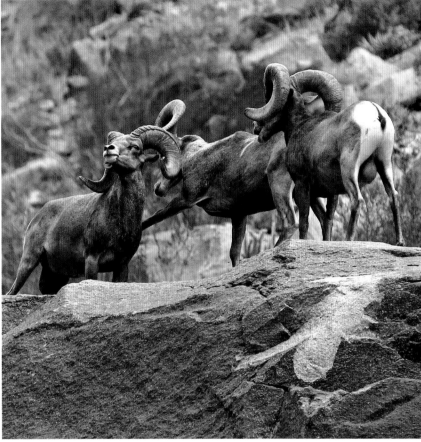

Taunting of other rams as a precursor to episodes of horn-to-horn battle often involves kicking the opponent as noted here. Kicks to the belly, the scrotum, and even one over the head may incite head butting.

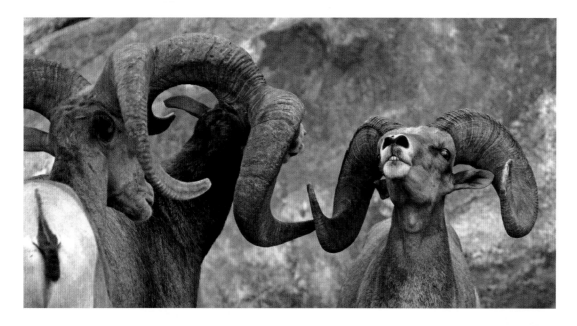

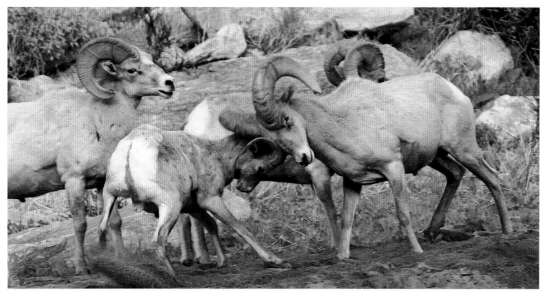

Above, Top: Two massive rams posture with eyes bulging, noses thrust upwards, and horns angled in preparations for the dominance battle. These two have likely met before but it appears it may be time to renew old rivalries.

Above: A young ram, just one to two years old, finds himself overmatched and completely dominated by one of his elders.

The two rams with their eyes opened wide, raise their muzzles upward, do a horn display, then may turn and walk away from each other for five or ten yards. Then, as if a signal were sounded, the rams quickly turn back to face one another, sometimes rising onto their hind legs, and run headlong toward each other. One tilts his head one way, the other opposite, and they smash at the base of the horns with tremendous power. The crash resounds through the canyons, echoing off the walls in an impressive concussion that breaks the desert silence, shatters the heat waves, and can be heard a mile away. The animals face off after impact, raising their horns once again, showing the whites of their eyes, mouths open in stunned stillness. Most often, one duel is not enough and the head-to-head impacts may go on for an hour or more. Finally one ram relents, submissively turns, and walks off in defeat. The dominant ram may follow and the two may find a suitable bedding area and take relief on a breezy slope for rest the of the afternoon. There is little doubt either of the rams will forget the duel, or who the dominant animal is, at least for this season.

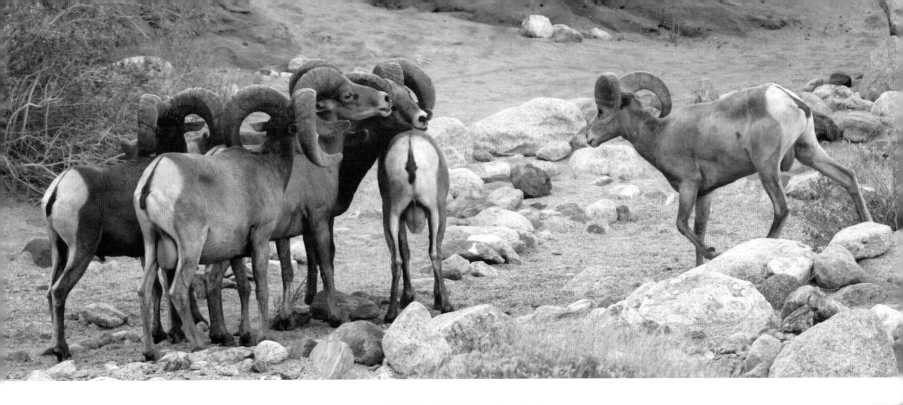

Above: There are times when the dominance battles involve more than two rams. The author once observed seven rams taking turns at head crashing, a few times a minute, for an hour or more.

Right: With bodies tensed and eyes bulged, two rams are poised for jarring impact in a dominance ritual.

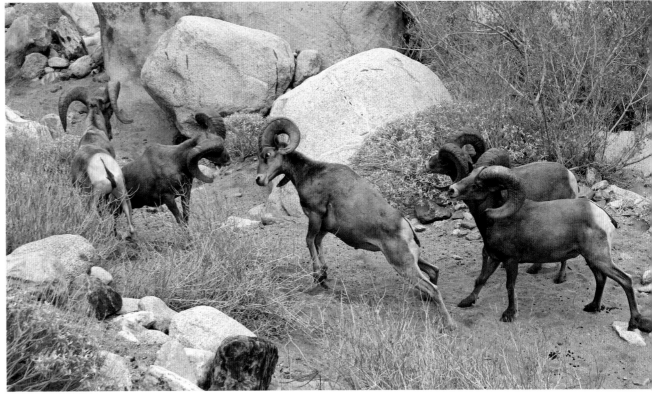

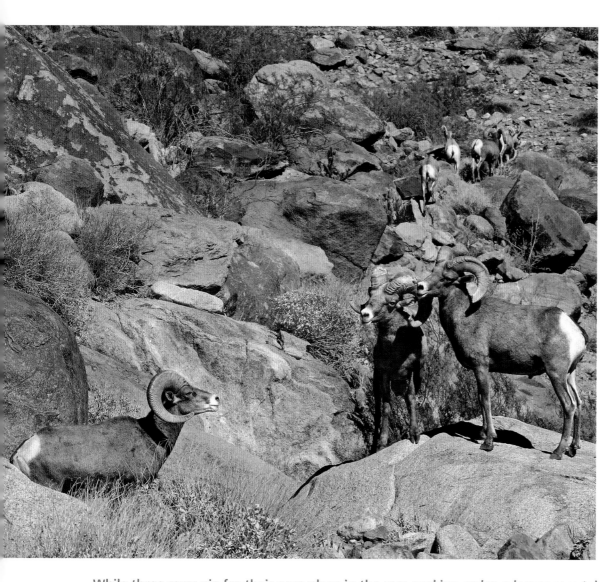
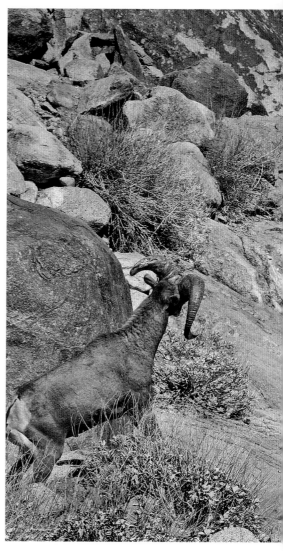

While three rams vie for their own place in the ram pecking order, a larger ram takes off with the females. The lower ram poses, seeing the ram on the upper right put his head back into a display, then thrusts forward for head to head combat, knocking both combatants off their feet. Note the lower ram's degraded left horn, likely infected and broken off in a previous battle. The horns of the uninvolved ram on the boulder show battle scars on the base of both horns. His larger size may mean he's standing this one out, allowing the two equally-aged rams to vie for dominance.

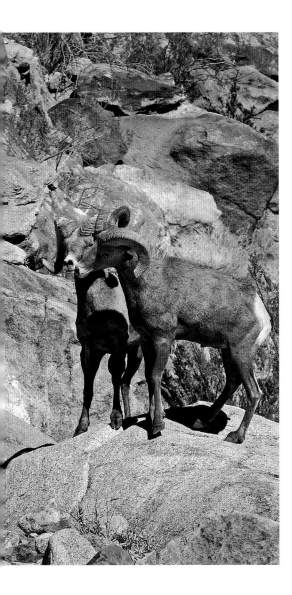

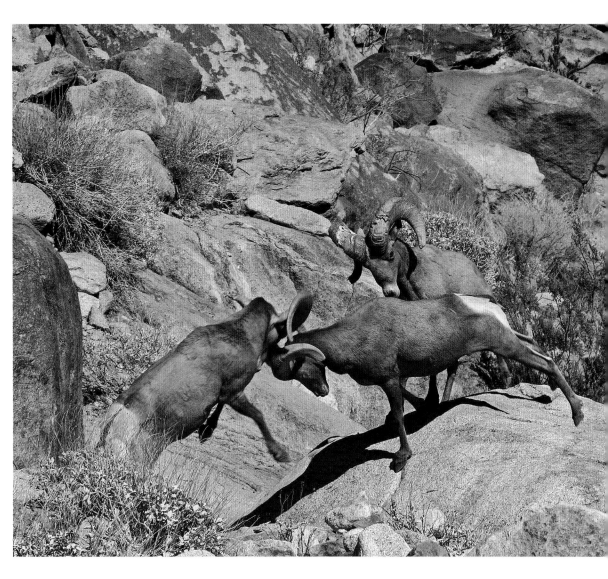

I've witnessed many ram battles in my five decades of sheep study, some in which more than two rams competed. One event involved seven rams on a boulder the size of a house. The rams on the highest point of the sloped rock seemed to challenge the one or two unfortunate rams who found themselves on the low point. Two rams at a time, every 15 seconds or so, crashed, the loud report of horn on horn reverberating in the canyon below. My partner and I were over a half-mile away and clearly heard what we thought were rifle shots until we found the mass of horns and bodies moving through the heat waves, and gazed in amazement for an hour or more at the gang of rams.

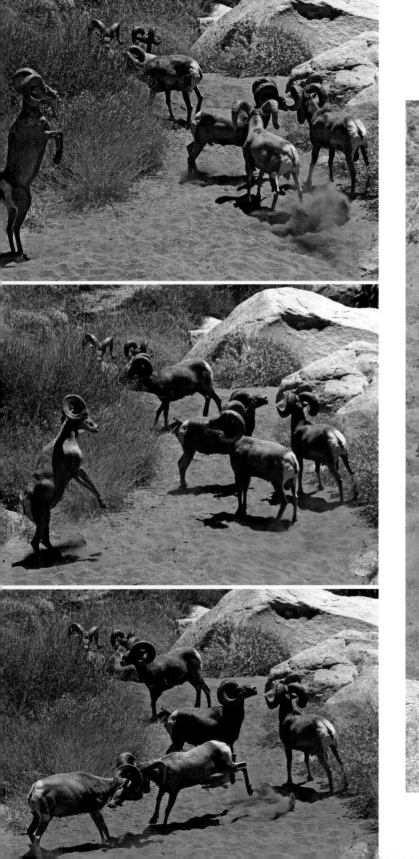
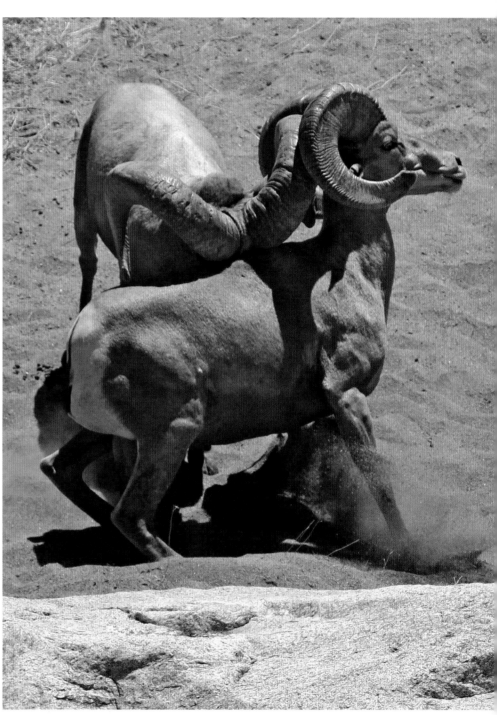

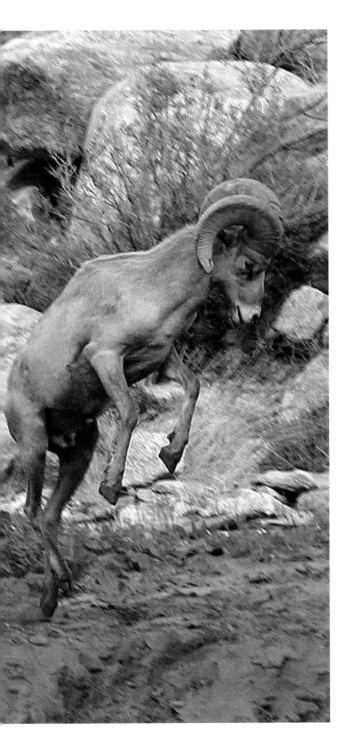

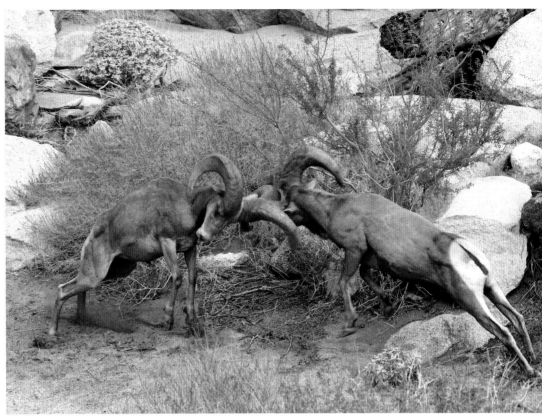

Opposite Far Left: Seven rams, in a sea of horns, picking fights with one another. In the upper photo a ram stands on his hind legs until a likely adversary turns to look up and immediately engages in combat. Dust flies and horns smash together in the summer air, reverberating through the canyons like rifle shots.

Opposite Left: Ram dominance bouts are usually conducted head to head, with the major contact being the well-reinforced base of the horns. At times contact is made elsewhere, such as this hefty blow to the back.

Left: "Rambunctious" is an apt description of male bighorn behavior during the rut season. Jumping, kicking, head-butting rocks and trees, and smashing bushes are sure signs the hormones are flowing.

Above: Two evenly matched rams go at it in a highly ritualized head battle, well calculated to match horn to horn. Injury or death is not a motive, only determination of which ram is most dominant, and who may go on to mate with nearby ewes.

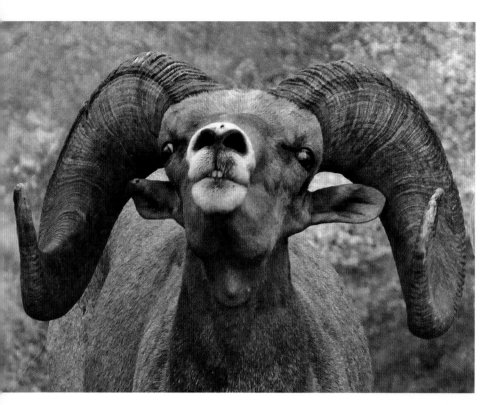

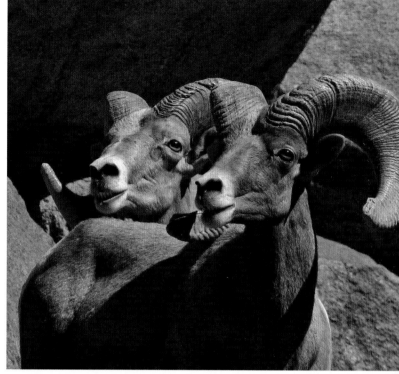

Above: A large desert bighorn ram, likely more than 10 years old, displays his massive horns. The horns and skull may weigh 30 pounds with a horn length of more than 40 inches and a basal girth of more than 16 inches. Note the deep annual growth rings. Rams may live to 15 years in the wild, while some ewes have been estimated to live up to 17 or 18 years.

Above Right: Two fine-looking mature rams pose amidst desert-varnished granite boulders in the Sonoran Desert.

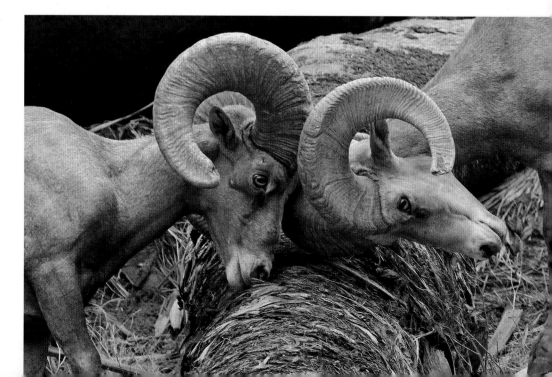

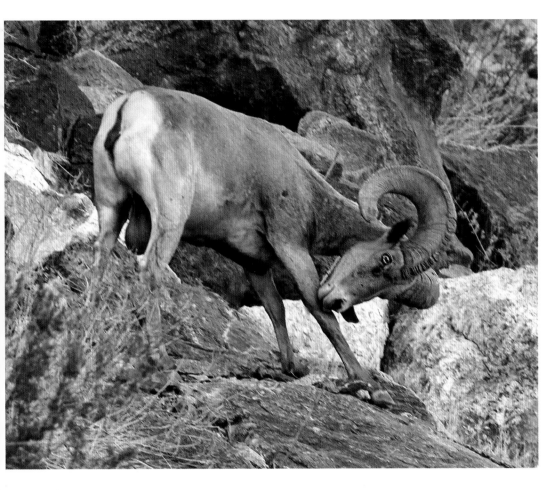

Horns have other uses for rams and ewes. Though ewes will use their horns to strike other ewes in competition for food and water, they also use their shorter, saber-like horns to open cacti and agave stalks to gain access to food. Rams and ewes will pound on the head of barrel cacti, busting the long spines out of the way, nimbly picking out the broken pulp and dislodged fruits with their lips. In some ranges many species of cacti make up part of the bighorn diet. One researcher documented bighorn selecting for fishhook or *Mammalaria* cactus, spending much of the day searching them out. Even cholla cactus, known for its formidable array of dense spines is used for food by bighorn, at times the ewe circling the limbs, clearing the spines with her horns, and nibbling away at the inner pulp.

Protection from predators is a likely use of horns for both ewes and rams, at least for coyotes and bobcats. It's doubtful that the horns protect bighorn from mountain lions, which seem to take bighorn sheep practically at will when they can stalk and ambush them effectively.

Evolution and selective breeding which favors dominant rams have made the bighorn sheep the animal with the largest horns in the New World.

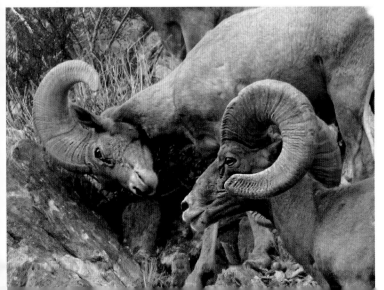

Opposite Lower Left, Above and Left: **Ram horns show the scars of many years of butting other rams, boulders, shrubs and trees.**

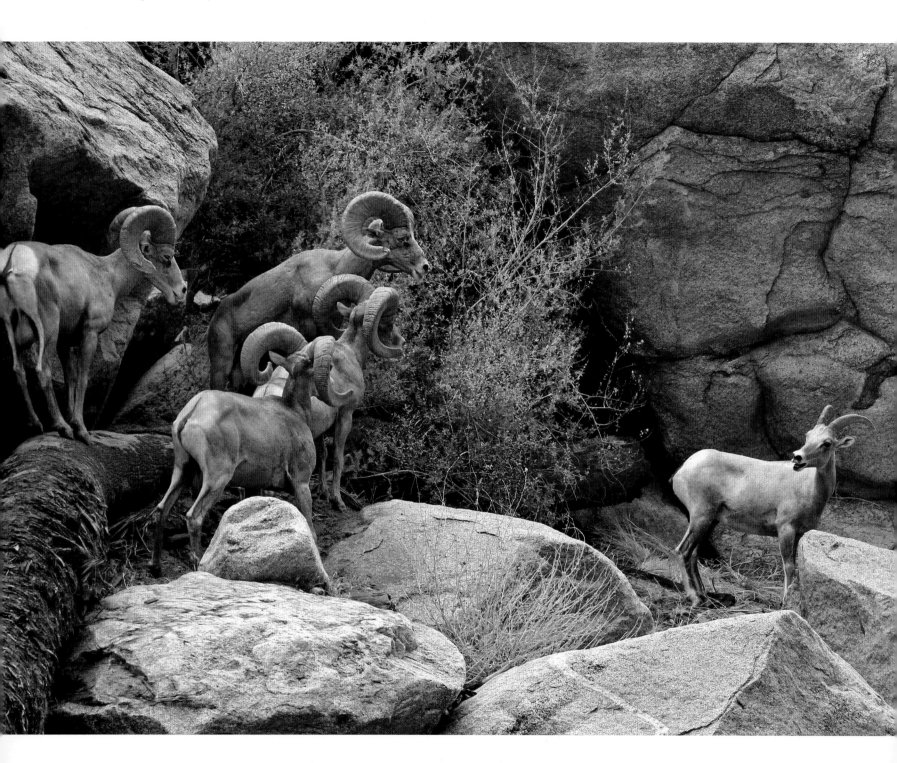

Breeding, Movement to Lambing Areas, Birth, and Nurturing of Lambs

Rams have generally established a dominance "pecking order" by mid-summer with the oldest, largest, most dominant rams taking first opportunities for breeding receptive ewes. Jostling and crowding among the rams occurs often, and at times while two large rams are reminding one another who won the last battle, a younger ram may take the opportunity to sneak in for female pursuit. Ewes often repel the approaches of lesser rams, but they nonetheless are pursued relentlessly.

A ewe will usually come into season, or *estrus*, after weaning her lamb if it has survived, usually by July in the lower deserts and later into August in the higher elevations and latitudes. Estrus produces hormone levels in the ewe which are detectable by rams, and receptivity in an individual ewe lasts about two days. If a ram in rut detects that a ewe is receptive or soon will come into estrus, the ram will doggedly pursue the female, nuzzling her hind quarters, sniffing her urine, or touching her vulva with his lips.

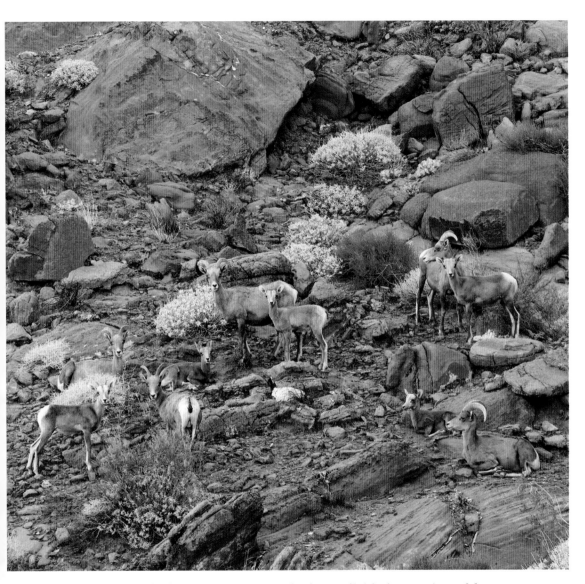

Opposite: **A bighorn ewe commands the undivided attention of four mature rams. During the late summer breeding period, known as the "rut," rams may pursue receptive ewes relentlessly for days until the opportunity for mating presents itself.**

Above: **Four mature ewes, each with their lamb, along with a yearling ewe and yearling ram (both far right in photo) relax in late summer. Soon rams will be courting the ewes for mating and there will be few serene group naps such as this one for a few weeks.**

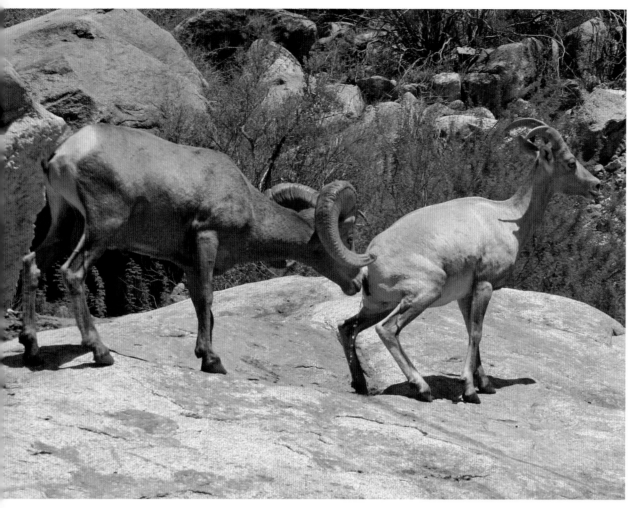

Above and Opposite Far Right: During the mating season a ram checks the receptivity of a ewe for mating. The scent of hormones in the ewe's vulva and urine are picked up on the ram's muzzle and tongue. The ram thrusts his head back and curls his lip in a posture known as "flehmen" to pick up the scent of the ewe. If she is receptive, mating may occur. If not, the ram may pursue her until she is. If mating does not occur, the ewe may come into heat every four weeks, being receptive to mating for only two days.

Right: A young ewe appears to fend off a large ram in a minor head rub. She may not yet be receptive to his courtship.

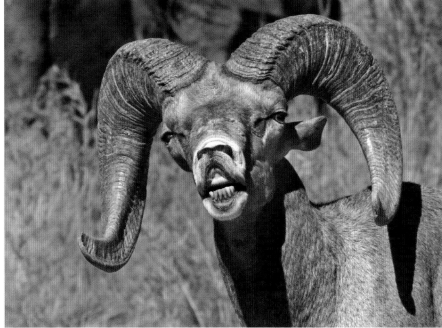

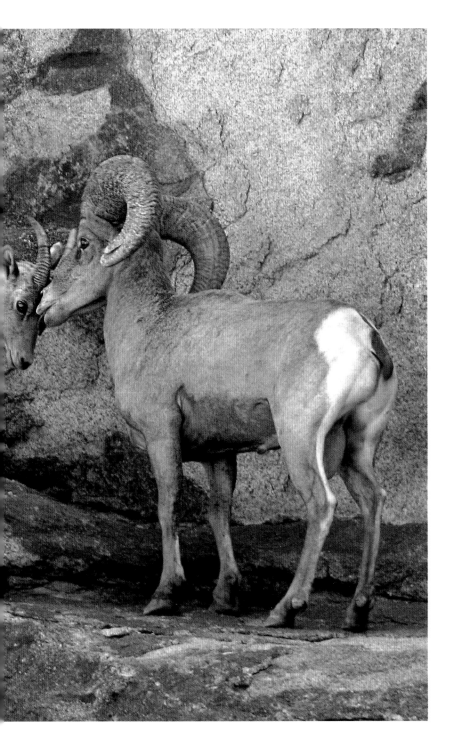

The ram raises his head and curls his upper lip in a posture known as *lipcurl*, or *flehmen*. The lipcurl tests the hormonal levels and receptivity of the ewe. The pursuit continues, with the ram chasing the ewe uphill and down.

A lot of energy is spent, visits to water may be necessary, and the game goes on for hours. When a ram tires and stops for shade or a rest, the ewe may be observed coming back to her pursuer and peering over the rocks as if to see why he is no longer interested. The chase begins anew and at some point the ewe may stop, urinate, and the ram sniffs the urine and performs the lipcurl once again, and eventually a mating bout will occur. The ram raises his front hooves onto the ewe's hind quarters, balances on his hind legs, and while grasping the female, inserts his long narrow penis into the ewe and makes every effort to impregnate her. Within a few seconds it's consummated.

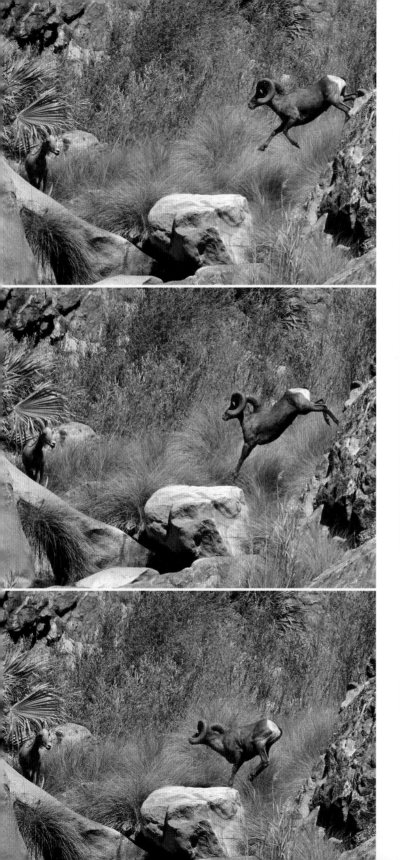

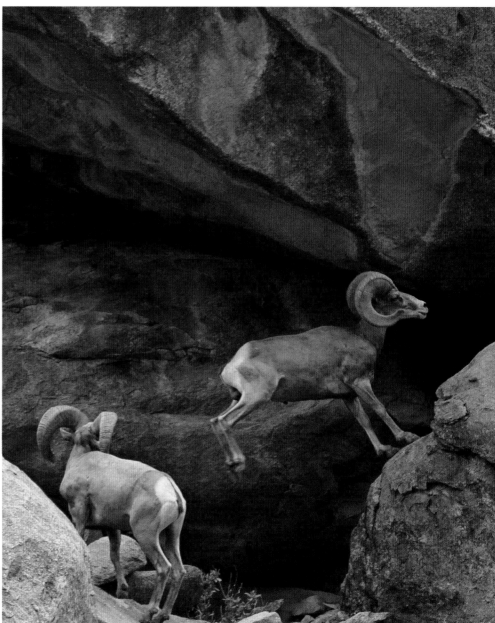

Left: A ram in pursuit of a ewe during breeding season shows agility and endurance. The ewe may run away, but when the ram pauses to rest, the ewe may come back, giving him renewed interest in pursuit.

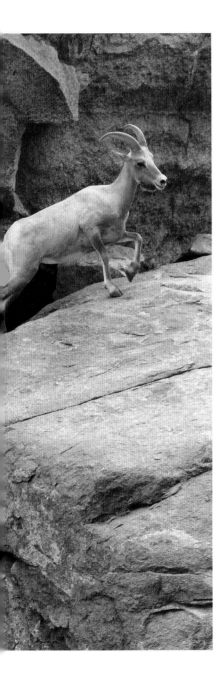

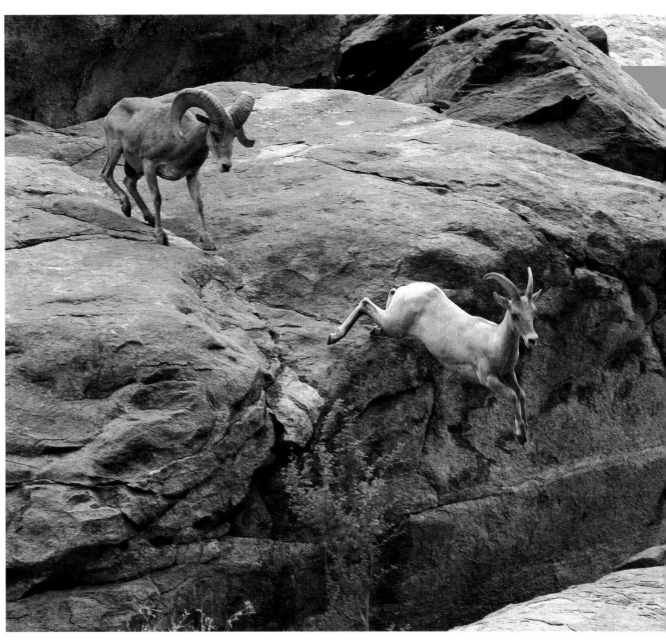

Above Left and Right: **A ram is in a relentless chase during breeding season. Courtship may go on for several days, depending on the receptivity of the ewe to mating. Rams often forego feeding and water during these bouts. Note the concave hindquarters of the ram, a sign of dehydration.**

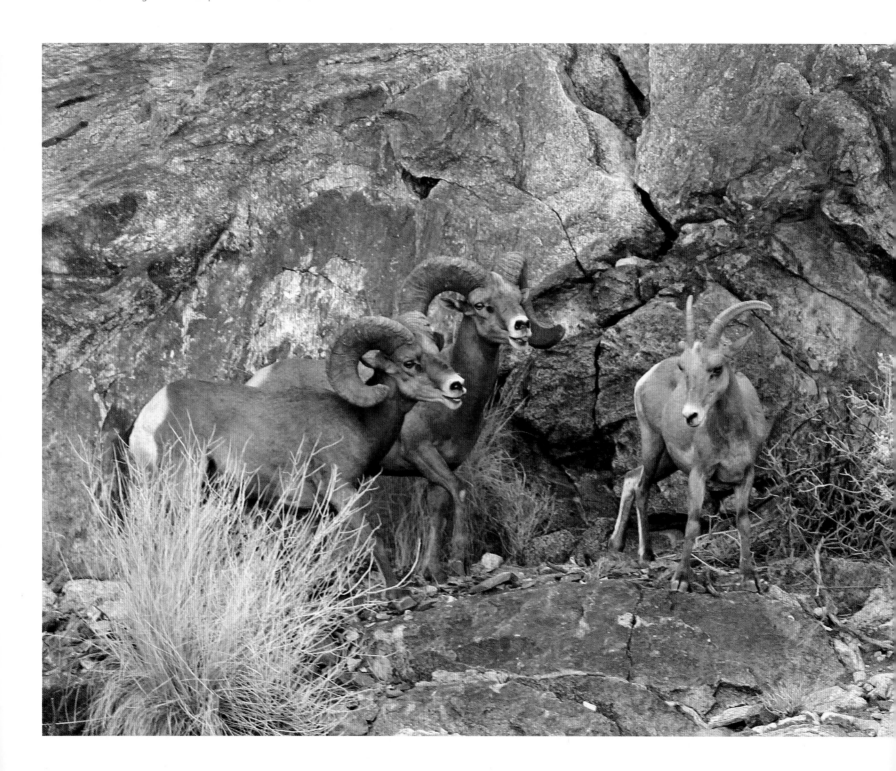

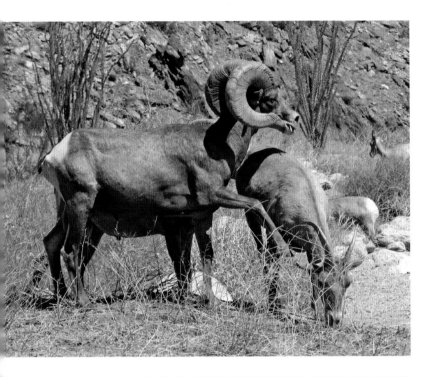

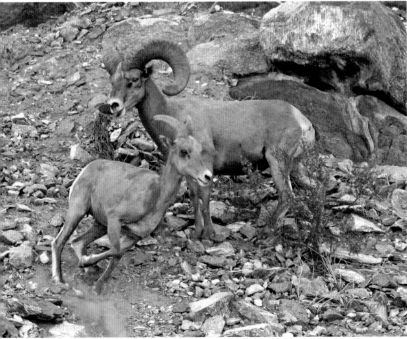

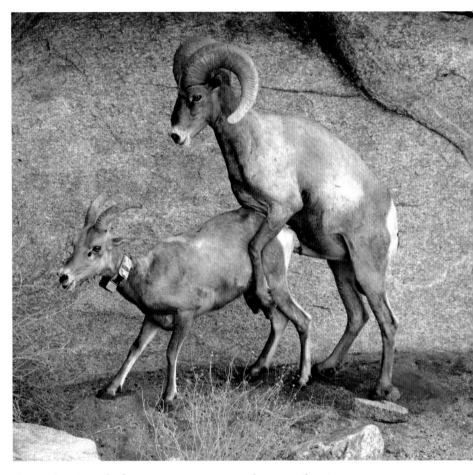

Opposite: Two hefty rams sense a ewe is receptive to mating and both linger to take advantage of the first opportunity to breed. Head butting between the rams will likely precede breeding the ewe.

Above Left: A kick to the neck is not likely to succeed in courtship, but this ram gives it a try.

Below Left: Hours of chasing, avoidance, courtship, nuzzling, sniffing, and persistence are involved in the mating rituals.

Above: After hours or days of courtship and chase, mating finally occurs, lasting only a few seconds. This seven- to eight-year-old ram mates with a radio-collared ewe.

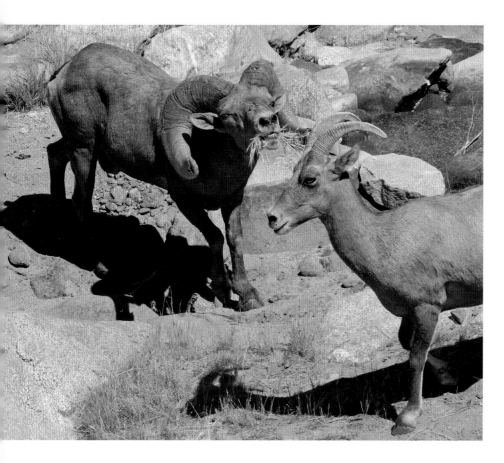

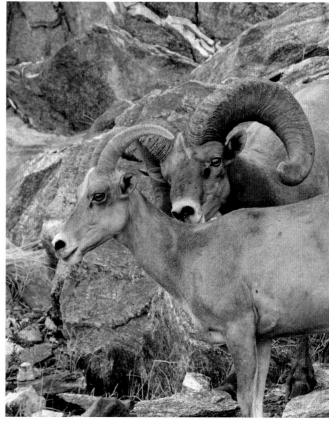

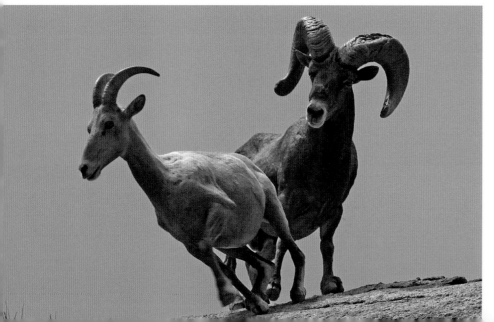

Above Left: This large ram can't seem to decide whether to eat grass or pursue the ewe for mating. With his neck and head in a low stretch, displaying to the ewe, he appears to be trying to do both at the same time.

Above: The dominant ram has isolated his quarry and waits by her side without competition for the right moment to breed. If successful the ewe will carry a single lamb for six months and give birth when the first green shoots of spring appear.

Left: A ram's pursuit of a ewe during the rut sends her lunging off a boulder. Ewes often head to canyon bottoms and lower slopes while being pursued, likely to minimize injury in rugged terrain.

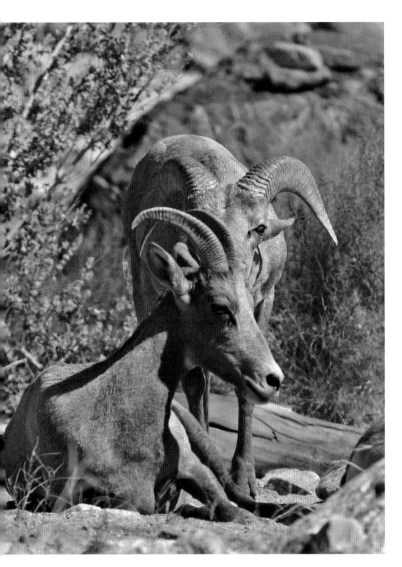

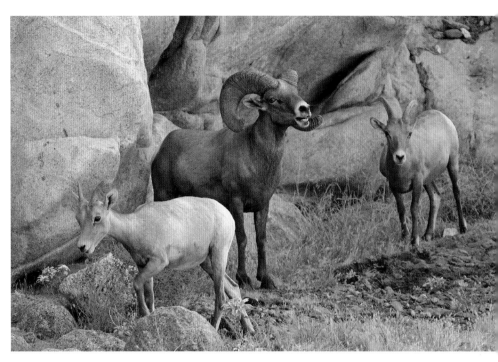

Above: **A two-year-old ram appears interested in possibly mating with a ewe, but his chances are slim. Larger, dominant rams will push the youngster out when the time comes for breeding.**

Above Right: **A mature ram courts an adult female still accompanied by her lamb of the year. The rut occurs in late summer, a stressful endeavor for rams and ewes. Frequent rests in the shade are called for and water is usually not far off.**

Further attempts may be made, but for the ewe, if mating is successful, she will usually not be open to courtship by other rams. If breeding is not successful on this attempt, and the ewe goes out of heat, she will not come back into estrus for about four weeks. She will come into estrus again for about 48 hours and once again be the center of attention among the rutting rams.

The rut continues from late summer into the fall, resulting in a majority of ewes being successfully impregnated. The cool nights of autumn allow the desert bighorn to depend less on their summer range near water, and many make a trek of five to ten miles to their winter range, where traditional lambing sites and nursery areas will be found. Gestation is six months, with birth closely timed to match the earliest green-up of grasses and annual forbs. Since spring emerges earlier in the southern climes, the lambing season usually begins earlier in Baja California and Sonora than it does in Utah or Nevada.

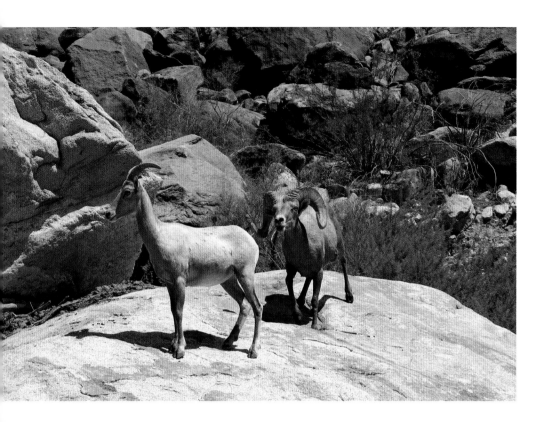

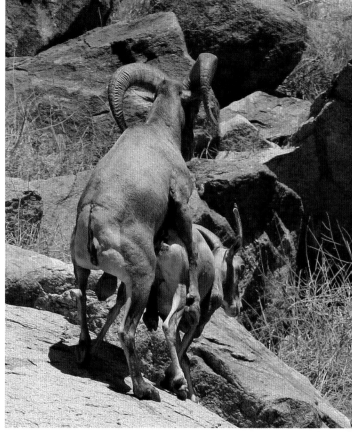

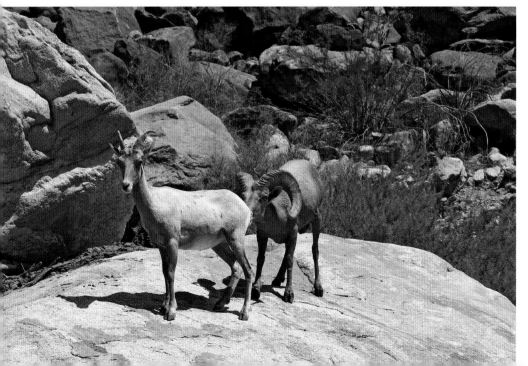

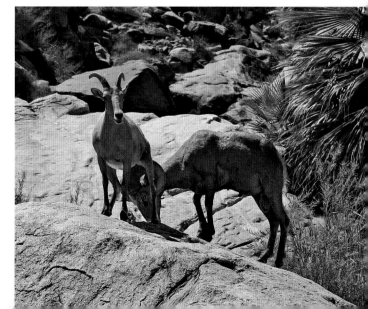

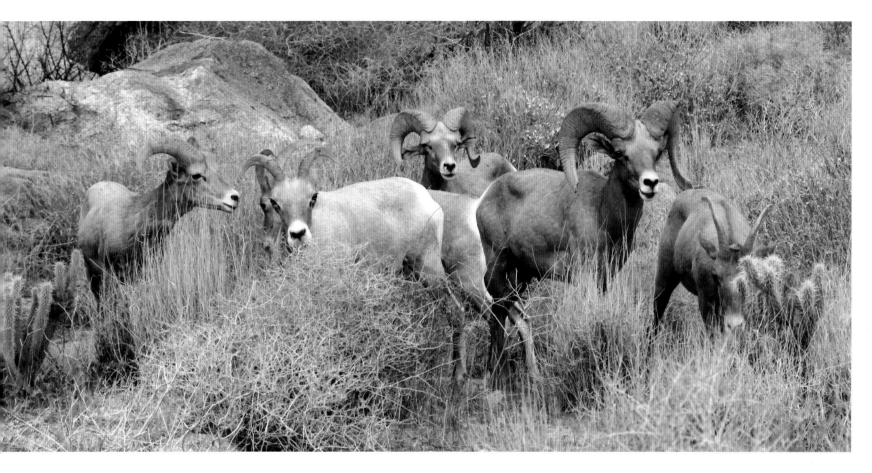

Opposite (counter clockwise from upper left):
A 3/4 curl ram, about 10 years old, pursues a receptive ewe. He first stretches his neck in a display, then sniffs her vulva and licks her urine to confirm she is ready, and quickly mounts her atop a boulder in a precarious breeding episode. If unsuccessful he'll continue his pursuit and try again.

Above: A group of three ewes and three rams. The two mature rams may have a chance of breeding with the three ewes, but the young ram on the left will have to wait a few years for his chance.

Right: An exceptional ram courts a mature ewe near a palm grove in the Sonoran Desert of California.

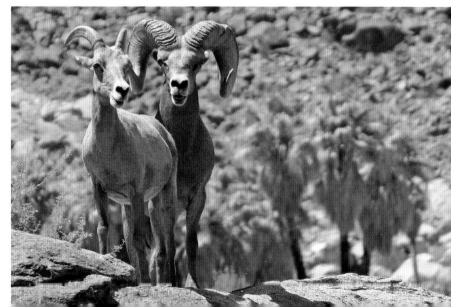

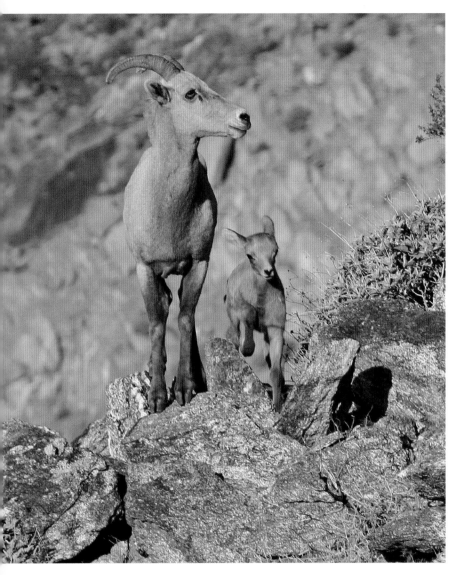

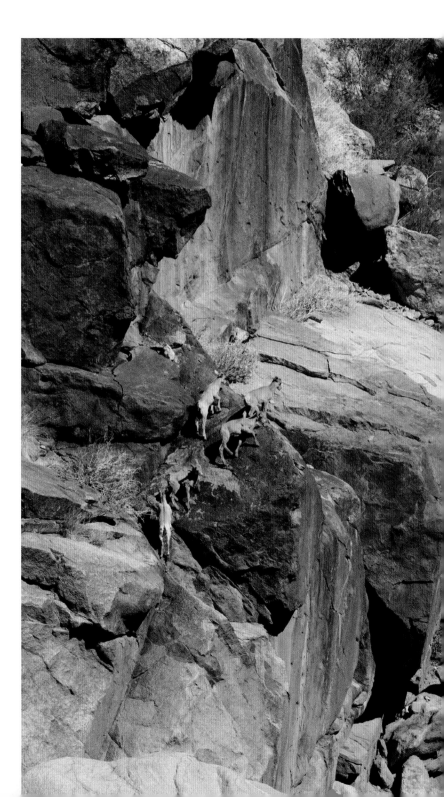

Above: Six months after successful breeding, a lamb of six to eight pounds is born, usually in isolation on a steep slope, away from the herd. Within the hour the lamb is standing and walking, and within a day or two is bounding in the roughest country in the west.

Right: Five lambs negotiate a dangerous cliff in their new home. Soft hoof pads and agility serve them well in learning to survive the steep desert environment.

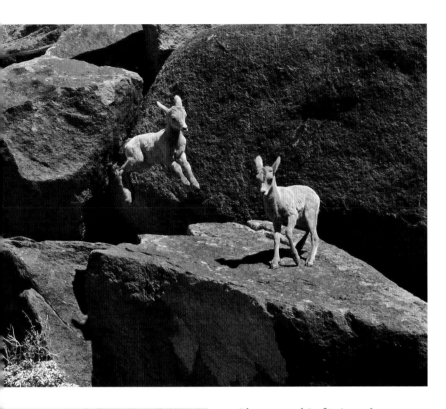

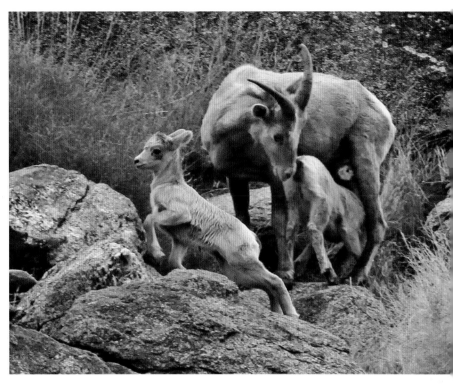

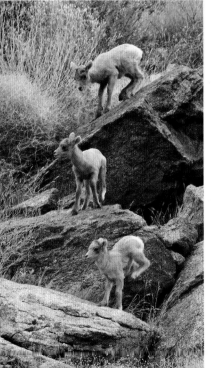

Above and Left: **Leaping, descending steep boulders, and frolicking build muscle and experience for young lambs.**

Above Right: **A ewe nurses her lamb while a newborn lamb runs across the slope to find its mother.**

Evolution and natural selection have refined the coincidence of emergent forage and birthing. A lamb born too early will find cold temperatures and little high quality forage to sustain it or its lactating mother, and one born too late will come into a world of heat and drying flora, making it difficult for the ewe to produce a sufficient quantity of milk. Giving birth to a healthy lamb as the plant world is coming to life for spring provides the ewe the best odds of raising her lamb. Even with evolution, spring greenery, an attentive mother, and a remote birthing site, a bighorn lamb has less than a 50% chance of surviving its first summer. The intense summer heat, unpredictable water availability, disease, predation, falls, and the many rigors of the desert present insurmountable challenges to many newborn lambs.

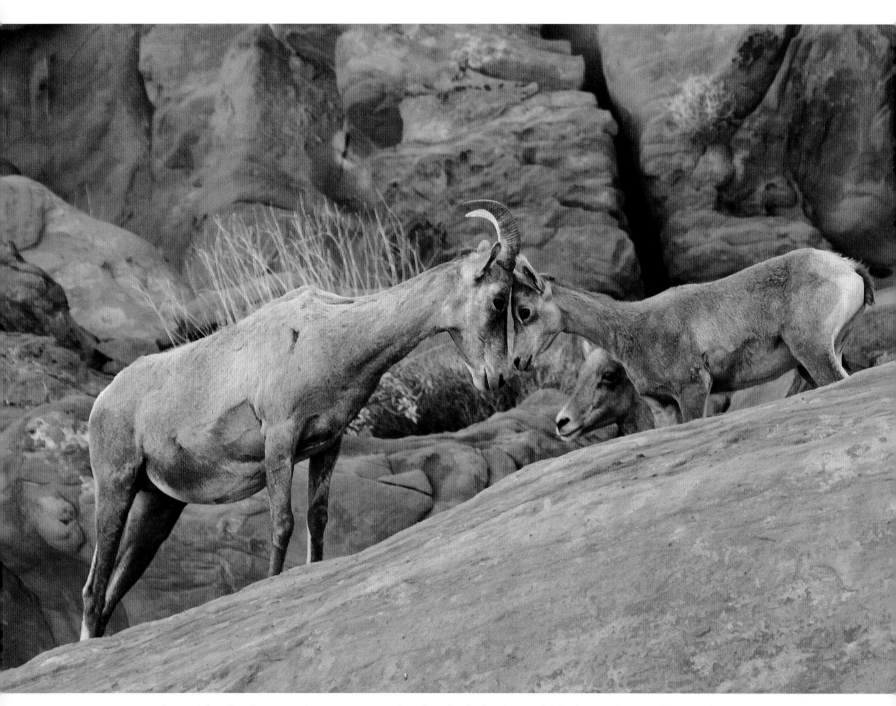

A ewe sparring with a lamb, part play, part preparing for the behaviors which determine pecking order.

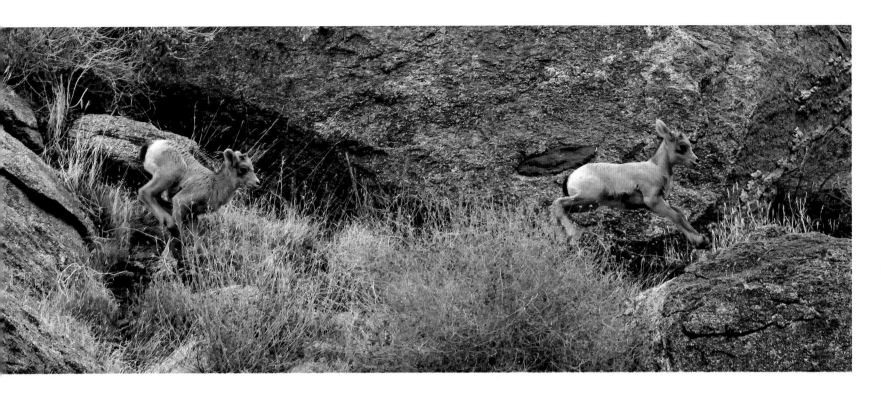

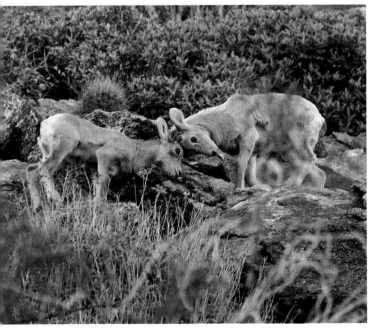

Lambs practice the behaviors they'll need in adulthood, running with agility and strength and butting heads with other sheep. Less than 50% of lambs born in the spring will usually survive their first summer.

Fidelity to the Homeland

Surviving its first summer will likely be the biggest challenge in a desert bighorn's life. Growth is rapid if forage is good and the ewe's milk plentiful. Last year's lamb, if it survived, may still be running with the ewe and is now a *yearling*. Yearling females will usually stay with their mother, while male yearlings may run with their mother's band for a year before departing to find other rams to run with. They will wander, exploring nearby mountain ranges, and will become familiar with the region. This will serve them and the bighorn population well, as someday the ram may be carrying his genetic line to adjacent ranges for breeding ewes there.

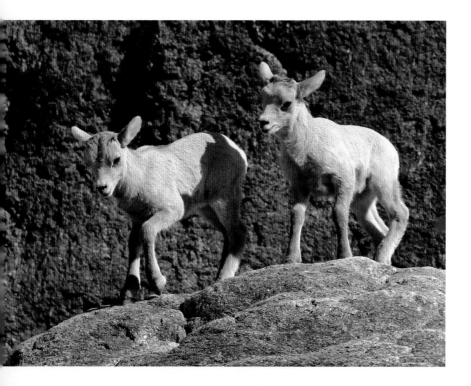

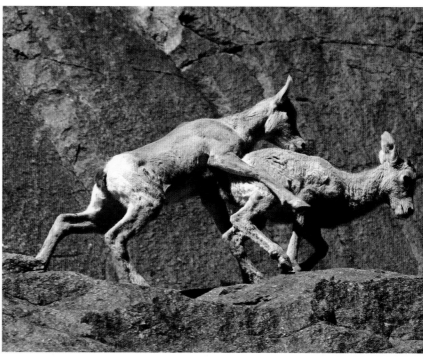

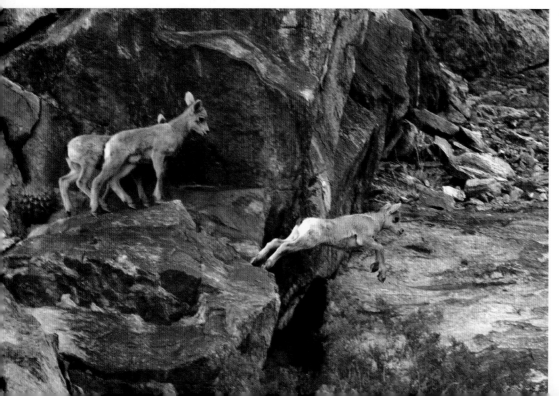

Above Left and Left: Newborn lambs delicately find their way among the boulders of their new home, and then in a challenging act of courage, practice leaping off giant boulders.

Above: Two-month-old lambs scramble along granite boulders, jousting and gaining strength and agility.

Opposite: Ewes head butt and kick, though not as much as rams. They will joust head-to-head or head-to-rib-cage in order to get their way with other females.

Ewes and their female offspring will generally remain within their home range with a high fidelity to their birth and summer watering areas. Inbreeding is usually avoided by the interchange of rams between mountain ranges, while the females maintain the matrilineal social structure of the desert bighorn. Yearling ewes most often do not breed, or at least do not become pregnant, although there are numerous instances of yearlings giving birth. By the time the young ewe is two years old she is almost as large as her mother and will enter the breeding pool of the population.

The matriarchs of the subpopulation know the locations of water sources, seasonal pockets which might pool up after a storm, select feeding areas, and danger zones of past predation events they may have witnessed or narrowly escaped. The elder ewes lead their growing lambs and yearling females to lambing areas at the onset of autumn and pass on the traditions of the herd, as passed down through countless generations of bighorn before them.

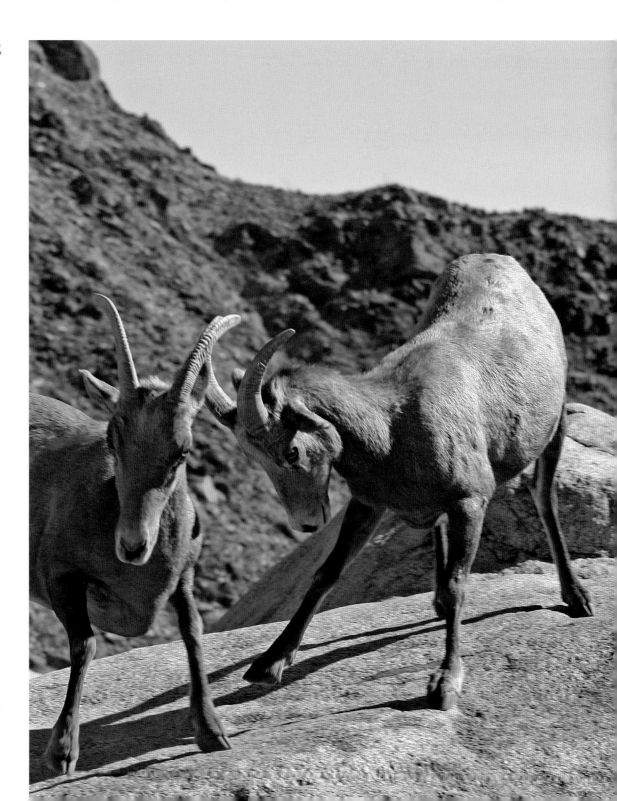

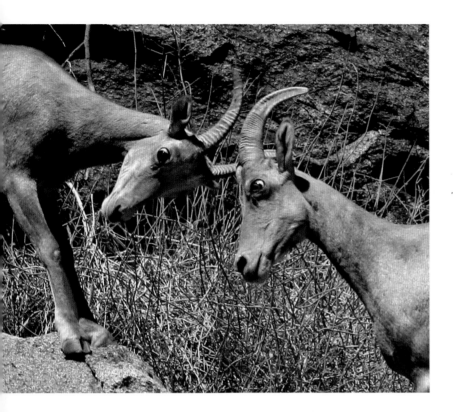

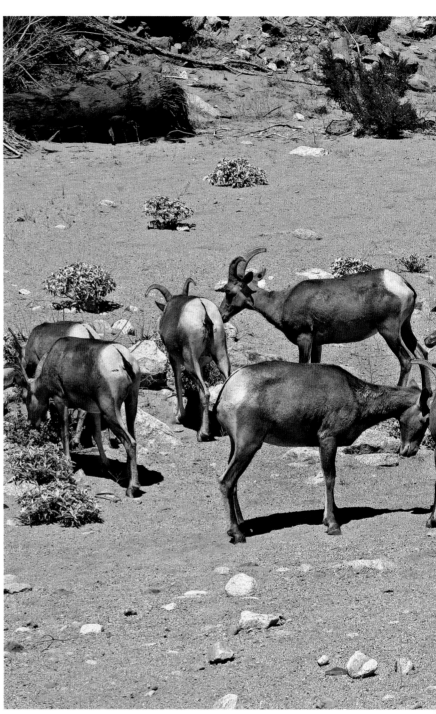

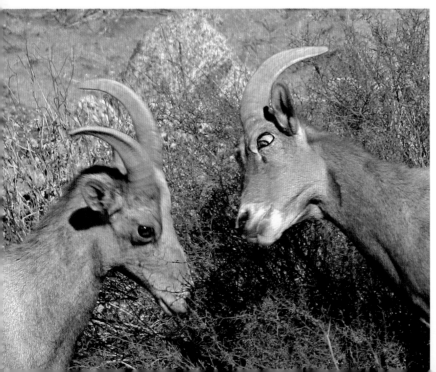

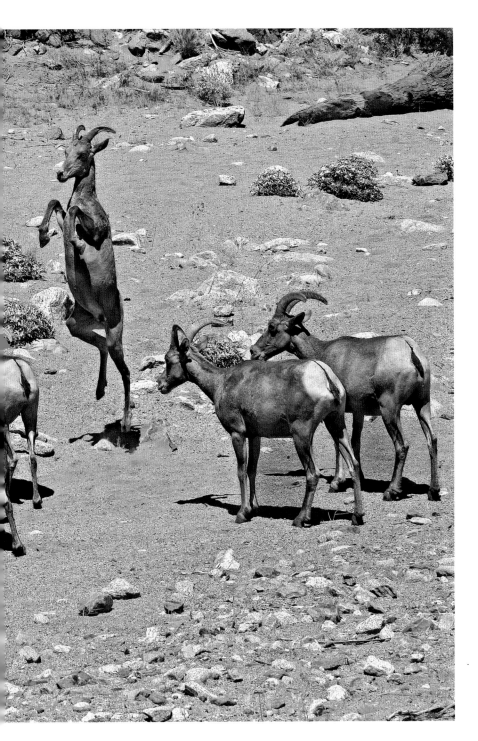

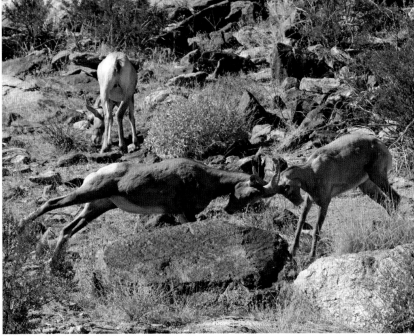

Opposite, Above Left and Below Left: With eyes bulged and heads cocked, ewes also establish dominance with other females in the group. Head crashing is usually not dramatic as it is among rams, but it gets the point across to the younger females.

Left: A mature ewe stands among her nine cohorts in a strange behavior rarely seen. One ewe in the middle appears to brace for head on head impact, but it does not happen. This behavior went on most of the day without the standing ewe gaining much attention from the group.

Above: After much taunting, kicking, and a few cheap shots to the rib cage, two ewes finally go head to head in a full-on battle.

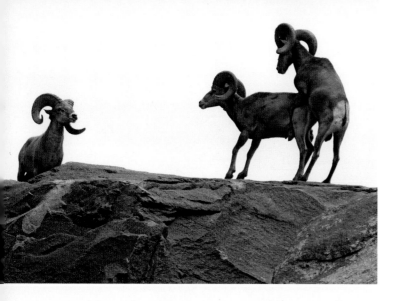

Rams—Adolescents to Elders

Yearling rams become less attached to their ewe groups and strike out to find others of their age. Soon they find themselves in the company of other young rams. Older rams will tolerate the younger males in the wanderings of the ram band, but the younger generation soon learns the rules of being a ram. The young rams learn to respect their elders, or pay the price of pain and submission. Large rams will not often engage in full combat with the young rams, but they'll soon let the lesser males know the rules. Rams will engage in behaviors such as mounting younger rams to demonstrate their dominance over them. The larger ram may even sniff the young ram's urine and do a lipcurl, treating the young ram as he would an estrous female.

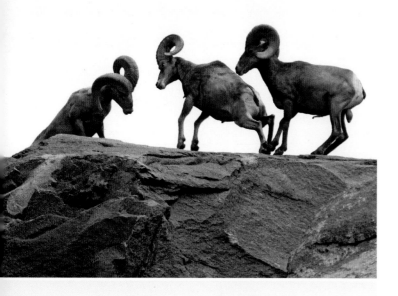

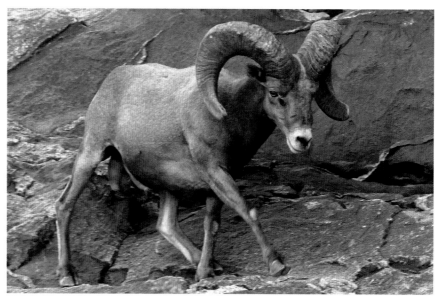

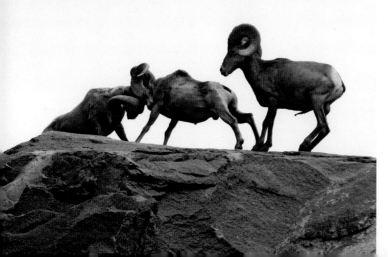

Left: Ram in the center goes from being mounted by one ram to head butting another ram in a matter of seconds. This ram is made submissive to one ram while vying for dominance with another.

Above: This ram, in his prime with heavy body, massive horns, and large hooves for negotiating the rocky terrain, will live 10 to 12 years on average and will cover many hundreds of miles in his quest to find mates and explore suitable habitat.

After summer, as many ewes are making the trek to winter areas for lambing and nurturing their young, the rams segregate from the ewe bands and may form bachelor herds of 15 rams or more. These ram bands may seek out high, remote ridges and slopes, or distant valleys and gentle terrain, not visited for the many months of summer. In one population in southern California, the wandering rams were observed to be the first to discover and take advantage of new emerging shoots of new growth after wildfires on the upper slopes of sheep habitat. Most desert bighorn do not typically enter dense growth, which is hypothesized to be a predator avoidance strategy. Fires clear thickets of vegetation and plants begin to regenerate, temporarily expanding the available habitat of the bighorn. Rams will exploit this high quality forage source, and the young rams running with their elders are schooled in the explorations of their surroundings. This knowledge may come in handy later in life when food and water resources are sparse and the need for moving out of the natal home range may be a life saver. Rams and ewes pass on habits and traditions to the younger generations, which are carried in the "herd memory."

Horn growth is dictated by genetics and nutrition. If high protein food sources are available and consumed, the horns of a yearling ram will rapidly gain length and girth, with growth rings being dark and heavily undulated. New horn growth comes from the base, much like a human fingernail emerging from the cuticle.

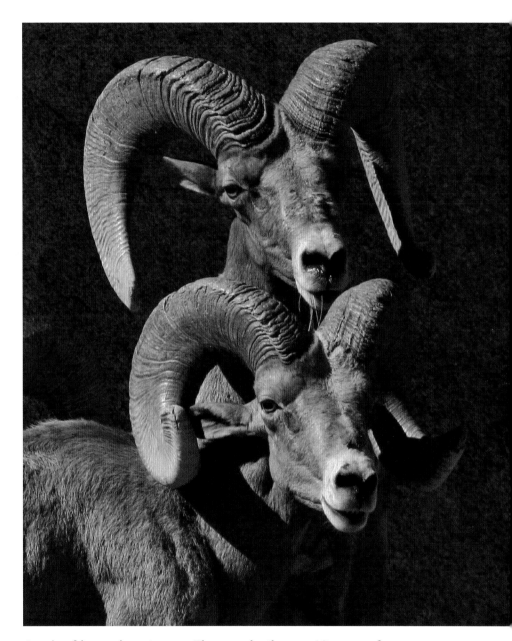

A pair of large desert rams. They are both over 10 years of age and carry horns that show their age. The ram at the bottom is what biologists and hunters would call a 3/4+, almost a full curl ram. Brooming of the horn tips allows the rams to maintain a wide field of vision to protect themselves from predators.

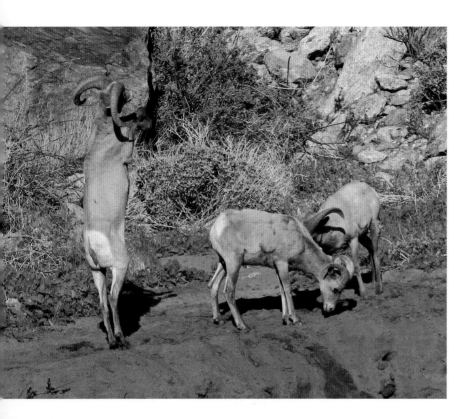

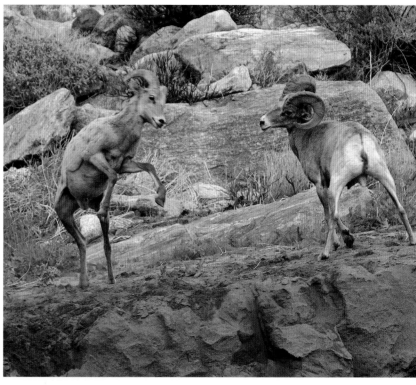

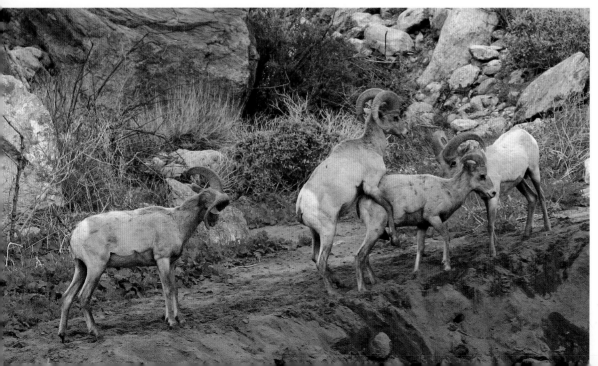

Above Left: An older ram stands on his hind legs, gaining a dominant posture over the younger challenger.

Above: The elder ram is head-butted and taunted by the younger ram.

Left: The elder mounts the youngster in a gesture meant to put him back in his place.

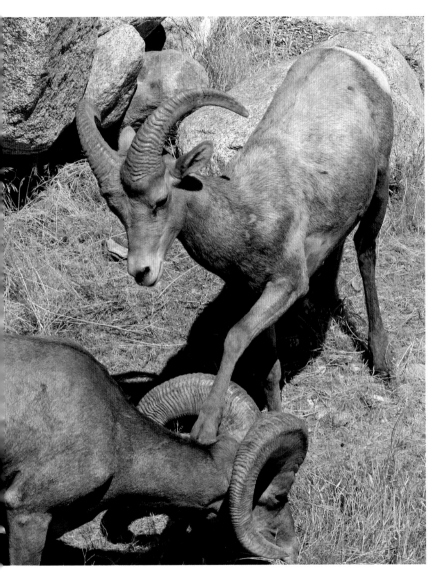
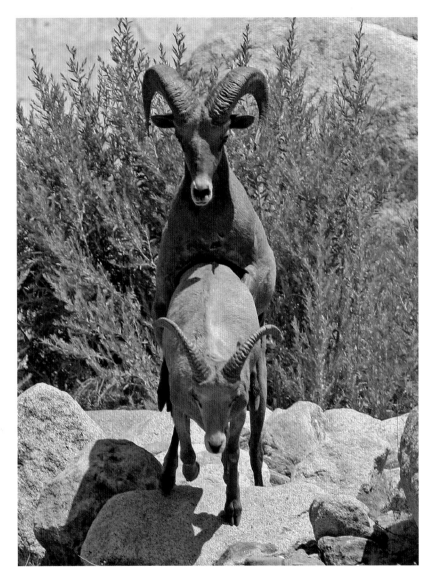

Above Left: A young ram hooves an elder ram in a behavior that will likely not end up in horn-to-horn combat. Rather than engage in combat, an elder ram may mount the smaller ram in an act of dominance.

Above Right: Putting a young ram into this submissive posture lets him know he's not ready for head butting and challenging his elders.

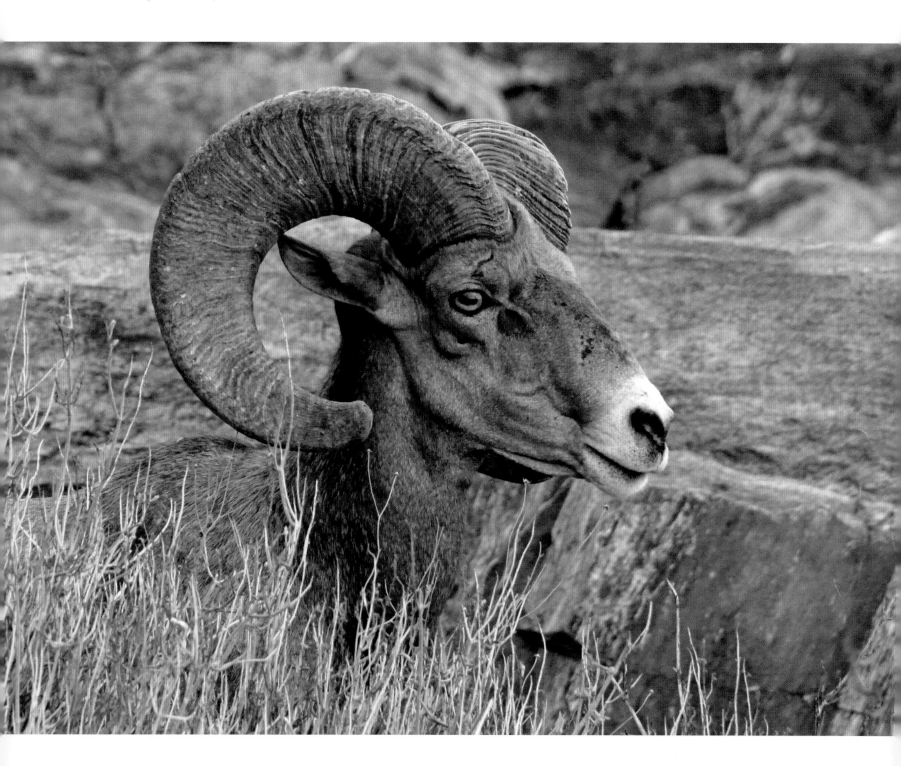

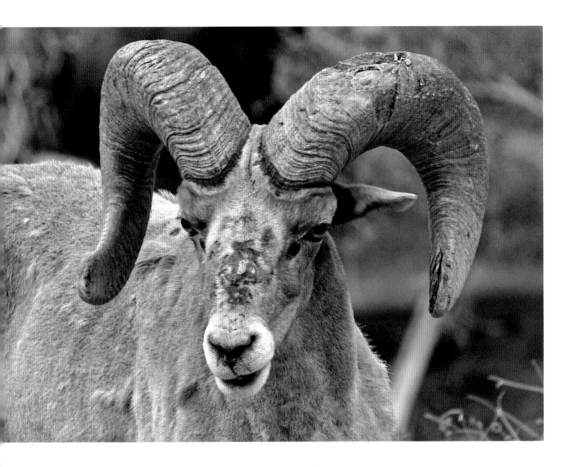

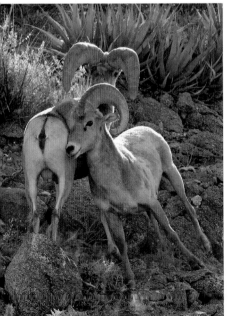

Opposite: Horn growth and size is a factor of nutrition and genetics. If a young ram finds excellent, high-quality forage early in life and does not get set back by disease, it stands a good chance of growing a huge set of horns, which it will carry throughout its life. Note the scarring on the bridge of the muzzle and the old wound above the right eye, likely signs of numerous dominance battles.

Above: The ram above shows years of battle scars and green horns from smashing barrel cactus and butting shrubs.

Left: In the presence of other rams there seems to be a constant need for pushing, shoving, horning, and one-upsmanship.

Hair and hide give way to soft horn, made up of keratin, but as the horn continues to emerge it hardens. The bony core of the skull supports the outer horn sheath of hardened keratin, the horns which remain with the animal its entire life. The small horn tips which emerged from the lamb's head at age two to three months, will become the pointed tips of the maturing ram, until such a time as the tips are broomed off, through rubbing, butting rocks, or during dominance battles.

Dominance among rams is maintained and reestablished as becomes necessary. The loud, crashing head battles of mating season still occur occasionally to bring challenging rams into line. A pecking order of males has been established. There is safety in numbers, as long as each ram knows his place in the ram band and respects his elders. As spring heats up and becomes summer, the bachelor bands and lone rams move back toward water sources, where they again come in contact with bands of ewes, yearlings, and newborn lambs. Hormones begin to rage once again as ewes come into estrus, rams break up their bands of males, and will spend most of their time and energy for the next few months in pursuit of continuing their genetic line.

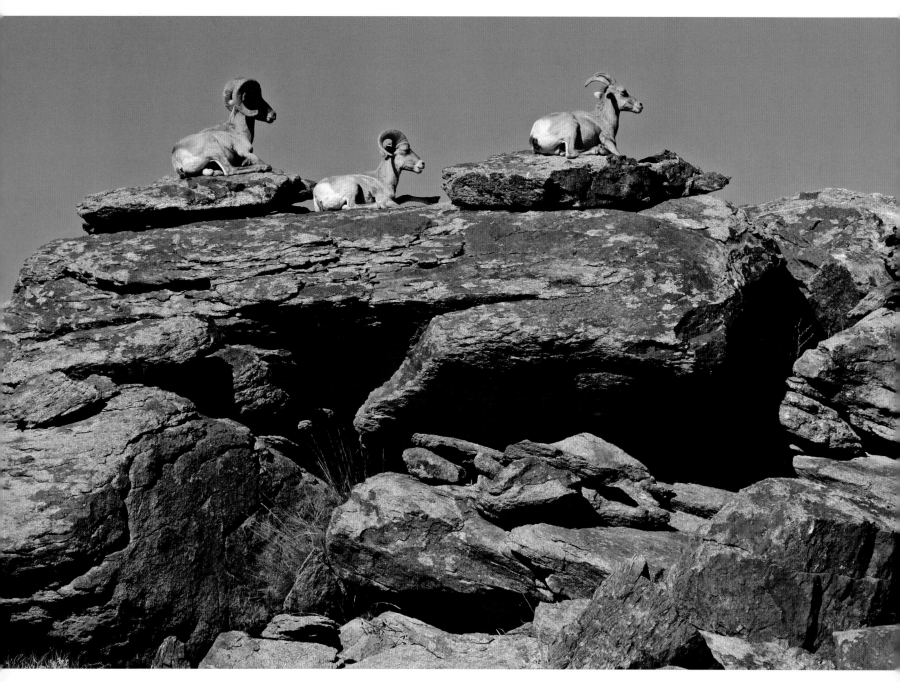

After several hours of the two rams pursuing this mature ewe, they all take a rest on a ridge top. The pursuit begins anew after a short rest and getting a good look around for danger.

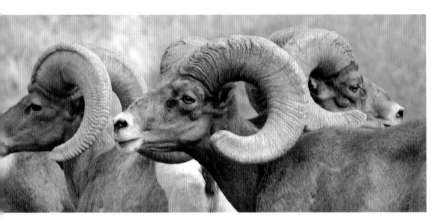

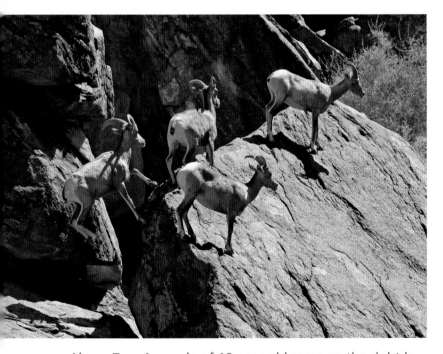

Above Top: **A couple of 10-year-old rams on the right in the company of a six-year-old ram. An annular horn ring coincides with the onset of rutting hormones, combined with the intense heat and poor nutrition of summer. Horn growth practically comes to a halt during the rut and is greatest during the abundance of springtime.**

Above: **Bighorn are able to leap vertically up to six feet or more, appearing to make such strides with little effort.**

Importance of Habitat Connectivity

While ewes have high fidelity to their home range, spending much of their life within a few miles of their birth place, rams tend to use their birth area as a home base for forays into surrounding areas for explorations to find suitable food, water, and females during the rut. Nearby mountain ranges are often separated by mountain passes, deep canyons, and open valleys. Open, unimpeded contiguous landscapes provide bighorn sheep the opportunity to move to alternate water sources in case a spring or guzzler in their primary home range goes dry. If large scale wildfire scorches the home range, the local subpopulation may need to move off to a nearby mountainous area for a period of months or years until their home area begins to recover. Heavy predation, severe drought, disease epizootics, human encroachment, or a lack of natural fire regimes may all be a trigger for bighorn movement. Access to these nearby habitats is essential to the long-term health of the bighorn subpopulations.

Wildlife management strategies require serious consideration of the needs of many species of animals in order to succeed in preserving the natural processes within the ecosystem. For desert bighorn sheep, planning for intermountain movements of desert sheep means keeping valleys and passes between bighorn subpopulations as free of fencing, canals, impassable freeways, housing projects, alternative energy projects, and grazing herds of domestic sheep and goats as possible. Efforts are made to mitigate fencing, canals, and roads with the use of overpasses and diversions to safe crossings. Development pressure for housing projects, golf courses, oil and gas development, construction of solar and wind turbine projects, and

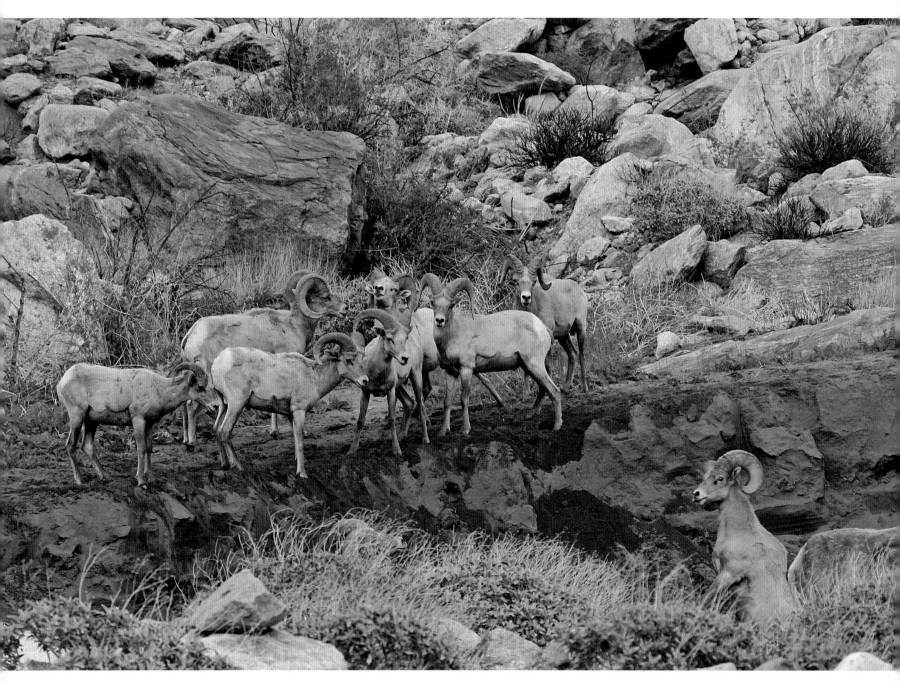

Ten rams of various ages jousting on a creek bank. The largest ram stands on his hind legs and challenges the ram in the wash bottom, hidden by the brittlebush.

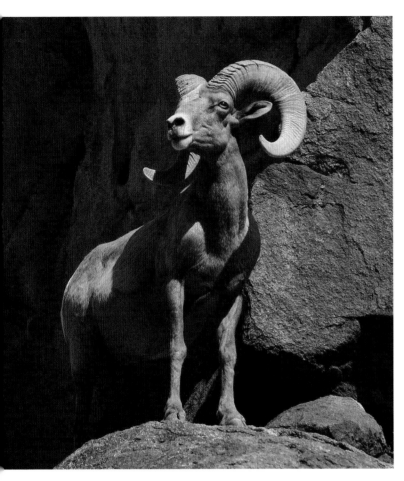

Above: **An old statuesque ram finds shade and safety among lofty cliffs. His eyesight is one of his first defenses against lurking coyotes and mountain lions. Some speculate the bighorn's eyesight may be as good as binoculars. We don't know that for sure, but we do know most of the time we find a bighorn it has already spotted us and is staring right at us.**

Above Right: A delicate balance faces us in today's world of development and alternative energy projects. Can we develop the West while maintaining quality wildlife habitat and movement corridors for animals to carry on as they have for thousands of years?

powerlines creates an ongoing balancing act between humans and sensitive species of wildlife such as the desert bighorn sheep.

Looking back over the last half of the 20th century, it has become clear that with more insight into the needs of wildlife, planning could have curtailed many of the human impacts on wildlife habitat and wildlife movement corridors. In today's world of wildlife management, expensive retrofitting of freeways, canals, bridges, and fences is making accommodations for wildlife with the need for intermountain movements, migrations, and habitat connectivity. Future projects will need to incorporate our important wildlife resources into the planning process by moving the projects out of vital wildlife movement areas, creating wildlife overpasses to allow for movement and migrations, and concentrating energy development on rooftops, or closer to the cities where the energy demand is greatest.

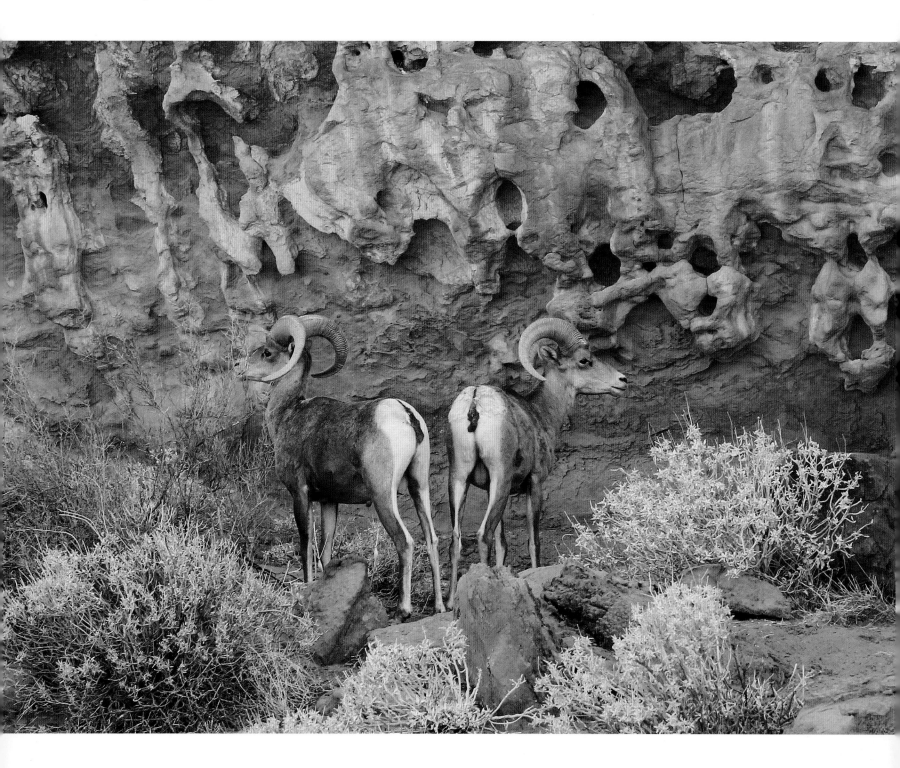

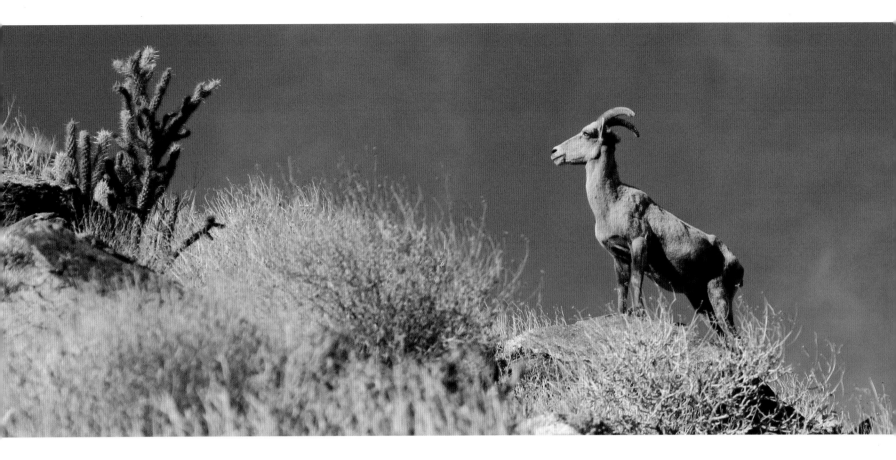

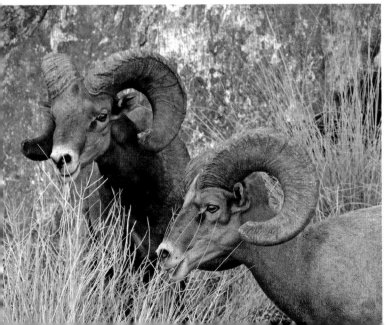

Opposite: A pair of two-and-a-half-year-old rams appear as bookends in the sandstone cliffs of their desert habitat.

Above: A mature ewe gazes around her domain searching for other sheep as well as potential danger. She lives in a desert wilderness where she can see for miles, smell the scent of danger, and hear the slightest rock fall from far away.

Left: A pair of massive rams may spend the winter and spring together, but become fierce opponents during the mating season when they'll vie for females and dominance.

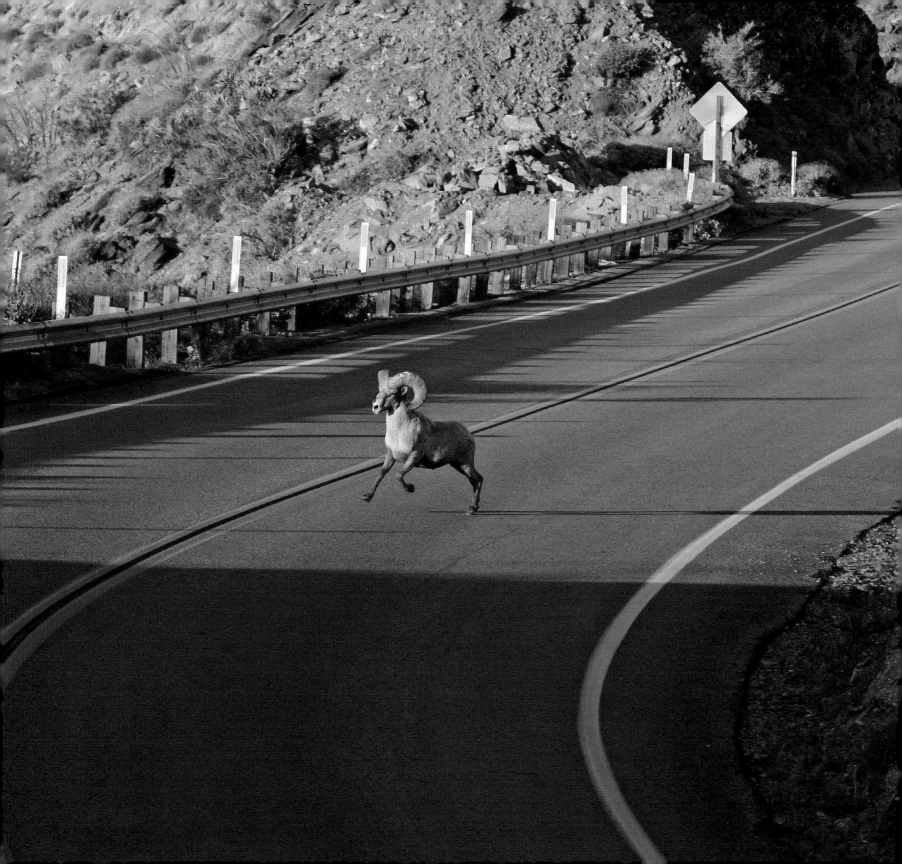

CHAPTER 5

Mortality and Threats to Bighorn Survival

If a bighorn lamb can make it through its first summer, chances of survival to a life span of eight to twelve years are good. Disease, poor forage, accidents, and predation face the lamb in its first few months of life, but when autumn arrives and the rigors of summer pass, the young bighorn has gained weight and endurance to meet the challenges of life. The lamb learns from the adults where to go for choice forage at various seasons, where to find water, how to be vigilant against predators, the level of wariness when encountering humans, and how to adapt to a life among the cliffs, cacti, rattlesnakes, and other bighorn.

Lamb mortality among desert bighorn populations averages around 60–75% in the first year. In thriving herds, lamb survival may be 50% or more for a year or two, and in declining herds a total loss of lambs can occur for one or more seasons.

Disease is a major culprit of lamb mortality, and in many cases the causes are never completely known, though disease agents may be discovered in blood sampling during a capture, or upon the necropsy of a recently deceased animal. Pneumonia is a common disease process which claims a number of lambs, but other challenges to the system may be precursors to the final pneumonic episode. Exposure to diseases passed from other bighorn may be the culprit, and diseases contracted from domestic sheep or goats, both viral and bacterial, can predispose desert bighorn to pneumonia. There are documented cases in which dozens, even hundreds of bighorn sheep have succumbed to diseases introduced to the herd by a single domestic sheep which had wandered away from its grazing flock. Documented cases of catastrophic bighorn losses due to livestock diseases have been recorded in

Opposite: **Habitat throughout desert bighorn sheep range has been fragmented by roads, canals, fences, and civilization. Efforts are now being made to create habitat connectivity and to reduce fatalities caused by vehicle collisions, drowning, and interaction with humans.**

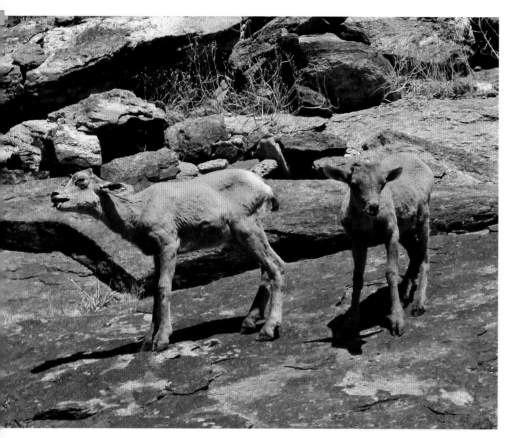

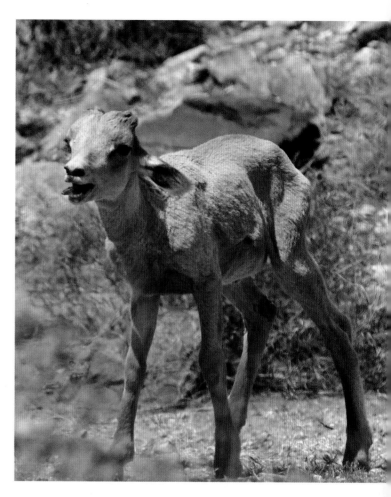

Above: In many desert bighorn populations lamb mortality can be higher than the average in some years, with survival only 10 to 20% by the end of their first summer. Note the poor condition of the sick lamb on the left and the healthy appearance of the one on the right.

Above Right: Sick lambs will exhibit drooping ears, open mouth, a runny nose and gaunt body. Respiratory diseases are common culprits in lamb mortality. Bacteria and viruses may weaken the lamb and it may die of complications from pneumonia.

Right: This young lamb was discovered dead in a canyon bottom not far from water. It appears to have died of disease since no obvious signs of predators were visible on its neck or throat. By the end of the day coyotes had scavenged it and within a few days only bones and hair will mark the site of its demise.

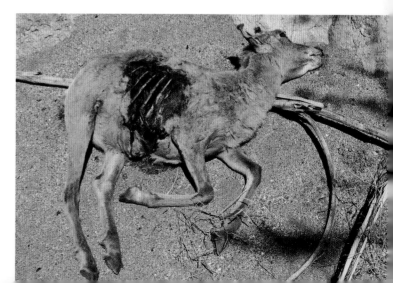

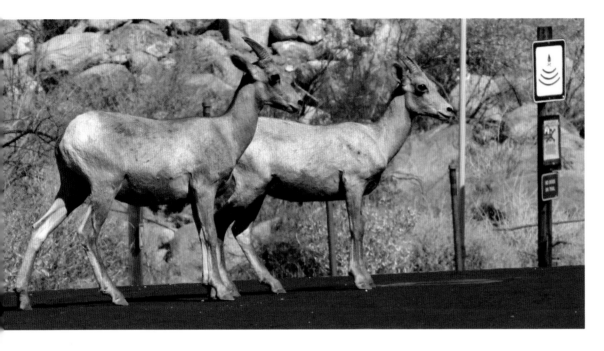

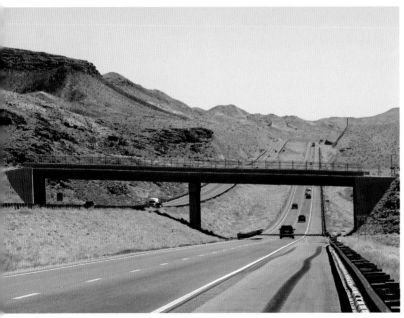

Above: **Desert bighorn often become accustomed to areas of human activity, such as golf courses, housing areas, and roadways, leading to increased mortality.**

Left: **The Arizona Game and Fish Department has been very successful with the construction of highway overpasses designed to allow bighorn and other wildlife to cross over highways and avoid vehicle collisions.**

Hell's Canyon of Idaho, in Lava Beds National Monument, and in the Old Dad/Marble Mountains complex of California.

Accidents, such as falls off cliffs, a slip into a narrow crevice, a broken leg, or rockslide have been recorded in the mortality reports of desert bighorn. Collisions with motor vehicles are common in some ranges, and as civilization expands, these events are becoming more common. One state highway in eastern Arizona has claimed the lives of scores of desert bighorn in a decade of record keeping. Recent improvements in western Arizona have shown excellent results in providing safe wildlife overpasses for desert bighorn, recording 170 bighorn crossings in a 20-month period between mountain ranges which had been bisected by the paved roadway. As humans have constructed homes adjacent to or within bighorn habitat, the incidence of drowning in pools, strangulation in fences, predation by dogs, vehicle accidents, and poisoning by toxic plants such as oleander have been increasingly reported.

Predation

The desert bighorn evolved from wild sheep which had migrated into the New World between 500,000 and a million years ago. Herds of pronghorn, deer, elk, horses, and camels thrived in the forests, marshes, and vast savannahs of the American West. Predators were diverse and common, represented by the dire wolf, gray wolf, bone-crushing dog, saber-tooth, American lion, cheetah, coyote, short-faced bear, and the mountain lion. Bighorn were served well by their adaptations for steep terrain, adept running, powerful musculature, and their powers of vigilant observation for predators of all types.

Today desert bighorn face a far shorter list of predators within the United States and Mexico. Chief among the predatory threats to bighorn are the mountain lion and coyote, with bobcat, golden eagle, and the jaguar rounding out the natural threats. Being gregarious, desert bighorn maximize their observation of surrounding habitat by having numerous sets of eyes remaining vigilant throughout the day and night. As a group of sheep graze and browse with their heads down, intent on consuming the choicest of forage, one or more sheep, often older ewes, will stand guard, peering out into the canyons and nearby slopes, ever watchful for danger or movement.

PHOTO COURTESY OF UC DAVIS, WILDLIFE HEALTH CENTER

Above Left: **Field observations and decades of research show coyotes mostly prey upon lambs, often those showing signs of injury or disease. Two or more coyotes have been known to team up in their pursuit of bighorn lambs.**

Left: **Mountain lions have been documented taking all age classes of desert bighorn—old, young, sick or healthy. Studies show a lion may feed on an adult bighorn for up to a week, before moving on to look for its next meal. Desert-dwelling cougars may have large home ranges, up to 400 square miles to meet their needs for food and finding mates.**

Eyesight, smell, and hearing are employed to give every indication of danger. Sudden movements of bighorn will trigger alarm in the group and a rush to steep terrain might be the first impulse of the group, at least until they can get to high ground, stop and turn back to check for danger. Did the sentinel sheep spot a predator? If not, it is back to feeding or resting, but always at the ready to flee to escape terrain if necessary.

Mountain lions are found in diverse habitats and freely move between forests, grasslands, chaparral, and desert canyons. The primary food source of mountain lions is mule deer and white-tailed deer, but their diets vary depending upon availability of prey species. As deer migrate to wintering habitat, lions will often follow. As deer numbers decline, the lion may switch to alternate prey species such as bighorn sheep, javelina, livestock, jackrabbits, skunks, and raccoons. Lions are secretive and are refined as stalkers and ambush specialists.

It is often said that predators take only the sick and the weak in a wildlife population, but studies of mountain lion food habits show they are opportunists and may take all age classes of deer and bighorn, as they become available to the lion. Certainly the sick and the weak will provide an easier opportunity, but so may a healthy ram or ewe discovered alone, intent on feeding or drinking.

Of the many bighorn mortalities I've had the occasion to investigate, one mountain lion kill of a mature ram provided an excellent example of the stalk-and-ambush tactic employed by the lion. The scavenged carcass of an exceptionally large ram was discovered in the bottom of a sandy wash, and as is common with lion kills, the intact entrails had been dragged a few yards away and hastily covered with sand and a rock. Drag marks led from the carcass to the base of a steep rocky slope. Blood and bighorn hair were found imbedded against a boulder at the base of the slope, and uphill from that was a path of broken bushes, shattered agave stalks, freshly churned dirt, and upended rocks. As we tracked uphill for 75 yards, we noted the downward path where the bighorn had tumbled, likely with the lion grasping its neck. We then came to the end of the torn earth to find a two-foot tall barrel cactus standing with its upper ribs bashed in and the inner pulp eaten out. Bighorn tracks and scat completely circled the large cactus, telling the story of the ram, focused on the inner pulp of the barrel cactus and feeding heavily with his head down among the cacti and shrubbery. The large bighorn had stood with his back and white rump skyward, eating his last meal before becoming quarry for a stealthy mountain lion.

Many studies of desert bighorn throughout their range reveal that in the 1990s and early 2000s the incidence of bighorn predation by mountain lions was increasingly reported, compared with research in the same areas in the 1960s and 1970s. Reasons are few but evidence is plentiful that the rate of lion predation on desert bighorn was no longer rare. In some studies, lion kills became the number one cause of adult bighorn mortality. In one study conducted by University of California, Davis, researchers in Anza-Borrego Desert State Park, the documentation of mountain lion kills on desert bighorn accounted for more than 60% of all known bighorn mortalities in a 10-year period. Similar scenarios played out in New Mexico, in the Kofa Mountains of Arizona, and in desert bighorn populations in Utah. In small populations of desert bighorn and Sierra Nevada bighorn, researchers feel that without direct reduction of lion numbers, the bighorn populations will not stand much of a chance of growing, or indeed in some instances, surviving.

Mountain lion removal by wildlife managers is deemed necessary in many states, but is controversial. In the case of New Mexico, an average of 2.5 lions are removed from bighorn habitat each year with the result being an increasing number of desert sheep today. The same rate of lion removal was practiced in the Sierra Nevada of California, where the endangered population of Sierra bighorn had plummeted to fewer than 100 animals. As a result of predator control and a proactive recovery plan, the Sierra bighorn numbers have quadrupled since implementation of both strategies.

In the Anza-Borrego situation, mountain lions were not selectively removed from the ranges, which allowed researchers to study what would occur in that scenario. One female lion and her two male cubs were documented taking more than 30 desert bighorn in a two-year period— they had apparently become bighorn specialists. At about two years of age, the cubs dispersed from their mother and shortly after she was found dead in the park, ironically of malnutrition. The bighorn population in Anza-Borrego Desert State Park rebounded from a low of about 200 animals in 1994 to almost 600 bighorn by 2013 with no lion removal.

Mountain lion control measures facilitate the recovery of depressed bighorn sheep populations in many areas. The challenges facing desert bighorn are many and complex: one solution does not resolve a suite of issues which may exist. I've often been challenged by folks throughout the West who claim to have one simple solution to the decline of bighorn sheep populations—"shoot all the lions—it's simple!" If only the solution to all the complexities facing the desert bighorn were so simple as one management action.

Observations of bobcats attacking bighorn have been made by reputable observers, some supported by photographs. It's thought that though bobcats are excellent predators of small mammals, birds, and reptiles, it is likely to be a rare event for a 20-pound bobcat to successfully take down and kill an adult bighorn sheep. One photo I saw taken by a helicopter crew studying desert bighorn showed an adult bobcat with its jaws locked onto the throat of an adult ewe, still standing and attempting to run. Bobcats have a greater chance of taking young lambs than they do going up against an adult bighorn. Another report documented a gray fox killing a young bighorn, probably a rare event.

Coyotes have been well documented killing bighorn lambs, especially near water sources. Two of the cases I have investigated involved lambs coming in for water near dense riparian thickets. One was observed by sheep counters at a summer waterhole survey. The band of sheep approached the small desert stream, when suddenly a coyote attacked, scattering them up the hillside. Lagging behind, coughing and unable to keep up, was the lamb. The coyote gave chase and as the lamb returned to the hillside and entered a gully, another coyote emerged from the gully to make the kill. The second lamb kill was not witnessed but was found moments after it was killed by a coyote. Necropsies revealed both lambs were weakened by severe pneumonia and likely could not run and keep up with the bighorn they had traveled to water with. After taking both lambs, about a week apart, to a veterinary lab for necropsy, they were returned to the kill sites for the coyotes to finish their hard-won meals.

Golden eagles have been observed preying upon desert bighorn on several occasions. One case in

the Pinacate Mountains of Sonora was well documented in the early 20th century by the Hornaday Expedition, collecting bighorn for museum specimens. A pair of golden eagles worked together to attack a yearling bighorn, reportedly attacking the back, above the kidneys, three to four times each. An angled attack by one of the eagles eventually knocked the bighorn off its rocky perch and it fell into a narrow ravine, where the eagles immediately began to feed on the carcass. The scientific literature does not reveal a large number of eagle kills of desert bighorn, but several similar incidents that show eagles can and do take sheep upon occasion.

Loss of Habitat

Loss of habitat, due to human expansion, coupled with diseases introduced in the 19th and 20th centuries by domestic livestock, have reduced bighorn populations more than any other factors. Bighorn ranges have been fragmented by freeways and rural roads, powerlines, fences, railroads, canals, aqueducts, cities, housing tracts, and grazing allotments. Desert water sources have been usurped by miners, ranchers, farmers, homesteaders, homes, towns, campgrounds, golf courses, and the introduction of exotic plants such as the invasive tamarisk tree.

Right: **Desert bighorn habitat is under intense pressure by human development. Highways, cities, canals, golf courses, wind turbines, solar farms, and power lines fragment bighorn habitat and reduce their chance for survival.**

Up to 75 desert bighorn sheep frequent a municipal park near Boulder City, Nevada. The bighorn have become a tourist and local attraction while they feed on the manicured and fertilized lawn. The high density of bighorn, coupled with the moist lawn and non-native landscaping pose a potential hazard to the bighorn herd. Diseases can readily spread from one animal to another when they are in such dense groups, and moist lawns can harbor parasites which cannot persist out in the dry desert. It remains to be seen whether the local park environment is suitable bighorn habitat. The sight of desert bighorn just yards from a picnic table has created a following of people who do not want to see the sheep excluded from the recreational area.

Development threatens the wide open spaces of the Southwest. Power corridors, wind turbines, highways, cities, and solar farms are frequently constructed with little to no consideration for the needs of our native wildlife. Serious habitat protection needs to be considered when projects are planned for wild places.

The wide-open West, once welcoming to metapopulations of bighorn for a few hundred thousand years, has been fragmented into hundreds of isolated mountain masses—some still connected to others while some have become islands, surrounded by humanity and the trappings of civilization. Long-term health of bighorn populations is enhanced by connectivity to multiple mountain ranges rather than being isolated onto an island range. Management strategies to benefit bighorn sheep today involve maintaining large tracts of lands for protection from development, coupled with the re-opening of movement corridors. Fence removal, construction of wildlife overpasses, water development, tamarisk tree eradication, and retirement of livestock grazing are strategies employed to reestablish open movement corridors for bighorn.

The introduction of non-native plants such as the highly invasive tamarisk tree from Eurasia has heavily impacted native water sources in all the western states. Millions of acres of tamarisk trees have choked water courses and canyon bottoms, effectively usurping surface waters and crowding canyons with dense thickets, impassable to desert bighorn. Rivers such as the Colorado, San Juan, Green, Gila, Salt, and Rio Grande are lined with tamarisk.

Tamarisk threaten desert water sources needed for wildlife by taking over native plant communities and outcompeting most native species.

Poisonous plants, such as the oleanders pictured above, are one of many hazards present when civilization encroaches on desert bighorn habitat. A single oleander leaf ingested by a bighorn sheep can cause death.

Tamarisk excludes scores of native plant species by outcompeting them for water, nutrients, and space. Tamarisk opportunistically germinates after fires, floods, and other disturbances in riparian areas of the West. It germinates rapidly, with each tree producing thousands of viable seeds, and the ability to grow as much as 14 feet in a single year. Bio-control, the use of natural pests which feed on the bark, flowers, or foliage of a target plant such as tamarisk, is being used to begin control of the invasive non-native. A beetle which feeds heavily on tamarisk leaves, a native of Eurasia and one that is species-specific to the genus *Tamarix*, has been released in Moab, Utah, and Big Bend National Park in Texas. After a few years of bio-control, the early results show control on tamarisk trees

along miles of river course. Programs by land managers aimed at direct tamarisk eradication have also shown amazing results.

One such program by California State Parks in the Colorado Desert District of southern California has effectively removed tamarisk from more than 180 miles of water courses in a three-decade effort. The results are that bighorn, mule deer, and numerous species of migratory birds, small mammals, and reptiles have once again had access to water and a diversity of native plant communities.

Disease

The introduction of domestic livestock diseases into the American West may be the most devastating impact humans have had on bighorn sheep. The native bighorn, separated from Old World sheep and goats for hundreds of thousands of years, have little resistance to the many parasites, viruses, and bacteria brought into their habitat with domestic herds beginning in the 18th century. Domestic livestock, bred throughout Eurasia for centuries, carried antibodies to many of the disease challenges their breeds had been exposed to—they either survived the diseases or perished, and through the generations most were well adapted to the diseases of the Old World. The native bighorn likely had developed their own defenses against the diseases of their New World. However, when faced with psoroptic scabies mites, Pasteurella (now known as Mannheimia) bacterium, mycoplasma bacterium, parainfluenza-3, blue tongue, and contagious ecthyma, untold numbers of bighorn perished.

The pressures of diseases and of grazing competition by cattle, feral burros and horses, domestic sheep, and goats continue to face bighorn and wildlife managers to this day. Segregation of domestic grazing and bighorn sheep

Native bighorn sheep have little or no resistance to a multitude of diseases carried by domestic sheep and goats, posing a threat to the future welfare of wild bighorn herds throughout the West.

habitat is essential to secure the future for healthy wildlife populations in the west. Policies call for separation of domestic sheep and bighorn on public lands today, but the advisory of a nine-mile buffer doesn't protect bighorn from the movements of domestics being herded between grazing areas and market or from seasonal shifts of grazing areas— and it only takes one animal coming in contact with the wild cousins to have profound negative impacts.

Government agencies are increasingly being influenced by politics to delay strict enforcement of grazing restrictions. Influential ranchers have lobbied for jobs versus protection of wildlife. Lack of segregation of wild bighorn from domestic sheep and goats continues to plague the wild populations throughout the West.

In 2013 the worst disease outbreak in modern California history struck wild desert bighorn populations in the Old Dad and Marble Mountains of the Mojave Desert. Reports of approximately 30 dead or sick bighorn being discovered gave cause for alarm and intense investigations by researchers from state and federal agencies. Several newspaper accounts set the toll at over 100 dead bighorn. Investigations found suspicion in the Marl Mountains where a hunter discovered a domestic goat running in desert bighorn habitat and shot the feral animal. Months later, a national park technician found several dead bighorn rams adjacent to a water source. Further searches recovered several dead bighorn from two more water sources nearby in the Old Dad Mountains. Field work documented many more animals, still alive, with symptoms of respiratory disease. The total number of desert bighorn dying in this epizootic is unknown but reports are that scores of bighorn possibly succumbed to disease.

The California Department of Fish and Wildlife embarked on an intensive aerial survey and found 126 individual bighorn in nine geographic areas of the region, observing 32 bighorn in what they classified as "compromised" condition, exhibiting nasal exudates, poor body condition, and inability to run when observed from a helicopter. Of further concern for researchers was the subsequent discovery of four dead domestic sheep in bighorn habitat, adjacent to an interstate freeway exit ramp. Near the four carcasses were sheep tracks and scat piles, leading biologists to surmise that there were possibly more domestic sheep which were put out of a transport vehicle which were not dead, and could have wandered into the adjacent ranges to infect desert bighorn.

Interaction with Humans

Humans have been hunters of bighorn for thousands of years, so there is a natural fear of humanity based in the genetic makeup of desert sheep. Yet behaviors change over time, and from one band of bighorn to another, depending upon human activities and the reactions of elder sheep, especially ewes. In non-hunted populations of bighorn the sight of a human may no longer signal danger, as it had for millennia.

Humans conducting recreational activities such as hiking and horseback riding, especially on designated and predictable trails, show little effect on some sheep herds, while in other herds the bighorn have abandoned the areas adjacent to popular trails. Desert bighorn in a canyon of the Sierra de la Giganta of Baja California may show a dramatic reaction to the sight of a human in the arroyo 200 yards away, while a band of sheep along the Colorado River in the Grand Canyon may show little interest in a raft full of boaters taking photographs from 50 yards. Past interactions with humans dictate how the bighorn may react—in one case poaching for food and trophies is common, while in the other case, the bighorn are a novel attraction and part of the Grand Canyon experience.

Desert bighorn sheep need ample wilderness quality habitat to maintain healthy populations over many generations. Examples of bighorn becoming acclimated to close proximity of humans often do not fare well in the long term. Bands of bighorn became accustomed to visiting golf courses along the base of the Santa Rosa Mountains south of Palm Springs. Residents became enamored of "their" bighorn visiting lawns, drinking from swimming pools, and walking their streets during summer. Studies by the Bighorn Institute, however, showed that civilization did not suit the bighorn well. Within a decade, the number of mortalities

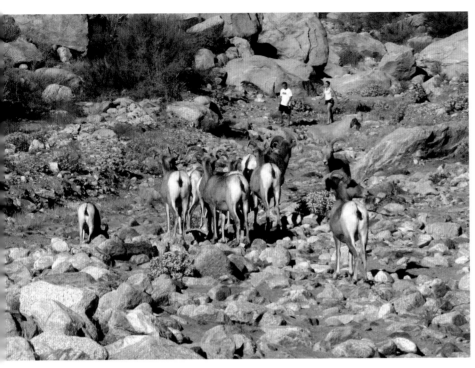

Desert bighorn are a wilderness animal by nature but have had to adjust to the presence of humans in their environment. If human activity is too loud, dense, unpredictable or threatening the sheep may abandon that portion of their habitat. If the human behavior is low profile, non-threatening, and somewhat predictable, the bighorn may become acclimated and tolerant to some extent.

increased to seven killed by vehicles, six by oleander poisoning, and one by strangulation on a garden fence. In addition one dead animal was found to have a heavy load of strongyle parasites, present in the moist lawns of the country club. Predation by coyotes and dogs also was noted to have increased in the close proximity of homes and dense shrubbery. Ultimately a chain-link fence was constructed along several miles of mountain front to keep the bighorn in their native habitat, and away from the enticement of lawns and blue pools during the heat of summer.

A popular community park in Boulder City, Nevada, is frequented by up to 70 desert bighorn from the River Mountains, one of the most populous bighorn populations anywhere. Political pressures call for the interface of the mountain range and picnic area to remain open to the sheep, for the enjoyment of the many visitors attracted to see desert wildlife. It remains to be seen if the use of this grassy park will be in the best interest of the wild bighorn. The concentration of animals on the exotic grassy park will increase the likelihood of disease transmission, parasite proliferation, and the possibility of ingestion of toxic plants.

Vehicular activities in bighorn habitat have been shown to impact the watering habits of desert bighorn. At Middle Willows in the Anza-Borrego Desert State Park, a summer

This seven-year-old ram visits a water source, built to conserve a rare species of desert pupfish. The ram appears to be reading an interpretive sign which begins, "Humans Care."

study at a water source frequented by about 40 desert sheep documented that bighorn use of the water source declined with the presence of even a single motorcycle or four wheel-drive vehicle on a day when ewes were bringing their lambs to water. Weekdays, with no traffic, showed a high frequency of bighorn use, while weekends with vehicles showed a marked decline in sheep use.

Recreational activities within bighorn habitat have varying degrees of impact on the native sheep. Water sources and lambing areas are the most vulnerable to human influences. Construction of recreational trails without thorough consideration of the needs of wildlife present conflict between advocates of outdoor recreation and wildlife. Numerous trails have been built in inappropriate areas of the West.

Outside of Palm Springs and Palm Desert, California, and in the hills above Tucson, Arizona, public meetings rise to the level of shouting and accusation. In the case of the Catalina Mountains on the margin of the city of Tucson, the population of bighorn on Pusch Ridge declined to zero during a frantic increase in trail activities including mountain biking, hiking, horseback riding, running dogs off leash, and finally the development of a housing project. Despite the promises of expert consultants who claimed the housing development restrictions would provide a model compromise for human-bighorn interaction, the sheep herd was extirpated. The lesson learned here is that if we are to error in our developments and actions, we should error on the side of the desert bighorn.

Many public hearings pit the financial benefits of a golf course and housing project against the livelihood of a few bighorn "up on the mountainside." As wild sheep expert Valerius Geist so aptly stated in his 1971 book, *Mountain Sheep*, "Their future depends less on their adaptations than upon the goodwill of man."

Poaching, once common in the United States for subsistence and illicit trophies, has been widely curtailed through public awareness, law enforcement, hefty fines, and jail time. Many states call for a loss of hunting privileges across several cooperating states upon conviction of wildlife poaching. Poaching remains a prevalent problem in several areas of Mexico, especially Baja California. Though hunting is regulated and based on scientific field surveys, the incidence of illegal hunting for food and trophies is still common. I recently spoke with a friend who had been on the phone with an acquaintance in Baja California Sur, who mentioned he was in the middle of eating a bighorn steak, though at the time there was a moratorium on bighorn hunting.

One strategy which may curtail rampant poaching in Baja California and elsewhere in Mexico is the captive breeding of desert sheep and the replenishment of excess animals back into their native habitats. A large-scale breeding operation was instituted on the private island refuge of Isla Carmen in the Gulf of California, just south of Loreto. Bighorn were captured on the Baja Peninsula from Sierra de la Giganta and other nearby ranges

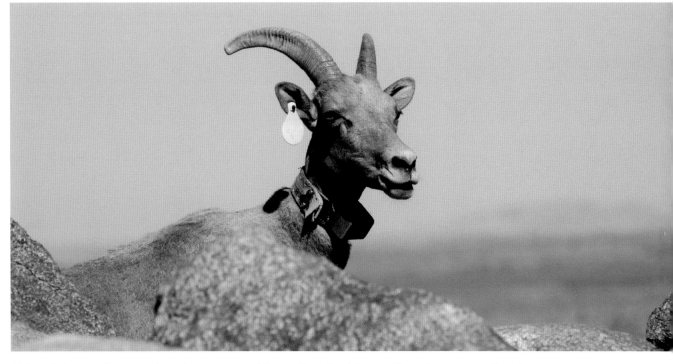

This adult ewe has a colored ear tag and is outfitted with a radio telemetry collar that employs GPS and satellite technology. The collar will transmit for up to five years and has its own unique radio frequency. It will switch to mortality mode if it detects no movement for more than four hours.

and placed in the protective refuge on the island. Within a few years several hundred bighorn called Isla Carmen home, and the next phase of the plan is to transplant excess bighorn back to the peninsula, to be carefully managed with oversight of the ejidos, or local villages. It is the goal that with local stewardship, and the revenues of future hunting programs being shared with the ejidos, local residents will care for the wildlife resources and assure the future of desert bighorn in Baja California.

Native wildlife is a precious resource which many citizens of the western states and Mexico feel ownership of and an investment in. Thousands of tourists, citizen scientists, and hunters have viewed bighorn sheep in parks and natural areas throughout the West, and many have participated in wildlife surveys, bighorn sheep counts, and regulated hunting programs. These citizens become educated about wildlife and spread their passion and knowledge to their families, friends, and coworkers. They become wildlife advocates, ready to defend wildlife and wildlands. Land managers and law enforcement agencies throughout the United States and Mexico depend upon the citizens to be out in the environment, safeguarding the habitat and the wildlife, and working together to enforce protective laws.

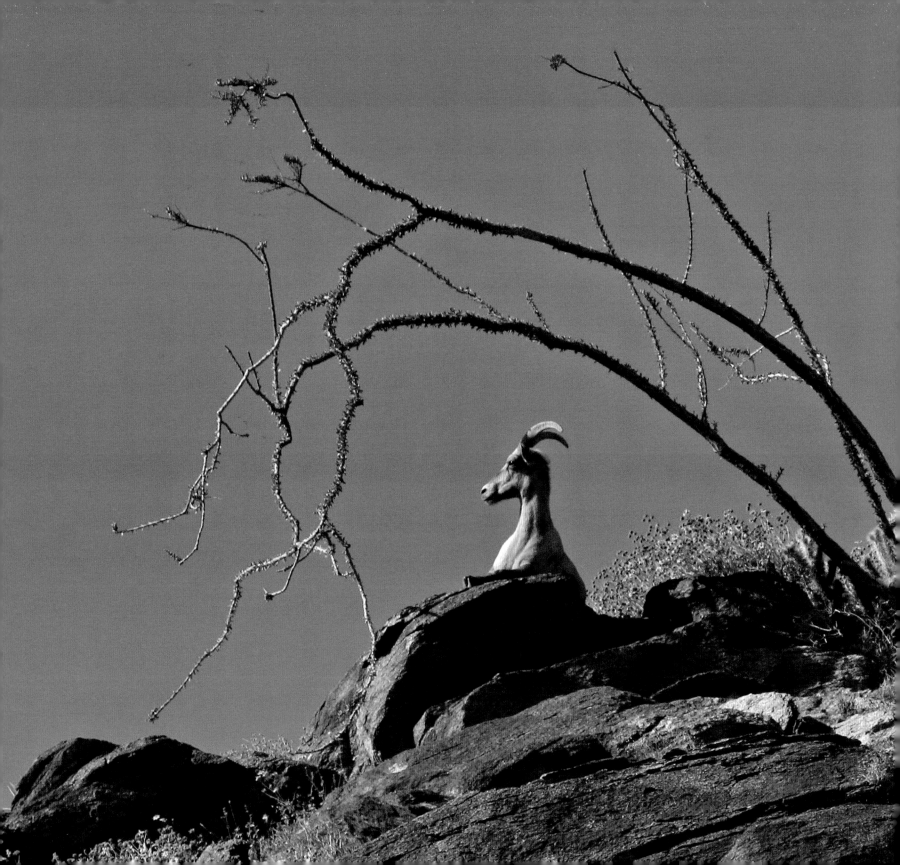

6 | *Hope for the Future— Maneuvering the Modern West*

CHAPTER

Populations of bighorn sheep in the western states and Mexico in the early 1800s have been estimated at about one million animals. Though no reliable research existed on which to make such estimates, it is widely accepted that there were at least several hundred thousand bighorn sheep in North America. Those widespread sheep populations were connected by rugged, interlaced mountain ranges, ridgelines, and open valleys. Bighorn herds were woven together in what ecologists term "metapopulations." What once were thought to be separate subpopulations, scientists now know many of these isolated herds are connected by seasonal or episodic movements of rams and ewes between mountain ranges. Ewe movements are often made between lambing areas and summer watering sites. Female seasonal movements are well documented up to 15 miles. Ram movements are usually tied to searching for females during

mating season, and may involve moves of up to 75 miles between a series of ranges.

Today, estimates for desert bighorn sheep populations in the wild show about 31,000 in North America. An additional 3,000 to 4,000 desert bighorn are being raised behind fences, mostly in Mexico, to bolster the wild populations.

The vigor of metapopulations of desert sheep is maintained over time by intermountain movements, providing genetic diversity and replenishment of animals throughout the region. Severe droughts, large-scale wildfires, disease outbreaks, high levels of predation, and prehistoric human hunting pressure may have pushed isolated sheep populations to low levels or even extirpation. If connections to adjacent ranges within the metapopulation remained unimpaired, bighorn movements would be maintained to provide resilience to local extirpations. Over time in the

Opposite: **A ewe rests on a granite boulder beneath an archway of ocotillo, gazing upon her vast home range.**

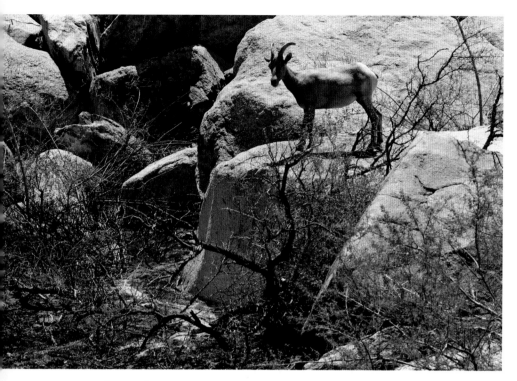

A desert bighorn ewe surveys changes in her habitat after a wildfire. Bighorn rarely succumb to fires and will return within a day or two to feed on emerging green shoots. Fire tends to open up dense vegetation, making the upper limits of bighorn habitat more suitable to bighorn.

19th and 20th centuries many metapopulations in the West became fragmented by railroads, interstate highways, irrigation canals, fences, and urbanization. Isolated mountain ranges became "islands" where severe drought, disease, or widespread fire could spell doom to the local bighorn herd. Today it is recognized that weaving isolated mountain ranges back together is a key to future wildlife management in North America. Reducing fences, canals, barricaded freeways, and other factors of habitat fragmentation allows for long distance wildlife movements and continued connectivity.

Domestic livestock introduced to the basins and ranges of the West brought diseases to native wildlife which proved devastating to bighorn sheep. Domestic sheep, goats, and cattle are capable of carrying highly contagious bacteria and viruses to which domestic stock have built immunity over centuries of exposure. When these disease agents were introduced to wild sheep by nose-to-nose contact, through water sources, or by soil contamination, the results often proved fatal to the native sheep. It is thought by many bighorn researchers that the single most devastating impact to native bighorn populations was the introduction of domestic livestock diseases. This syndrome is quite similar to the introduction of European diseases by explorers and settlers to aboriginal Americans. Today, perhaps less than 5% of the original populations of desert bighorn sheep remain in the wilds of North America.

Bighorn Conservation, Management, and Hunting

The management of desert bighorn sheep herds in the western states and Mexico has made great strides since the 1960 and 1970s. Scientific research, the use of technology such as telemetry and GPS collars, huge efforts by volunteer organizations and non-profit groups, coupled with responsible hunting programs, have resulted in a strong rebound in desert bighorn populations in several western states as well as in northern Mexico. Recognition of the metapopulation concept of habitat management has drawn attention to maintaining the interconnected corridors of mountain ranges to benefit wildlife.

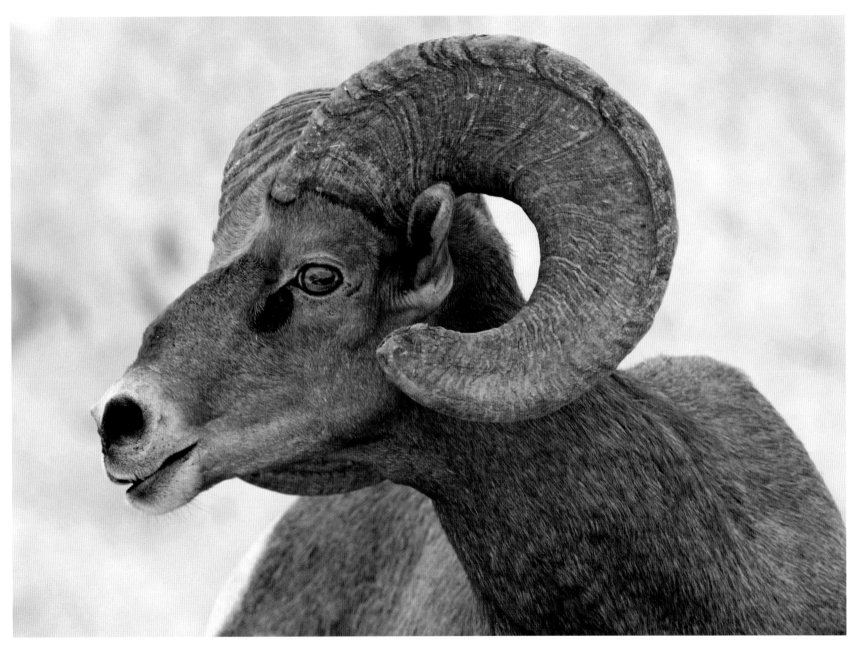

A large, 10-year-old ram such as this would be highly sought after by photographers and hunters alike. Hunters have long supported conservation and recovery of bighorn sheep throughout North America and Mexico. Well-regulated hunting programs in seven Southwest states of the U.S. and several Mexican states have provided millions of dollars in revenue for now-thriving desert bighorn populations.

Bighorn populations fluctuate and not all population declines and increases can be fully explained by researchers and land managers, but overall awareness of the habitat needs of desert bighorn and implementation of land management strategies has benefitted bighorn populations. Funding for research, habitat improvements, bighorn transplants and restoration, and land conservation come largely from state fish and game departments, land management agencies, and private wildlife conservation and sportsmen's organizations. Well-managed hunting programs in each of the western states and several states in Mexico bring large amounts of funding and support into desert bighorn management and conservation.

To date, more than $25 million has been raised through the auction of desert bighorn hunting tags. At the 2013 Wild Sheep Foundation convention, $3.19 million was raised through sheep permit sales and auctions. Most of this funding is turned back into bighorn management programs in the western states. Hunting quotas are set by diligent population surveys coupled with a formula for designating the maximum number of rams to be taken from a given population. Breeding is often accomplished by the dominant rams, which are capable of mating with multiple females during the rut season. Regulated hunting programs have been conducted in the western states quite successfully for decades without negative impacts on the overall population. In fact, the programs are responsible for a great deal of success for bighorn management, habitat enhancement, surveys, and transplants. To date, more than 20,000 desert and Rocky Mountain bighorn have been transplanted to reestablish or enhance populations in Canada, the United States, and Mexico.

Restoration of Bighorn Populations

Desert bighorn have been restored to many sites throughout their historic range in the United States and in Mexico. The bighorn populations of Texas, Chihuahua, Coahuila, and Nuevo Leon were extirpated, but through transplants from other states, and aggressive restoration plans, desert bighorn once again range through large areas of prime habitat. Sheep have also been restored in New Mexico through the efforts of the U.S. Fish and Wildlife Service and the New Mexico Department of Game and Fish and their captive breeding program at Red Rock, New Mexico. In California, the first captive breeding facility was established by James DeForge in 1982 at the Bighorn Institute in Palm Desert, California. The Institute has been responsible for the release of more than 120 captive-bred desert bighorn sheep into the wild near Palm Springs

All the western states which are home to desert bighorn sheep have cooperated in the movement of sheep from mountain ranges with abundant, thriving herds into those with low numbers of bighorn. Many ranges which experienced local extirpation have been restored through the transplantation of bighorn sheep, usually from a range nearby or one possessing genetic stock close to those thought to have once inhabited the region.

One notable area which has provided large numbers of transplant stock is the River Mountains of Nevada, near Lake Mead. Hundreds of desert sheep have been captured over recent decades in this mountain range using baited net traps. Bighorn are habituated to fermented apple mash delivered to remote desert canyons. The bighorn appear to become "addicted" to the sweet mash and once that occurs, equipment is delivered to the site, in the form of poles and piles of nets. As time goes by the poles are

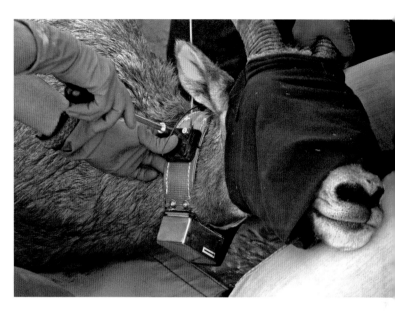

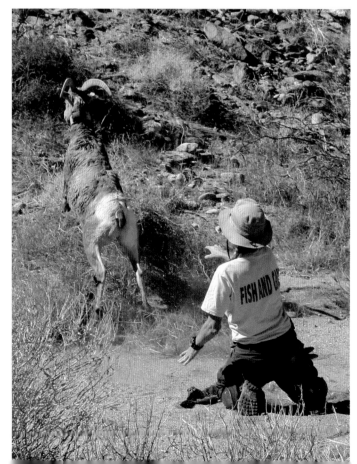

Above Left and Center: Bighorn are captured by a helicopter employing a net fired from a hand-held netgun. The selected animal is gently pushed to a safe capture location where it is netted. Biologists secure the bighorn, calm them with blindfolds, and place them in bags for transport back to a base camp.

Above Right: Trained veterinarians and biologists assess the bighorn's health status, draw blood for disease analyses, and secure a radio or GPS collar, along with ear tags. The animals are not drugged, but are blindfolded to keep them calm.

Right: After a 20-minute health check-up and sporting a new radio collar and ear tag, the bighorn's blindfold is slowly taken off, its eyes adjust to the sunlight, and is safely released. Bighorn most often return to the site of their capture within a few hours, and have quite a story to tell their herdmates.

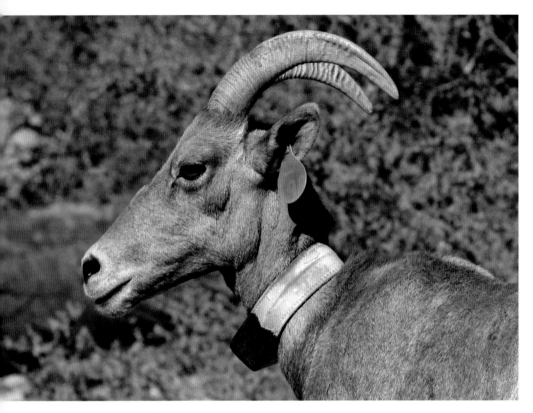

This mature ewe carries a radio collar and distinctive ear tag. She will be the only one in her range to have a yellow and black collar and blue tag in her left ear. Researchers will monitor this ewe as long as her collar transmits, which may be five years, or until her death.

Bighorn are often moved in horse trailers, some named "ewe-hauls," to their new homes, sometimes in a far-off state. Such transplants have been a huge success in many cases, and in the example of the states of Texas, Coahuila, Chihuahua, and Nuevo Leon, are responsible for bighorn being present in the state once again.

Status of Desert Bighorn Sheep Populations in North America

Arizona

The 2013 estimated population was 5,000 desert bighorn. In recent years it has been reported that desert bighorn sheep populations have stabilized. The sheep population in the Kofa Mountains of southwest Arizona stabilized at about 400 bighorn after a dramatic decrease from its previous estimate of 800. The Arizona Game and Fish Department successfully transplanted 1,941 bighorn as of 2011. In 2011, 8,315 hunters applied for 99 tags. Hunters had a success rate of 98%. In 2009 three auction tags brought in revenues of $312,000 for bighorn management programs. In 2010 and 2011 these tags brought $311,075 and $309,550 to the Arizona bighorn management program. In 2013, 107 tags were sold for desert bighorn hunts.

Arizona has made great progress on reestablishing bighorn movement corridors across highways with its construction of three wildlife overpasses on State Highway 93, east of Hoover Dam. Sheep began using the landscaped overpasses soon after construction was completed, and

erected and later the nets. The sheep run down slopes when they see the truck arrive with buckets of apple pulp and soon the trap is set. Capture crews hide among the rocks and shrubs awaiting the net drop on the herd, and when the time comes, the net falls on as many as 30 bighorn. Planned chaos ensues. Biologists, veterinarians, and trained volunteers secure the animals in the nets, affix blindfolds to calm the sheep, tie hobbles to restrain them, and then begin processing the animals for medical testing and transport to their destination.

the project has become a model for other western states. Data show 1,657 sheep crossings in a 22-month period on the newly constructed wildlife overpasses, with only 25 sheep crossings in a 20-month period at undercrossings. Bighorn feel safer remaining *above* danger, rather than crossing *below* it.

California

The 2010 estimate of 5,200 desert bighorn is an increase of more than 700 animals from the 2003 estimate. The California Department of Fish and Wildlife continues to conduct the capture and radio/GPS collaring of bighorn from many of its statewide populations, coupled with field research on the ground and aerial monitoring of telemetered animals. Populations of bighorn in California have been increasing since the late 1990s, despite the increase of the human population throughout the state. Several desert bighorn populations have been documented as expanding into historic habitat, establishing new subpopulations, which is encouraging and bodes well for future expansions. The bighorn of the Peninsular Ranges in Riverside and San Diego counties rebounded from a low of 280 bighorn in 1996 to about 950 in 2012.

Alternative energy projects including solar panel fields and wind turbine farms have been proposed on public lands throughout the California desert, posing challenges to the integrity of bighorn habitat and movement corridors in many areas.

The California Department of Fish and Wildlife, along with its partners in the public and private sector, including many volunteers, is to be credited with maintaining a high level of success in light of declining state budget and allocations to wildlife management.

In 2010 revenues were $8,000 for 22 draw tags and $190,000 for the fundraiser tag. Since the inception of legal bighorn hunting in 1987, total revenues for bighorn management through 2010 have been $2.7 million.

The Bighorn Institute, a private, nonprofit organization located in Palm Desert, California, was established in 1982 by James DeForge. The Institute rescued and nurtured the first captive bighorn sheep destined for release back into the wild in California. Prior to this the stance in the state of California was a hands-off approach to captive breeding or rescue and release into the wild. Several locations held bighorn for public viewing in zoos and living museums, but the Bighorn Institute broke ground in the captive breeding of bighorn, as well as the capture of sick bighorn, giving veterinary care, and releasing the revived bighorn back into native habitat. The Institute has released more than 125 desert bighorn back into the wilds in the Santa Rosa and San Jacinto mountains of California since 1985. The fact that there as many desert bighorn existing in the northern Santa Rosa and San Jacinto mountains today is a testament to the dedication of James DeForge and his team at the Bighorn Institute. The Institute performed much of the early landmark work in disease detection and therapy in desert bighorn, under authority and permits issued by the California Department of Fish and Wildlife and the U.S. Fish and Wildlife Service.

Colorado

The 2010 estimate is 425 desert bighorn in four herd units. Bighorn numbers are stable in two herd units on Black Ridge and Uncompahgre, though lamb recruitment has been low three years in a row in the Uncompahgre. Sheep in the Middle Dolores and Upper Dolores regions

show extensive movement between the two units and have made a comeback after a large decline around 2000. Estimates here in the late 1990s were around 200 bighorn, but in 2000 only 24 could be documented. This number has risen to about 74 as of 2011. Transplants have been conducted within the Dolores region. Six hunting tags were issued in 2009. Domestic sheep and goats within bighorn habitat are a concern in some areas.

Nevada

The current estimate is 6,600 desert bighorn in 41 ranges within Nevada. In 2011, surveys tallied 3,665 bighorn, while in 2012 that increased to 4,015. In 2008, 173 hunting tags were issued in Nevada with hunter success of 88%, increasing to 281 hunting permits in 2012 with a hunter success of 86%. Nevada transplanted 181 desert bighorn in 2011 to augment five herds and one new subpopulation in historic range. Notable in the state is the documentation of a GPS collared five-year-old ram, which in several months traveled from the River Mountains near Lake Mead, to Utah, then to northern Arizona, where he was found dead. It is estimated this young ram covered approximately 250 miles of desert terrain in three states before his death.

New Mexico

In 1979, the statewide estimate for bighorn sheep was 50. As of 2012, the estimated number of desert bighorn was 750 animals. New Mexico began transplants in 1979 using the captive breeding facility at Red Rock. In addition to the captive herd providing animals, transplant stock was also received into the state from captures in Arizona and Mexico. In almost three decades, 500 desert sheep were transplanted, but for the first 20-year period almost no population growth was documented until an aggressive mountain lion control program was instituted. Transplants and possibly predator control, coupled with increased lamb survival and improved habitat conditions have resulted in the statewide desert bighorn population growing from an estimated 170 to more than 750.

In 2011, the first capture and translocation from a wild herd in New Mexico was conducted in the Fra Cristobal Mountains to the Hatchet and Peloncillo mountains. The Fra Cristobal Mountains, which are managed by Turner Industries, hold more than 200 desert bighorn and are likely to supply more animals for future transplants in New Mexico.

According to Eric Rominger, Senior Sheep Biologist for the New Mexico Department of Game and Fish, mountain lions were, and continue to be the primary cause of bighorn mortality. Approximately 85% of documented mortalities on radio-collared bighorn sheep were due to lion predation. Lions were documented to have killed 17% of radio-collared desert bighorn sheep annually. Although there are seasons for the sport hunting of mountain lions in bighorn sheep habitat, the overall impact of sport hunting on lions is thought to be ineffective, with an average of one lion per year being taken from bighorn habitat. The New Mexico Department of Game and Fish controls mountain lions in all desert bighorn ranges, with an average of 2.5 lions per year being removed. On public lands in the state, the Bureau of Land Management installs and maintains most waters used by wildlife, including big game guzzler systems. Eric Rominger considers the most successful program benefitting desert bighorn in New Mexico has been the mountain lion control program, coupled with bighorn transplants into former ranges.

When the population of desert bighorn sheep had plummeted due to disease epizootics such as scabies, the state's population of desert sheep was listed by the state of New Mexico as an endangered species. Once the scabies issue was resolved and predation controls and transplants were found to be successful, the state determined the desert bighorn population had recovered and delisted the species in 2011.

The first statewide hunting program was inaugurated in 2012 with 21 permits in six hunting units. The raffle and auction permits brought in an annual average of nearly $200,000 and the public hunting tags generated another $50,000. A 2013 permit was sold through the Wild Sheep Foundation convention for $180,000. Due to the high cost of gaining a tag for out-of-state hunters, a pool of several million dollars is generated for the state during the bighorn hunting tag drawing process. Raffles for desert bighorn sheep tags are conducted by the New Mexico chapter of the Wild Sheep Foundation. This group funds a portion of the mountain lion control work, has funded census work and fencing at the Red Rock facility, and also purchased a stock trailer to be used for bighorn transplant operations.

Texas

The 2013 estimate is 1,500 desert bighorn sheep. Desert bighorn populations continue to expand in all occupied bighorn habitat. Sixteen hunting permits were issued in the 2009–2010 season with high hunter success. Twelve tags went to private landowners, one permit to Texas Grand Slam, one to the Texas Bighorn Society, and one to Big Bend National Park, which was not used for hunting. By 2013, the number of hunting tags increased to 17, with 14 on private lands and three on public lands. Since 1988 through 2012, 130 hunting tags have been issued and auctioned or raffled. Ten hunting tags auctioned through the Wild Sheep Foundation over the years have brought in over $1 million for bighorn management in Texas. Sheep management has also been greatly enhanced by the cooperation of the Federal Aid in Wildlife Restoration Program, the Wild Sheep Foundation, the Texas Grand Slam hunt program, the Texas Bighorn Society, and private landowner partners.

Desert bighorn sheep were extirpated from Texas by the early 1960s, but have shown remarkable success through transplants and the extensive public/private partnership. About 98% of Texas is held in private ownership, so agreements between the Texas Parks and Wildlife and private landowners has been essential to conduct bighorn restoration in the state. Non-native aoudads (*Ammotragus lervia*) pose a threat to native bighorn in many areas of Texas, and about 2,000 were recently removed from desert sheep habitat in southern Texas.

Transplants of desert bighorn into Texas have been essential, since no sheep existed in the wild after the early 1960s. History was made in 2010 when the largest in-state transplant of bighorn occurred. Forty-six bighorn were captured by netgun from Elephant Mountain Wildlife Management Area and released at Big Bend Ranch State Park. This success was followed in 2012 with 95 more bighorn moved to Big Bend Ranch State Park. Today, with the success of establishing desert bighorn in numerous areas of Texas, there are no longer any captive breeding facilities in the state. All captures and transplants are conducted in wild herds. The estimated 1,500 desert bighorn today brings the population back to the estimated population in the late 1800s—a true conservation success story.

An exciting project provides much optimism for the future. The El Carmen-Big Bend Conservation Corridor Initiative provides the opportunity for a "transboundary mega-corridor" between Mexico and Texas. The cooperative project involves Texas Parks and Wildlife, CEMEX (Cementos de Mexico), National Park Service, Texas Bighorn Society, Mexican conservation agencies, and numerous private landowners. The project couples Big Bend Ranch State Park, Big Bend National Park, Black Gap Wildlife Management Area on the U.S. side of the border with Maderas del Carmen Protection Area in Mexico. Radio-collared bighorn released in Big Bend Ranch State Park have been recorded crossing the Rio Grande into Mexico, re-establishing this important international wildlife corridor. Maderas del Carmen holds 577,300 acres of land in a protected status.

Utah

The 2013 estimate is 2,000 desert bighorn in 21 populations, down from the 2009 estimate of 2,700 desert bighorn. Utah has transplanted 732 bighorn since 1973. Two desert bighorn populations have shown recent increases, two others are stable, while five subpopulations have shown a decline. For 2012–2013, Utah offered 37 desert bighorn hunting tags with a 90% hunter success rate.

Conflicts continue in Utah between domestic sheep grazed in or adjacent to bighorn sheep habitat. Sixteen bighorn were captured and removed from the San Juan area to avoid contact with domestic sheep and 19 bighorn were taken out of Zion National Park and placed in nearby ranges to relieve pressure on that increasing herd.

Mexico

Desert bighorn sheep in Mexico have made a dramatic turnaround in the last two decades. Successful land protection strategies have preserved large areas, both in public and private control. In 2012, 66 hours of flight time during bighorn surveys resulted in 1,036 sheep observed and an estimate of approximately 2,300 free-ranging desert bighorn in Sonora.

Transplants onto two islands have proven to be huge successes, resulting in more than 600 bighorn being removed from the islands to return desert bighorn to former ranges in Baja California Sur, Sonora, Chihuahua, Coahuila, and Nuevo Leon. From an original transplant in 1976 of 19 bighorn from the mainland of Sonora onto Isla Tiburon in the Gulf of California, the island population remains at over 500 desert bighorn, even with over 500 having been taken off over the years for new bighorn programs in areas where sheep had been extirpated decades before. Hunting permits for Tiburon Island have brought in as much as $200,000 each, with most of the funds supporting the indigenous Seri Indians. Population estimates for Isla Tiburon in 2006 were 813 and 588 in 2009.

In 1995–1996, 30 desert bighorn were captured in Baja California Sur and released on Isla Carmen, just off the coast of Loreto, Baja California. Today, official estimates show more than 300 bighorn call Isla Carmen home, under the watchful eye of the foundation OVIS Mexico. Approximately 30 hunting permits are sold annually for hunters to take management and trophy rams on Isla Carmen. These permits sell for as much as $90,000 each.

Since 1996, 80 auction fundraising tags in Baja California Sur and on Tiburon Island, Sonora, have brought in $6 million in revenues. Forty-seven permits in the

Vizcaino Biosphere Reserve, in Baja California Sur, have brought in an average of $60,000 apiece.

The last of the desert bighorn in the state of Chihuahua were thought to have disappeared in the 1960s, while sheep in Nuevo Leon and Coahuila are thought to have been driven to extinction much earlier. In Chihuahua, a successful captive breeding operation has been established with about 300 bighorn on La Guarida Ranch, owned by the Vallina family. Ultimately the family hopes to release animals onto surrounding mountain ranges owned by local ejidos.

In Coahuila, programs funded by the Mexican corporation CEMEX reestablished about 100 free-ranging desert bighorn sheep in their native habitat. The "Pilares" captive breeding facility, just south of Big Bend, began with desert bighorn sheep from Sonora, and as of 2012 had more than 300 desert bighorn. The state of Coahuila is working with Texas Parks and Wildlife to reestablish and maintain the bighorn movement corridor along their common border in an effort to enhance the international metapopulation of desert bighorn. Texas is planning more reintroductions to the Big Bend region of south Texas.

In Nuevo Leon, a private facility holds about 50 desert bighorn. These animals originally came from Sonora and the Chihuahua captive breeding facility at La Guarida.

Returning Water to the Ranges

For humans to survive in the desert environment they need access to water sources. Exploration routes, trade routes, seasonal movement trails, village sites, prospector's cabins, agriculture, livestock grazing, and entire civilizations were based on the availability of water. Sometimes this meant establishment of a cabin, village, mission, trading post, or town along the banks of a river or stream. Other times,

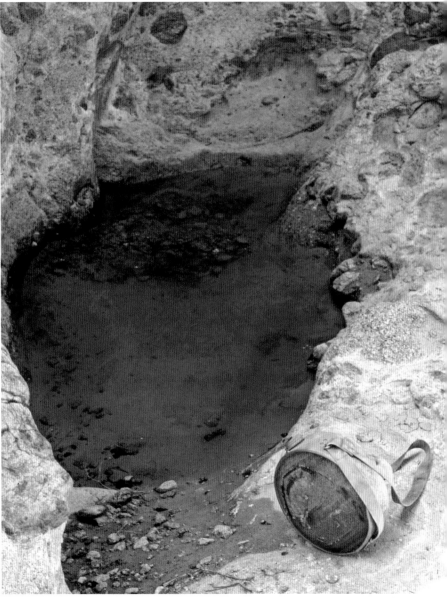

PHOTO BY MARK C. JORGENSEN

Tinajas are rocky basins which hold water after rain storms. In some desert ranges tinajas may provide the only water available to wildlife. Some large tinajas hold more than 10,000 gallons of water for years at a time, going dry only in the most prolonged droughts.

the need for life-giving water meant setting up camp or operations adjacent to an isolated spring or seep. As people established their networks throughout the American West, taking over stream courses and rare water sources, shy animals such as the desert bighorn were pushed out of well-watered canyons, further into remote mountain ranges. Bighorn were often forced into waterless ranges where their long-term survival proved precarious. Local extinctions have been attributed to the lack of reliable water sources in what would otherwise be suitable bighorn habitat.

Beginning in the mid-1900s wildlife managers developed strategies to establish water sources where natural waters had been usurped. Damming of seasonal streams, construction of horizontal wells in dry or muddy springs, collection of rain waters, windmills, and even trucking water into remote storage tanks were some of the many management strategies used throughout the West to enhance bighorn habitat. By the 1980s, designs of man-made water sources or "guzzlers" were refined and their numbers increased dramatically as agencies and private conservation groups struggled to hold onto their dwindling bighorn populations. Construction of systems which gathered seasonal rainfall, piped it into large storage tanks, some above ground, some subterranean, and metered the water into drinker boxes fit with on-demand float systems became the sole water available to many bighorn populations throughout the western states.

The establishment of water enhancement projects such as wildlife guzzlers could not happen without the organization of large groups of volunteers. Many have come together in nonprofit organizations such as the Society for the Conservation of Bighorn Sheep, the Arizona Desert Bighorn Sheep Society, Desert Wildlife Unlimited, Nevada

Bighorn Unlimited, Texas Bighorn Society, Fraternity of the Desert Bighorn, local chapters of Safari Club International, and many regional and local chapters of Wild Sheep Foundation. These tireless groups of unpaid bighorn advocates have constructed and maintained hundreds of wildlife watering systems throughout the western states, contributing millions of dollars of materials, and hundreds of thousands of hours of their valuable time. These private groups have accomplished what government agencies could never afford considering staff and finances.

Controversy has arisen with the construction of wildlife guzzlers in wilderness areas on federal and state lands in several western states. Purists oppose the introduction of human improvements in "pristine" wilderness areas and claim that wildlife should be left to fend for itself as it has for thousands of years. One big question is, once humans have removed all the water from desert mountain ranges through grazing, mining, homesteading, farming, or construction of highways, what kind of "wilderness" do we have left?

Humans owe it to the wilderness to pay back the loss of water sources taken over the past two centuries of settlement and "civilization." Low-profile, camouflaged, and even buried guzzler systems have been developed which provide reliable water in remote areas without infringing on the wilderness qualities. It is incumbent upon land managers to thoughtfully analyze the presence or absence of historic waters in desert ranges and to consider replacing those important waters which humans have negatively impacted. Consideration should be given to the history of the range, the proximity of deer and mountain lions in the range and how new waters may impact the relationship between desert bighorn, deer, and lions. The question,

what is a desert wilderness with all the native water sources stolen? is answered by putting water back into these vast natural areas in ways that are not obtrusive and do not detract from the wild, serene qualities for which the wilderness area was established.

Restoring Bighorn Habitat

Feral animals have long infringed on desert water sources, at times impeding free access to water for desert bighorn sheep. Feral burros, horses, goats, and cattle can and do push bighorn sheep out of water sources. Bighorn prefer unfettered access to water during summer months, and in many cases will avoid springs or waterholes where competing ungulates such as burros and cattle frequent. Feral animal removal programs have relieved native bighorn of much of their competition, but work remains in the western states and Mexico to control non-native livestock and exotics such as aoudad and oryx from desert sheep habitat.

Most projects designed to remove feral stock from the wilds are met with an opposition group attempting to defend the feral animals. Burros, horses, aoudads, oryx, pigs, and even wild cattle have had advocacy groups. Often the issues come down to a matter of priorities: do we want native wildlife populations thriving on our public lands, or do we want to see our natives pushed out by herds of burros and horses, or exotic game animals?

Exotic plants have posed a major threat to the desert water sources of the West. Number one on the list of non-native plants threatening the integrity of desert waters is the tamarisk (*Tamarix* sp.). Several varieties of the salt-loving tree from the Middle East and Asia have found their way into rivers, streams, arroyos, tinajas, seeps, and springs in

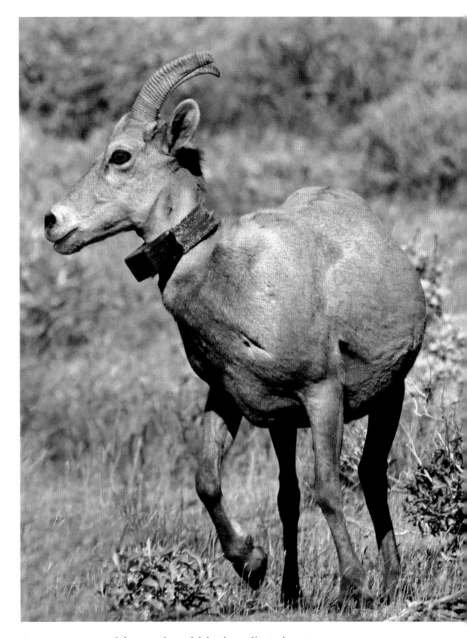

A young ewe with a red and black radio telemetry collar will be tracked for years and provide vital information on home range, population estimates, movement corridors between mountain ranges, lambing success, and predation.

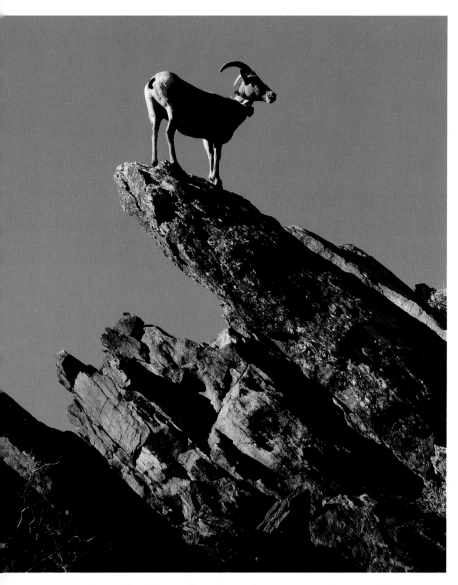

An old radio-collared ewe has provided years of critical data to wildlife researchers. Land managers use such scientific data to improve the future of desert bighorn and other wildlife. Research informs agencies and citizens of critical habitat needs, movement corridors, lands which are vital for acquisition and protection, and assists scientists in accurately estimating population size and range.

all the western states from below sea level to over 7,000 feet in the Rockies. It has been estimated that a single tamarisk tree may consume up to 200 gallons of water per day through evapo-transpiration. This figure, multiplied by the thousands, or hundreds of thousands, of tamarisk trees which exist in some remote regions, accounts for massive losses of available water. Tamarisk creates "monocultures," excluding native plant and animal species over hundreds of thousands of acres. Desert seeps and small springs can be usurped by just a few tamarisk trees growing nearby, precluding use of the springs by desert birds, small mammals, deer, and desert bighorn sheep.

Water projects, guzzlers, fencing to keep out burros, removal of non-native ungulates, and control of non-native tamarisk trees have greatly enhanced the quality of desert bighorn habitat throughout their range.

Restoring Desert Bighorn Habitat Connectivity

Recent success is Arizona to reestablish bighorn movement corridors between mountain ranges involves the construction of wildlife overcrossings to bridge habitat across state highways. This project is proving to become a model for other states where highways, canals, railroads, and fencing has fragmented millions of acres of desert bighorn habitat. Three "wildlife overpasses" were completed in 2011 over State Highway 93 and were found to be successful within a matter of weeks. Only days after completion, groups of ewes and lambs were photographed crossing over a paved highway between mountain ranges, once again making the connection which bighorn had known for thousands of years, prior to the new era of interstate highways. In a 22-month period of monitoring, 1,657 desert bighorn crossings were documented on

the new wildlife overpasses—this is considered a huge success in weaving the fragmented mountain ranges back together again.

The realization that metapopulations of wide-ranging desert bighorn sheep require connectivity and open movement corridors has opened new avenues of research and habitat restoration in the West. Re-establishing access to habitat connectivity benefits numerous species of plants and animals and maintains the age-old landscapes which are so vital to the health of the ecosystem. Agencies, zoological societies, sportsmen's groups, conservation organizations, and land conservancies are working together to identify missing linkages throughout the Southwest. Government and organizations are acquiring private lands from willing sellers to put fragmented habitat back together, assuring the free movement of bighorn, deer, coyotes, mountain lions, and jaguars far into the future.

Predator Control

New Mexico

Five hundred desert sheep were transplanted in almost three decades, but for the first 20-year period almost no population growth was documented until an aggressive mountain lion control program was instituted. Transplants, coupled with predator control, have resulted in the statewide desert bighorn population growing from an estimated 170 to more than 750.

According to Eric Rominger, senior sheep biologist for the New Mexico Department of Game and Fish, mountain lions were, and continue to be the primary cause of bighorn mortality. Approximately 85% of documented mortalities on radio-collared bighorn sheep were due to lion predation. Lions were documented to have killed 17%

of radio-collared desert bighorn sheep annually. Although there are seasons for the sport hunting of mountain lions in bighorn sheep habitat, the overall impact of sport hunting on lions is thought to be ineffective, with an average of only one lion per year taken from bighorn habitat, therefore the New Mexico Department of Game and Fish controls mountain lions in all desert bighorn ranges. The department averages removal of about 2.5 lions per year, which they have deemed a sufficient rate to allow the restored bighorn herds to thrive.

California

Mountain lions have a protective legal status given to them by the voters of California. Legal exceptions to this protection are made in the case of human safety, protection of privately owned livestock, and for the protection of populations of bighorn sheep listed as endangered. Two bighorn sheep populations in California were designated as endangered by the U.S. Fish and Wildlife Service, the Sierra Nevada bighorn sheep (*O. c. sierrae*), and the desert bighorn (*O. c. cremnobates* [now *nelsoni*]) population within the Peninsular Ranges of southern California. The Sierra Nevada bighorn have been determined through genetic analysis to be a distinct population, likely derived from migrations of the California bighorn of Oregon and British Columbia, while the desert bighorn of the Peninsular Ranges have been designated as a distinct geographic segment of the Nelson's desert bighorn sheep. As previously described, both endangered populations suffered high percentages of loss due to mountain lion predation in the 1990s and 2000s.

The researchers of the Sierra Nevada herd were determined to reduce lion numbers and concentrated on

those individuals known to be taking bighorn sheep. Over a decade, approximately two lions per year were removed from the ranges, after a tally of more than 60 Sierra bighorn had been preyed upon by lions. The Sierra population was at a precarious level of about 125 bighorn, down from an estimated 400 sheep a decade earlier. With a concerted effort to find individual lions responsible for bighorn kills, 22 lions were taken in a 12-year period, resulting in an increase in the bighorn population to approximately 500 Sierra bighorn in 2013.

Studies of the desert bighorn of the Peninsular Ranges showed that over 60% of all known bighorn mortalities were attributed to mountain lions from the early 1990s to the early 2000s. No lions were removed, but the populations of both lions and bighorn were studied using GPS and radio telemetry collars. The population of desert bighorn sheep in the Peninsular Ranges within the United States dropped to an estimate of 280 bighorn in 1996, but by 2013 had rebounded to almost 1,000 bighorn. The dynamics between mountain lions and desert bighorn are complex. In some depressed bighorn populations lion control has proven to be effective in providing the bighorn a chance to recover, while in others, the fluctuating swings of bighorn populations go on, probably as they have for centuries, without human intervention.

Funding Management Programs

Revenues to re-establish wild bighorn sheep populations have come from state and federal coffers, private donors, and wild sheep support groups. Groups such as the Wild Sheep Foundation and the Desert Bighorn Council have supported field research and created guidelines for habitat assessment and management, capture protocols, domestic livestock management plans, and have brought in large sums of funding through donations, fundraisers, and in the case of the Wild Sheep Foundation, the auction of hard-to-get hunting tags for many states and Mexico.

Desert bighorn sheep hunting programs exist in all of the western states where bighorn are numerous enough to sustain hunting. Auction tags for desert bighorn have been known to exceed $300,000 for the chance to hunt a wild sheep. More than $25 million has been funneled into bighorn sheep management programs from the tremendous efforts of advocacy groups such as the Wild Sheep Foundation, their many local affiliates, and numerous bighorn volunteer organizations. Millions more in revenues have benefitted bighorn sheep management and restoration programs around the western states, mostly derived from the sale of bighorn hunting tags and the auctions conducted by numerous bighorn advocacy groups.

Hunting Programs

Funding derived from well-managed hunting programs has meant success for many bighorn management programs. States assess sheep populations and determine a maximum number of hunting tags which will be apportioned for the coming year, then often dedicate those revenues for wild sheep management programs. Transplants, helicopter surveys, telemetry tracking projects, and the funding of field researchers is made possible, to a great extent, by revenues derived from hunting tags and auctions. In some states there would be little or no funding for long-term desert bighorn management without dedicated revenue programs tied to the harvest of a small percentage of rams from the state's bighorn populations. Since dominant bighorn rams are capable of breeding with multiple ewes

during the rut, the hunting of a few rams in a large range does not impair a hearty population from thriving.

Mexico has made great strides in desert bighorn recovery and management, funded by private corporations and donors, federal and state programs, and by realizing revenues from well-regulated hunting programs. Bighorn sheep have been reintroduced into the three Mexican states of Coahuila, Chihuahua, and Nuevo Leon mostly through private programs. Sheep populations in Baja California Sur have been greatly enhanced by blending private efforts with local community sponsorship. Animals raised in the wild on Isla Carmen have been reintroduced back to the Sierra de la Giganta on the Baja Peninsula, where they are thriving once again.

Conclusion

Humans have revered, hunted, and eaten desert bighorn sheep for more than 10,000 years. They have used their hides and sinew for clothing, their horns for bows and utensils, and their hooves for ceremonial rattles. Today, the desert bighorn is managed as a symbol of wilderness and unspoiled America. It is enjoyed for recreational wildlife viewing and photography, and is sought by sportsmen as a coveted trophy and a source of wild fare.

Humans have had the most profound impact on the native sheep of any single influence. The introduction of domestic livestock, coupled with market hunting in the 19th century, took a heavy toll on the bighorn. By the 1950s, diseases, overhunting for meat, fragmentation of habitat and competition from introduced feral burros, horses, domestic sheep, goats, and cattle had left the bighorn sheep herds a mere few percent of their original numbers.

Concern for the welfare of the diminished herds of Rocky Mountain bighorn, Sierra Nevada bighorn, and desert bighorn caused people to rally in their defense. Conservation groups, hunting organizations, volunteers, ranchers, corporations, Native Americans, and government agencies worked tirelessly in the last few decades to improve the future for bighorn sheep populations. These groups have worked to preserve habitat, reestablish connectivity, conduct bighorn transplants, restore water sources, captive breed, research diseases, regulate livestock grazing, generate funding for research and land acquisition, and raise public awareness of the importance of managing bighorn sheep populations throughout their range.

Today, estimates of desert bighorn populations in seven western states in the United States and six northern states of Mexico number over 31,000 animals. In many states there are more desert bighorn today than at any time since the 1800s. Desert bighorn sheep have been returned to Texas, Chihuahua, Coahuila, and Nuevo Leon, where they had been extirpated. Plans call for numerous transplants to historic ranges in coming years. Desert bighorn sheep are once again crossing the Rio Grande from Texas to Mexico as connectivity is reestablished and habitat is protected. Studies using high-tech radio and GPS collars continue to reveal the complexities of desert bighorn natural history. People have risen up to support sustainable bighorn populations, to restore habitat, and to insure the future of this majestic symbol of wild places. Their future truly is, in our hands.

Selected Bibliography

Bleich, Vernon, PhD, Laura Abella, and Ben Gonzales DVM, 2013. "Bighorn Sheep and Disease in the Old Dad Peak System and Marble Mountains of California." Unpublished report for California Department of Fish and Wildlife.

Boyce, Walter, PhD, 1995. "Peninsular Bighorn Sheep Population Health and Demography Study." Final Progress Report for. California Department of Fish and Game, Sacramento.

DeForge, James R, 1998. "The Effects of Urbanization on a Population of Desert Bighorn Sheep." Abstract for the 5th Annual Conference of Wildlife Society, Buffalo, New York.

Desert Bighorn Council Transactions, Vol. 50, 2009. Status of desert bighorn in the United States and Mexico.

Desert Bighorn Council Transactions, Vol. 51, 2011. Status of desert bighorn in the United States and Mexico.

Geist, Valerius, 1971. *Mountain Sheep, A Study in Behavior and Evolution*. Chicago: University of Chicago Press.

Hayes, Charles C., Esther S. Rubin, Mark C. Jorgensen, Randy A. Botta, and Walter M. Boyce, 2000. "Mountain Lion Predation on Bighorn Sheep in the Peninsular Ranges, California." *Journal of Wildlife Management* 64(4):954–9.

Hornaday, William T., 1983. *Campfires on Desert and Lava*. Tucson: University of Arizona Press.

Jorgensen, Paul D. 1974. "Vehicle Use at a Desert Bighorn Watering Site." Desert Bighorn Council Transactions 18:18–24.

Lee, Raymond, 2012. Personal communications with the author on status of bighorn in Mexico.

Mead, Jim I., and Louis Taylor, 2004. "Pleistocene (Irvingtonian) Artiodactyla from Porcupine Cave, Colorado," in *Biodiversity Response to Climate Change in Mid-Pleistocene—The Porcupine Cave Fauna from Colorado*. Berkeley: University of California Press.

Monson, Gale, and Lowell Sumner, 1981. *The Desert Bighorn, Its Life History, Ecology, and Management*. Tucson: University of Arizona Press.

Murray, Lyndon, PhD, 2012. (Paleontologist and Curator of the Anza-Borrego Stout Paleontological Research Laboratory in Borrego Springs, California) Personal communication with the author.

Ostermann, Stacey D., Esther S. Rubin, Bob Atwill, Walter M. Boyce, 2002. "Feral Horses in Coyote Canyon, Anza-Borrego Desert State Park." Final Report #920-99-00237. California State Parks and Wildlife Health Center of University of California, Davis. Colorado Desert District Library.

Ostermann-Kelm, Stacey D., Edward A. Atwill, Esther S. Rubin, Larry E. Hendrickson, Walter M. Boyce, 2003. "Impacts of Feral Horses on a Desert Environment." Report to California State Parks, Colorado Desert District, Borrego Springs, CA.

Peterson, Christine, 2012. "Wyoming Artist Rediscovers Ancient Art." *Wyoming Star-Tribune*, November 25, 2012, Casper, Wyoming.

Rominger, Eric, 2012, personal communications with the author on status of desert bighorn in New Mexico.

Rubin Esther, PhD, 2000. "Recovery Plan for Bighorn Sheep in the Peninsular Ranges, California." With contributions by Dr. Vern Bleich, Dr. Walter Boyce, Jim DeForge, Dr. Ben Gonzales, Mark Jorgensen, Dr. Stacey Ostermann, Dr. Oliver Ryder, Pete Sorensen, Steve Torres, and Dr. John Wehausen. U.S. Fish and Wildlife Service, Portland, Oregon.

Rubin, Esther Salzman, 2000. "The Ecology of Desert Bighorn Sheep (*Ovis canadensis*) in the Peninsular Ranges of California." PhD diss. California State Parks Colorado Desert District Library.

Rubin, Esther S., Water M. Boyce, Mark C. Jorgensen, Steve G. Torres, Charles L. Hayes, Chantel S. O'Brien, David A. Jessup, 1998. "Distribution and Abundance of Bighorn Sheep in the Peninsular Ranges, California." *Wildlife Society Bulletin* 26(3):539–551.

Thornton, Gray N., ed. *Wild Sheep Foundation* Magazine Spring 2013, Vol. 1-1. Report on the Annual WSF Convention.

Torres, Steve G., 2013. (California Department of Fish and Wildlife.) Personal communications with the author on status of desert bighorn sheep in California.

U.S. Fish and Wildlife Service, Carlsbad Field Office, Carlsbad, CA, 2011. "Peninsular Bighorn Sheep, (*Ovis canadensis nelsoni*), Five Year Review, Summary and Evaluation." California State Parks, Colorado Desert District Library.

Valdez Raul, 1982. *Wild Sheep of the World*. Mesilla, NM: Wild Sheep and Goat International.

Valdez, Raul, and Paul Krausman, 1999. *Mountain Sheep of North America*. Tucson: University of Arizona Press.

Wang, Xiaoming, 1998. "Systematic and Population Ecology of Late Pleistocene Bighorn Sheep of Natural Trap Cave, Wyoming." University of Kansas. Digital Commons, University of Nebraska, Lincoln.

Wehausen, John D. 1996. "Effects of Mountain Lion Predation on Bighorn Sheep in the Sierra Nevada and Granite Mountains of California." *Wildlife Society Bulletin* 24(3):471–47.

Wehausen, John D., and Rob R. Ramey III, 1993. "A Morphometric Reevaluation of the Peninsular Bighorn Subspecies." Desert Bighorn Council Transaction 37:1–10.

Wells, Ralph E. and Florence B. Wells, 1961. "The Bighorn of Death Valley. Fauna Series of the National Parks of the United States." Fauna Series No. 6.

Index

Sunbelt Desert Bookshelf

Anza-Borrego: A Photographic Journey | *Ernie Cowan* | Striking full-color photographs of Anza-Borrego Desert State Park feature ecosystems from mile-high mountains to sea level in this largest contiguous state park in the continental U.S.

Anza-Borrego A to Z: People, Places, and Things | *Diana Lindsay* | This is an encyclopedic reference to the history and place names of the region and is a companion to *The Anza-Borrego Desert Region*.

Anza-Borrego Desert Region | *L. Lindsay & D. Lindsay* | This detailed area guidebook covers much of San Diego County and parts of Riverside and Imperial counties. Includes hiking and off-road trails and a large fold-out map to the region.

Baja California Plant Field Guide, 3rd Edition | *J. Rebman & N. Roberts* | This expanded and detailed field guide includes over 715 species in 111 plant families in Baja California, of which over 50% are found in southern California.

Bighorns Don't Honk | *S. Lester & N. Jensen* | A bighorn sheep saga for children from nine to ninety includes important facts about this western icon with fun-to-read rollicking verse and hilarious illustrations.

Cave Paintings of Baja California: Discovering the Great Murals of an Unknown People | *Harry W. Crosby* | This world-class archaeological region in remote central Baja California includes rock art of desert bighorn sheep.

Desert Bighorn Sheep: Wilderness Icon | *M. Jorgensen & J Young* | This comprehensive photographic work combines the finest collection of bighorn photos ever assembled with an informative and engaging text that will appeal to both the scientist and the layman.

Fossil Treasures of the Anza-Borrego Desert | *G.T. Jefferson & L. Lindsay, eds.* | A richly illustrated volume by 23 leading scientists and specialists that reveals North America's most continuous fossil record for the last 7 million years.

Geology and Lore of the Northern Anza-Borrego Region (SDAG) | *M. Murbach, C. Houser, eds.* | Leading geoscientists give in-depth regional information. Includes self-guiding trip logs. Topics include mines, history, groundwater, faulting, and the science-based metal sculptures of Borrego Valley.

Geology of Anza-Borrego: Edge of Creation | *P. Remeika & L. Lindsay* | This non-technical guide introduces the southern California desert enthusiast to one of the most active geologic and seismic regions in North America. Includes field trips.

Gold and Silver in the Mojave: Images of a Last Frontier | *Nicholas Clapp* | This exhaustively researched pictorial pieces together the final days of the Old West through visually rich and rare photographs that include both sweeping landscapes and extraordinary intimate images.

Palm Springs Oasis: A Photographic Essay | *Greg Lawson* | This is an elegant display of the Coachella Valley with breathtaking sights of enchanting, spring-fed canyons and brilliant desert flowers. Text is in English, Spanish, French, and German.

Palms to Pines: Geologic & Historical Excursions through the Palm Springs Region (SDAG) | *S. Snyder, B. Miller-Hicks, J.A. Miller, eds* | Papers explore deep time, regional tectonics and faulting, economic resources groundwater, and Native American history of Coachella Valley. Field trips included.

Ricardo Breceda: Accidental Artist | *Diana Lindsay* | This is the award-winning story of the unlikely metal sculptor dubbed "Picasso of Steel" that created over 130 unique sculptures located in Borrego Valley, California. Includes a map.

Rock Art of the Grand Canyon Region | *D. Christensen, J. Dickey, & S. Freers* | This visually stunning book opens a window to the past within this majestic region rarely seen by millions of visitors. It includes rock art depicting desert bighorn sheep.

San Diego County Bird Atlas | *Phillip Unitt* | This atlas covers almost 500 species with detailed accounts and maps of their distribution, habitat, nesting, movement, taxonomy (including subspecies), status, historical changes, and conservation outlook.